The American Barn

David Plowden

W. W. Norton & Company New York | London

The American Barn

To my children: John, Daniel, Philip, and Karen.

The text of this book is composed in:
 Scala (FontShop International) and
 Interstate Light (Font Bureau)
With the display set in: Interstate Light (Font Bureau)
Manufacturing by Mondadori Publishing, Inc.
Design and Composition by: John Bernstein Design, Inc.

Library of Congess Cataloging-in-Publication Data
Plowden, David.
 David Plowden : the American barn / photographs by David Plowden.
 p. cm.
 ISBN 0-393-02557-8
 1. Barns – United States – Pictorial works.
 I. Title: American Barn. II. Title.

NA 8230 .P64 2003
728'.922'0973 – dc21
 2003053969

W. W. Norton & Company, Inc.
500 Fifth Avenue, New York, N.Y. 10110
www.wwnorton.com

W. W. Norton & Company Ltd.
Castle House, 75/76 Wells Street, London, WIT 3QT

1 2 3 4 5 6 7 8 9 0

Contents

Introduction

Apart from its enormity, what I remember most vividly about our old barn was driving a team of horses with a full wagon load of loose hay up the ramp into the loft. It was no easy feat. It was all uphill on a one-lane dirt road from the fields. There were two sharp turns to negotiate and before making the final assault on the ramp into the loft you had to stop to let the horses "blow." While they were catching their breath you had time to figure out how you were going to make the wide turn into the barn so you would be sure not to catch the rear wheel of the wagon on the edge of the stonework and dump the whole load over the side. My heart was always in my mouth as I stood on top of the hay, reins in hand, coaxing the horses on. I will never forget the sound of the steel wheels grating on the gravel and the heavy thud of horses' hooves pounding on the floorboards, their flanks heaving from the effort as they came to a halt safely inside.

Then the real work began: unloading the hay. There were usually four or five of us, mostly the farmer's children, boys and girls: Alan, Sonny and Laura, it didn't matter. We all pitched in —two on the wagon and the others in the loft. Armed with pitchforks, we heaved a ton or more of loose hay with each load. After it was done, whoever was driving backed the team and the empty wagon ever so carefully out of the barn.

In our barn, like most in the Northeast, by far the largest space was allotted to the loft where enough hay was stored to feed the livestock through the long Vermont winters. The portal to the loft was an immense maw through which wagon loads of hay were pulled by sweaty, straining teams of horses. The loft itself was

colossal—at least two stories high from the floor to the topmost rafters and close to two hundred feet long. Although I knew little about framing, the barn's truss work seemed to me a masterpiece of simplicity and ingenuity. Like most barns in the region it was of timber-frame construction, which consisted of two parallel rows of vertical posts made of rough, hand-hewn timbers that supported equally massive horizontal beams that were connected to the posts by diagonal braces. Everything was held together by wooden pegs, or treenails, which were driven into holes bored in mortise and tenon joints. As I remember there were no nails anywhere in the trusswork, which made it all the more wondrous to behold. Everywhere the timbers were festooned with cobwebs that had collected generations of hay dust and chaff.

The ground floor beneath the loft was completely different. That was where the milking parlor had been. At one time it had been a warm and cozy place filled with sounds of cows munching where in winter the windows were steamy and there was always a cat waiting for a plate of milk. Norton Thurber, from whom we bought the farm in 1940, was the last to milk there. He had sold his herd before we arrived on the scene. Even after years of disuse the place always smelled of stale urine and old hay. What I remember best were the rows of ancient wooden stanchions that had been worn smooth by generations of cows that had rubbed their necks against them. On the west side high above the stone foundation was a row of windows through which the late afternoon sunlight turned cobwebs into strands of lace and shone on the gears of unused machinery that languished there. The side opposite the defunct milking parlor was the complete antithesis. There were four or five box stalls where Mr. Kendall,

the farmer, kept the horses and the young stock. The air reeked with the pungent smell of horse manure. Twice a day the stalls had to be cleaned out and fresh hay put down. The animals had to be fed and watered. The latter was a laborious job as there was no running water in the barn. Each animal had to be led to an immense wooden watering trough across the paddock where you hoped the last would drink his fill before dark.

Way up in the back hills of Vermont electricity must have seemed an unnecessary luxury to the Bloods who originally settled the farm and to old Norton Thurber from whom we purchased it. They were the archetypical frugal Yankees. In fact there were no electric lights anywhere on the farm when we moved in just before World War II. Light after dark, if it was needed, was provided by kerosene. The old lanterns were potentially lethal when combined with tons of dry hay and a structure built of century-old timbers. There was a cardinal rule which was driven home by my mother from the time I was a little boy: always hang your lantern on a hook or nail *before* you start to work. *Never* put it on the floor next to you where you might accidentally knock it over and set the barn ablaze.

In addition to being terrified that I might start a fire, I was always scared to death whenever I set foot in the barn at night. I did so only if the Kendalls had gone home and some chore had been forgotten. I still know no place that is more terrifying at night. All the monsters I conjured up in my young imagination surely awaited me in the darkness. I tried with all my might to concentrate on the task at hand, telling myself all the way across the paddock to the barn door that there was nothing to be scared

of—only my friends, like Old Chub and Jerry and my favorite little Jersey calf were waiting for me inside. But once I opened the door, reason gave way to terror. The light from my lantern created a surreal, grotesque tableau and I wanted to turn and run. I had to walk the full length of the barn because the animals were stabled at the far end. At each step, I was sure I was being watched by unseen eyes and followed by some spectral being.

Whenever and wherever it was dark and I was alone, I thought of the "Hartford boy." Though we referred to him as the "Hartford Boy" he was a grown man and the adopted son of the Hartfords who lived in the hollow down the road. He was "not quite right in the head" and it was said that he had set fire to several barns. I was terrified of him. Perhaps he was lying in wait in the darkness of the cavernous barn, and at any minute he might sneak up behind me and garrote me on the spot. Once I had completed my chores I would turn and run as fast as I could out of the barn, being careful not to trip and drop my lantern. I raced to the house knowing that a whole host of demons and monsters was at my back. I didn't catch my breath until I slammed the door behind me and was safe and sound inside the kitchen.

At some point long ago our great cow barn had been painted red, but by the time I knew it only vestiges of color remained on its weathered flanks: long, pale slivers that mingled with the grain of the wood. The boards were silvered and warped by the ravages of countless winters and the sunlight of summer days. Despite its age it appeared to have achieved a state of perennial grace as if it were impervious to time. At least that is how I will

always see it. The only trace of its silo's existence was a ring of stones on the barn's north end which was covered by a thicket of black raspberry bushes.

After the war things began to change. Mr. Kendall arrived one morning on a brand-new Farmall "M" tractor, and soon thereafter the team and the old "Number 7" McCormick mowing machine were gone. Only Old Chub remained, like a spare locomotive, to do odd jobs like pulling the Dump Rake to clean up the fields. He was a wonderful, docile old fellow with no initiative whatsoever. While raking he would plod along slower and slower until I felt he might begin to fall asleep in the traces. I would give him a smart slap on the rump with the reins to wake him up and in a few minutes he would begin to doze off again. It might take half a day to rake six acres but I'd give anything to be sitting high up on the slotted steel seat of the old hay rake on a warm summer day with Old Chub plodding along —neither of us with a care in the world.

With the Farmall came a McCormick side delivery rake and baler that spat out neatly tied rectangles of hay across the fields like huge lumps of sugar—and made unloading hay a cinch compared to heaving it off the wagon with a pitchfork. Of course the loft wasn't as much fun to play in. Hanging from a beam and jumping into a soft bed of hay was very different from landing on a pile of brick-hard bales.

In the late 1940s Old Chub passed on to greener pastures. At the same time Mr. Kendall decided that the twenty-mile trek to and from his own farm in East Northfield on the Massachusetts line

wasn't worth the effort any more. He told my mother he'd cut the hay one more time. Once again we all took part in what had been a summer ritual ever since I was ten. This time, instead of heading up the long hill for the barn we piled the bales on his truck which lumbered away to his farm with the last load. By the time I went back to school in September the animals were gone and the great loft was virtually empty.

When Mr. Kendall drove away, the barn was never the same again. It had lost its purpose. Its only regular inhabitants were a band of feral cats who survived on a diet of mice and assorted rodents. Come spring, as always, barn swallows by the score arrived to breed and fledge their young. For several summers the box stall nearest to the door was home to my sister's beloved companion: her horse, Silver. One year Silver had a companion of sorts herself who occupied the stall farthest from the door, a pig named Susie Q, who was taken away at the summer's end in a burlap bag squealing mightily.

My mother firmly believed that if you owned land it was your obligation to maintain it. Austin Gassett, who farmed just down the road from us, would have been the logical choice to replace Mr. Kendall, but by then he had decided that it was too hard to eke a living out of the rockbound hillsides of Vermont. Land prices were soaring. He sold his place to two widow ladies from Oklahoma, bought the Texaco station in town, and drove a taxi on the side. There was Mr. Waterman, a "shirttail" cousin of Mr. Kendall's who had a farm a mile or so away. He had dutifully made the rounds of the back country in a 1937 Chevrolet station wagon once a week throughout the war, delivering a supply of

bottled milk and cream to his customers. Why Mother said the milk was always "on the edge" and soured whenever there was a thunderstorm, I'll never know. Be that as it may, Mr. Waterman too had decided that farming was a losing proposition and had taken a full-time job driving a milk tanker for Maple Farms, the local co-op. Mother then turned to Fred Knapp, who ran my aunt and uncle's farm in nearby Dummerston. He agreed to cut the hay, lime the fields, and run a few heifers in the back pasture, but the days of driving wagon loads of hay up the ramp were gone.

By the time I went to college in 1951, my sister, Joan's, dear friend, Silver, had followed Old Chub to wherever it is that all good horses go. Fred Knapp had become a farmer in his own right. He had built a state-of-the-art, round milking parlor that could milk fifty head of holsteins in about two hours and was the envy of most dairymen round about. In spite of his success he dutifully cared for our fields. But his few young heifers were no match for the legions of white pines that had begun to march over the back pasture. It was a losing battle, one that I waged for years with an arsenal of axes. Despite my best efforts, in the end the pasture became a forest.

Fred had no use for an assortment of archaic farm equipment that had been languishing in a half-open space under the barn ever since we bought the farm from Mr. Thurber. By rights it should have been in the Smithsonian. There was an old mowing machine with a slotted steel seat, a rusted hay rake, a tedder, several harrows of one sort or another, and a collection of assorted parts: whiffletrees and the like which we offered to anyone interested if they would take them away. Surprisingly

there were still enough old-time farmers around in the back hills who used horses, and in no time the space was emptied. There was also an immense wooden wagon, which one summer Joan and I painted bright blue with red spoked wheels and which we sold to an orcharder on Route 5 north of town. He placed it prominently by the side of the road in hopes of snaring those nostalgically inclined to stop and buy a peck of MacIntoshes.

By now the old barn had stood empty and unused for four years. The ravages of time and winter had begun to take their toll. Of most concern was a nasty hole in the roof which, despite our attempts to patch, had each year grown into an ever larger festering wound. It became obvious that more drastic measures would be needed if the barn were to be saved. We talked to several contractors who estimated it would cost $10,000, "or better," just to stop the roof from leaking. Sadly, repairs to an abandoned, unused, defunct old barn were not a priority. There were other more pressing matters in our lives that needed attention.

After my graduation from college, I took a job with the Great Northern Railway and moved briefly to Minnesota. There I was surrounded by nothing but farmland stretching as far as I could see — to the ends of the earth it seemed. The farms as seen from the train were like scale models on a sea of black loam.

This was the great American heartland, where the fecundity of the soil was unmatched and the prosperity of the farms was unlike anything I had known in Vermont. Most of the dairy barns in Minnesota were immense gambrel-roofed structures.

They looked like the toy barns Fisher-Price used to make with which a generation of kids, including mine, played.

One September evening I found myself back at our farm in Vermont. No one was there. The house was empty. The old cow barn looked more forlorn than ever. Many of the roof rafters and even some of the massive floorboards in the loft where I remembered the sound of the horses stamping their hooves were so badly rotted that they would barely hold up my weight. Down below where the horses used to be it was dank and dark and smelled of decay. Everything was covered with mildew and clumps of fungus. I was all alone with my memories. I walked back and forth over the once familiar ground, among all the shards of a time past. I walked up the ramp to the loft and sat down in front of the huge door. It was a beautiful evening. Everything was absolutely still and suffused in a tincture of golden light from the fading sun. Suddenly I was aware of the sound of two lone crickets singing to each other somewhere in the tufts of grass that had taken root between the crumbling boards. I sat there for a long time mesmerized by the tranquillity and the poignancy of those two creatures' plaintive love duet. As I listened I was stricken with sadness. I knew there would be a freeze that night. Come morning everything would be covered with a hoar frost and there would be no crickets singing at eventide.

That winter was particularly severe, the snow particularly heavy. Early one morning in February I was awakened by the telephone. It was my mother. "The barn collapsed last night. Millie Ellis called to say they heard what sounded like an explosion in the middle of the night."

The hole in the roof proved to be a mortal wound. The weight of the snow was so great, the timbers so weakened, that the great barn split in half and fell in upon itself.

My mother and I went to Putney to see what had happened with our own eyes; the sight was devastating. I was overcome with sadness to see our stalwart old barn in ruins. Rising out of the wreckage, a skeleton of massive timbers still stood in place. Remarkably, a good deal of the siding survived as well. It was obvious to both of us that there was much that could be salvaged. We placed a notice in all the papers from Brattleboro to Rutland and several in New Hampshire stating that anyone would be welcome to help themselves to any salvageable material if they hauled it away. The response was overwhelming. For a full year farmers, contractors, all manner of people from as far as two hundred miles came. They drove away with truck load after truck load of beautiful weathered boards and hand-hewn timbers. Come winter most of what was usable had been recycled. Many an old barn — including our own sugar house — sorely in need of mending was shorn up and repaired. A motel and a restaurant were built down by the interstate out of timbers from the barn. The silvered siding was considered a valued commodity by many homeowners who wanted to remodel or build anew, and I'm sure that much of it found its way into dens and living rooms near and far.

In the end, the remains were bulldozed into an immense heap down by the swamp. It reminded me of the carcass of a prehistoric creature, a mammoth or a mastodon. I prayed for snow to cover it, but it was a long time in coming. Finally when the snow was deep enough the fire department came up one miserable day in February, doused it with gasoline, and set it afire. It burned for two days and two nights, a funeral pyre of memories and cherished times gone up in smoke. I stood watch over it until there was nothing left but a mound of glowing embers and ash amid a circle of bare ground in the snow.

It was always said that there were more cows than people in Vermont. It certainly seemed that way in the middle of the last century, when the small farm was still the linchpin of rural life. Red barns with white silos and herds of cows were scattered everywhere across the hillside meadows of the Northeast. In the great middlewestern heartland, where man lived on the interface between land and sky, the vast, unrelenting landscape was punctuated by groves of trees wherein the barns of myriad farmsteads were clustered together like small towns. Today at speed along the interstate the scenario looks much the same, but exit at some point and take the back roads as I have. You will discover that rural America has been ravaged.

Agibusiness, the economy of scale, federal government policy, suburban sprawl spawned by the automobile and the proliferation of the interstate highway system have all conspired against the small family farm. The America of "citizenfarmers," that Jefferson once envisioned as the bedrock of the republic's stability and freedom, no longer exists. By the time we sold our farm in 1977 and left, Putney Interstate 91 had torn Bill Appel's farm asunder along with most of the best agricultural land in the Connecticut River Valley. Southern New England had become part of the weekend belt, a playground for those seeking refuge

from Boston and New York. Many a farmer in what had been "real country" awoke to find himself on the fringe of somebody else's "vicinity."

One hundred years ago 80 percent of Vermont was farmed. Today barely 20 percent is. Vermont is not an exception. Between 1979 and 1998 over 300,000 farms vanished nation-wide. With the loss of the farms, barns are disappearing at an alarming rate, not just in Vermont but all over America.

As a photographer I felt compelled to begin making a record of this once-familiar icon before it vanished. It became a cause. Starting in New England in the mid-1960s I began to photo-graph barns in earnest. Over the course of the next forty years I sought them out wherever I could find them.

In 1975 I made a trip to Isabella, Clare and Osceola Counties in Michigan, where I photographed some of the largest examples of round-roofed "Gothic barns" anywhere. Although that part of the state still had a thriving dairy industry, perhaps as many as a quarter of the farms I saw were abandoned. When I returned in 1999 to take photographs for this book, only two of the farms I had photographed before were still in operation.

Last spring I went to Wisconsin in search of more barns. On the way home I stopped to talk with a farmer in Green County, in the heart of Wisconsin's farmland, whose barn I had photo-graphed two years before. There were about a half-dozen work-ing dairy farms in his neighborhood then. I asked him how things were. "I'm hanging in there," he said. "I'm the last fellow still milking on the road." Farther on I stopped in to see another farmer. "You know," he said as I was about to get into my car. "There's nobody else milking between here and Monroe. Last year when you were here there were four of us."

The north country from Vermont to Minnesota traditionally has been America's dairyland. Thus it was no coincidence that it should have been the domain of enormous barns, barns big enough to give shelter to livestock with cavernous lofts to store hay and grain to feed them all winter long. The old cow barn I once knew so well was one of these, an immense and noble structure. It was a typical, English, gable-roofed, bank barn built into the side of a hill like most of those round about—only it was much larger.

It was as plain as a loaf of bread, neither fancy nor embellished in any way. Being on a hardscrabble farm, it was strictly a work-ing affair. As such it reflected the essentially frugal nature of the Yankee ethic. Not all barns were as austere as ours. Even in New England many barns were adorned by a cupola or ornate ventilators often capped with weather vanes that featured beauti-fully cast metal cows or horses. Although most farms had a multitude of other buildings—such as a horse barn, a chicken house, an ice house, a milk house, a corncrib and various machine sheds—the cow barn was the centerpiece, the heart and soul of the farm and as such was the object of great pride. Many a farmer had his name emblazoned prominently on the side. Others adorned their barns with all manner of decoration from simple painted arches on the door, star and diamond motifs, to elaborate paintings. Many of these were the work of itinerant

barn painters who would return every so often to retouch their work. Their subjects ranged from primitive depictions of whatever animals were housed inside to intricately executed murals of the "Horses of Herren" or the "Peaceable Kingdom." Needless to say, every farmer was always looking for ways to keep his barn painted. He could rarely resist the offer of the Mail Pouch representative to have whatever side faced the road turned into one of those once ubiquitous Mail Pouch "billboards."

The variety of barn styles is enormous. They come in every size and shape depending on where they were and what they were to be used for. Often they reflected the diverse ethnicity of the American people who built them, being referred to as "Dutch" or "English," "Sweitzer" or "German." There were often profound variations between the barns of different regions. For instance, the Pennsylvania barn, with its characteristic overhanging forebay, has long been considered one of the most distinctive vernacular farm structures. However, it was not confined to the Keystone State. Many Pennsylvanians followed the westering course taken by so many of their fellow Americans, and their characteristic barn took root in Ohio, Wisconsin, and beyond. The round barn, which lately seems to have achieved almost cult stature, was a form indigenous to the Midwest. Often they were not truly round, but ten, twelve, or even sixteen sided. The distinctive gambrel-roofed Wisconsin dairy barn, developed by the University of Wisconsin in the early part of the twentieth century, became the standard cow barn in much of North America. Twin barns, built like Siamese twins, were unique to northwest Ohio, whereas connected barns were developed in Maine and New Hampshire so that, in essence, one could go

from the front parlor to the manure pile without ever going out of doors. Many barns were bought "by the yard" directly from the pages of the Sears and Roebuck catalog and were shipped with all the parts ready for assembly. Perhaps the most striking were the great Victorian barns of the late nineteenth century. Whatever their shape, size, or decoration, all but a very few barns were the essence of vernacular architecture, invariably built by local carpenters or farmers who "raised" them, using whatever material was close at hand, whether wood or stone or brick — or a combination of all.

You can't make it anymore milking fifty head as Fred Knapp did so successfully half a century ago and certainly not milking thirty by hand as Norton Thurber once did. Today's farm is like a factory. It a world of mass production where everything is done on a gigantic scale and where the small farmer is totally outmatched. Enormous, characterless pole barns or those made of prefabricated sheet metal confine hundreds, or sometimes thousands, of animals who are fed bulldozed loads of grain and hay. Milk from row upon row of cows is pumped away in plastic pipes into huge tanks like oil. The monstrous modern farm machinery requires structures of equal proportion to house them. In time the rural landscape as we think of it will no longer exist. The majestic old barns will have disappeared. I mourn their loss. This book is my tribute to them, lest we forget their importance as the centerpiece of the family farm and rural culture.

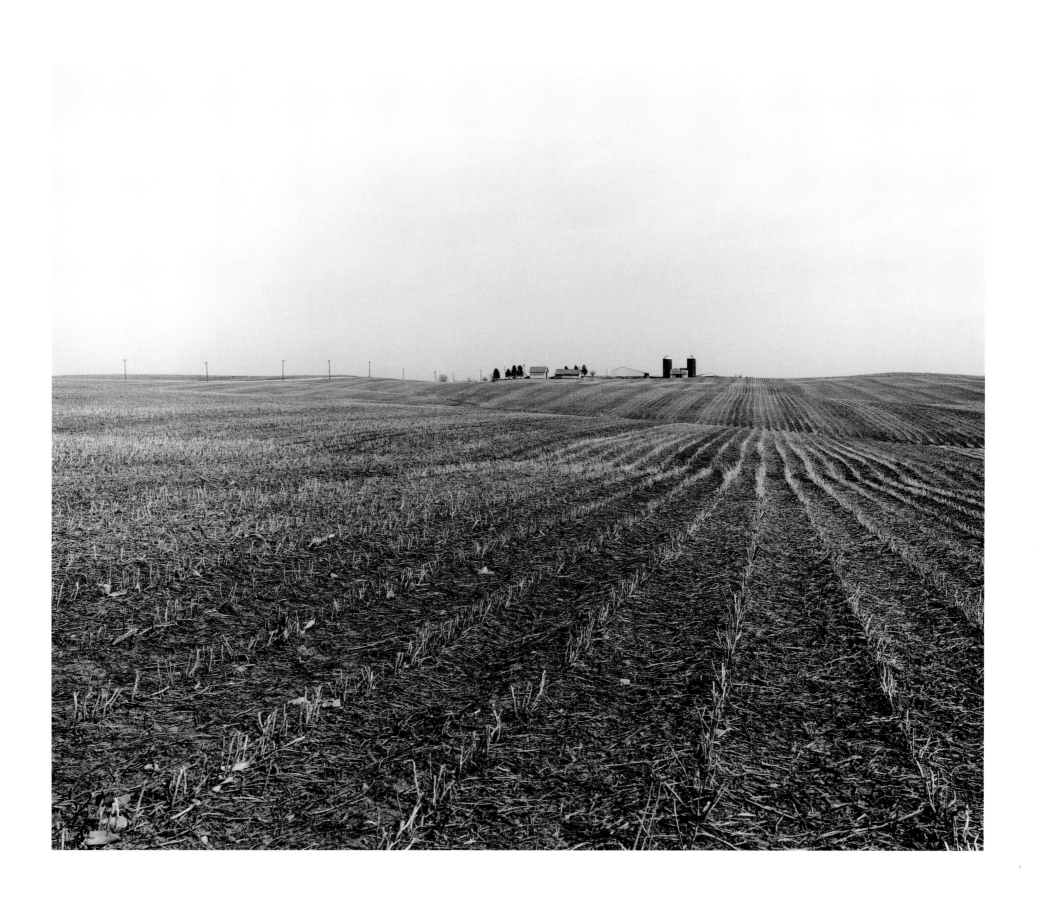

1 · Near Rochelle, Ogle County, Illinois (1990)

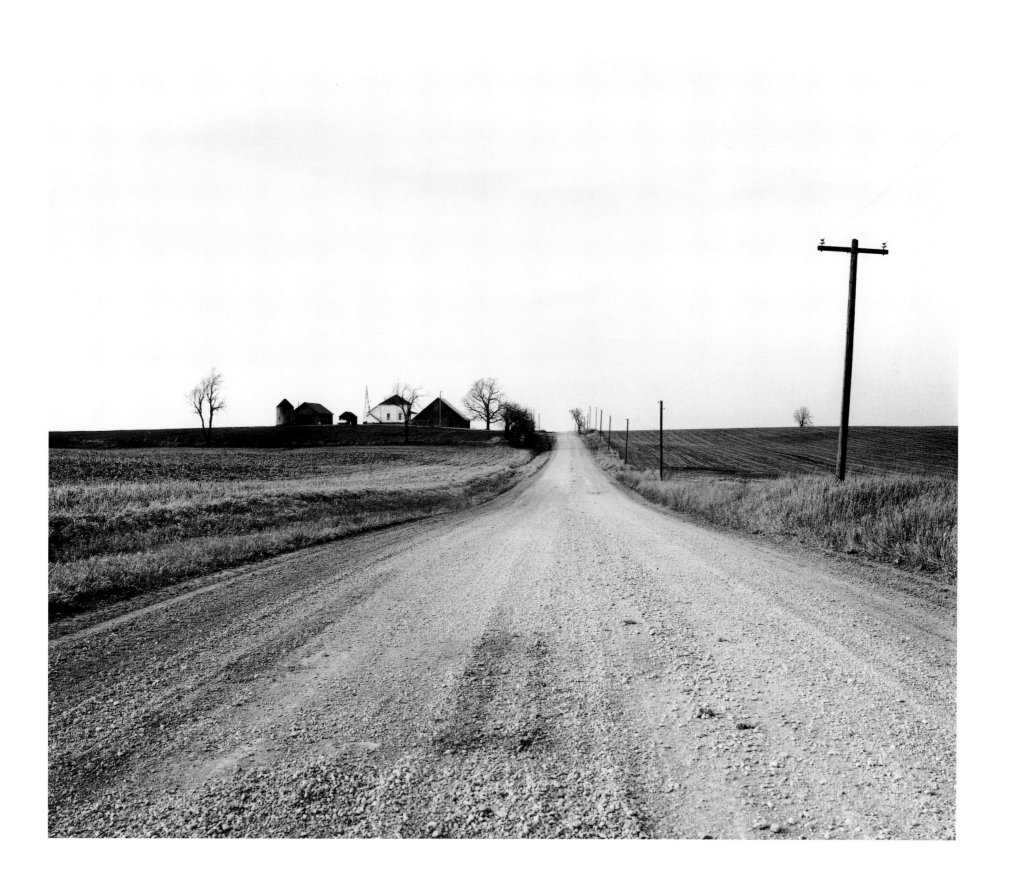

2 · Ogle County, Illinois (1990)

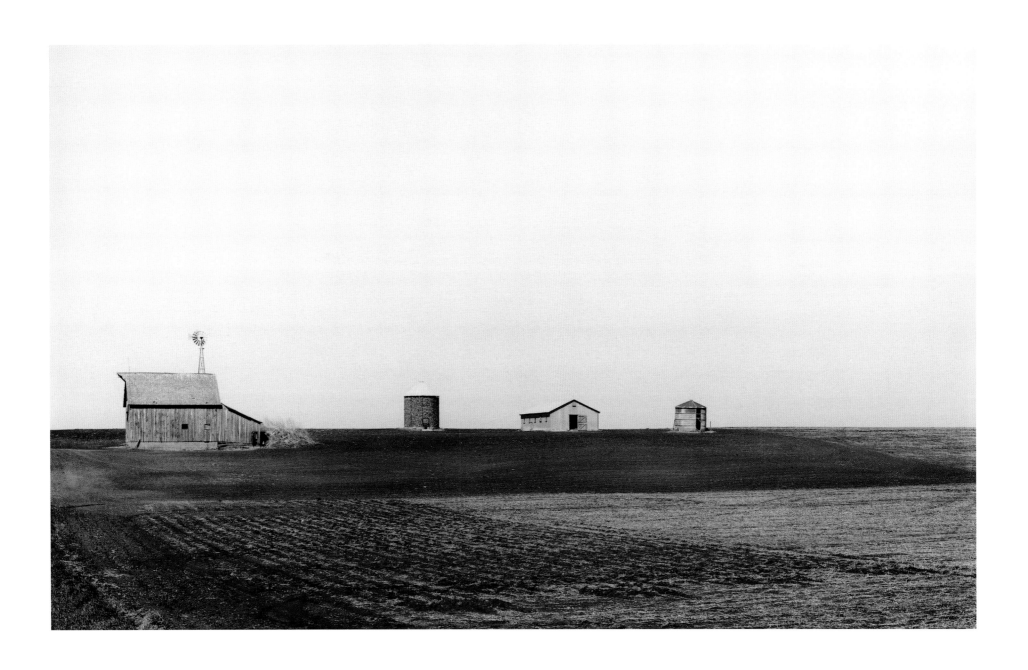

3 · Mills County, Iowa (1987)

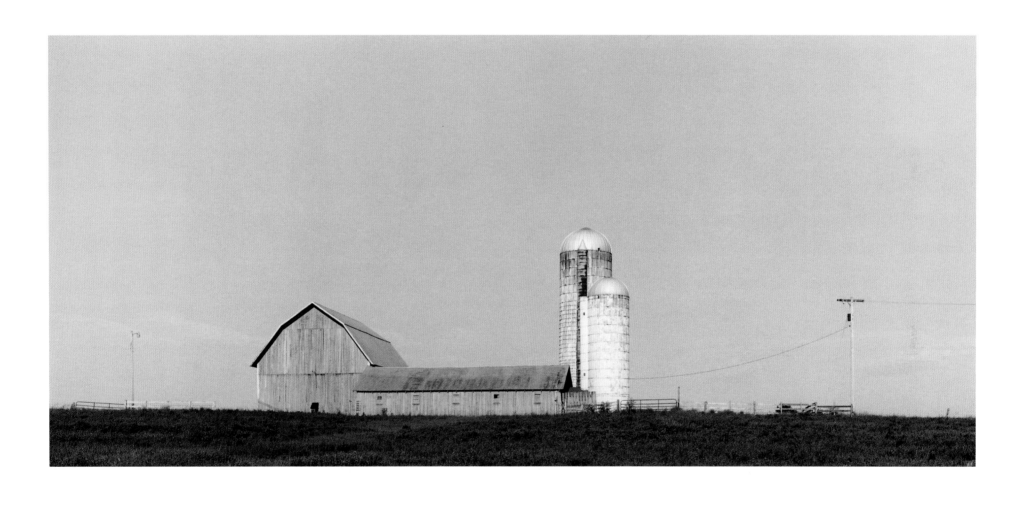

4 · Clare County, Michigan (1999)

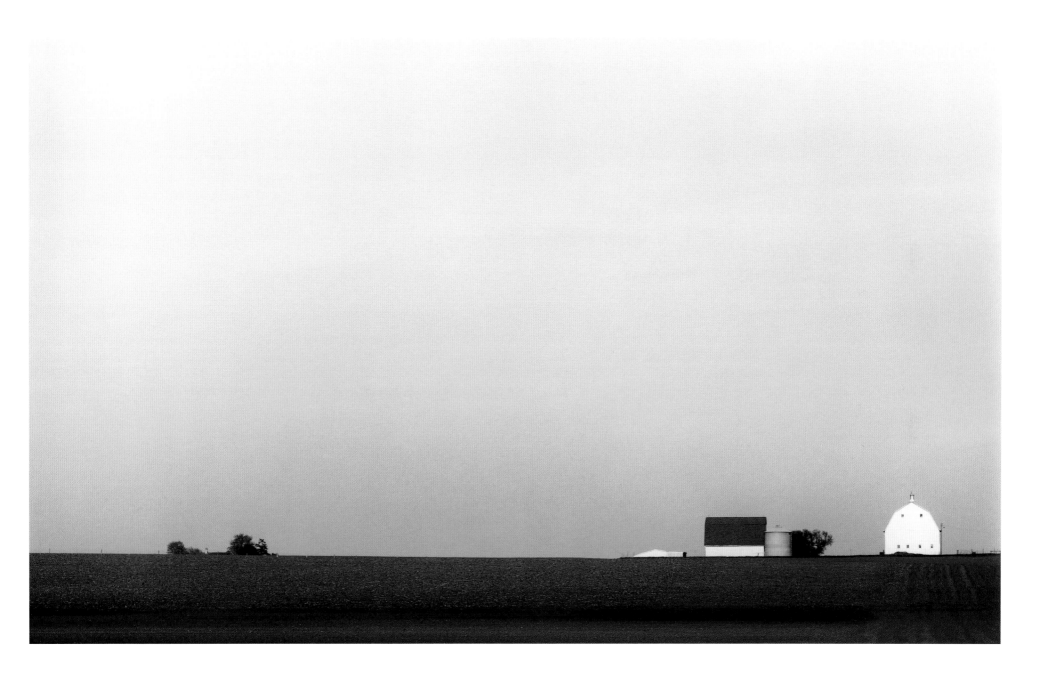

5 · Cedar County, Iowa (1987)

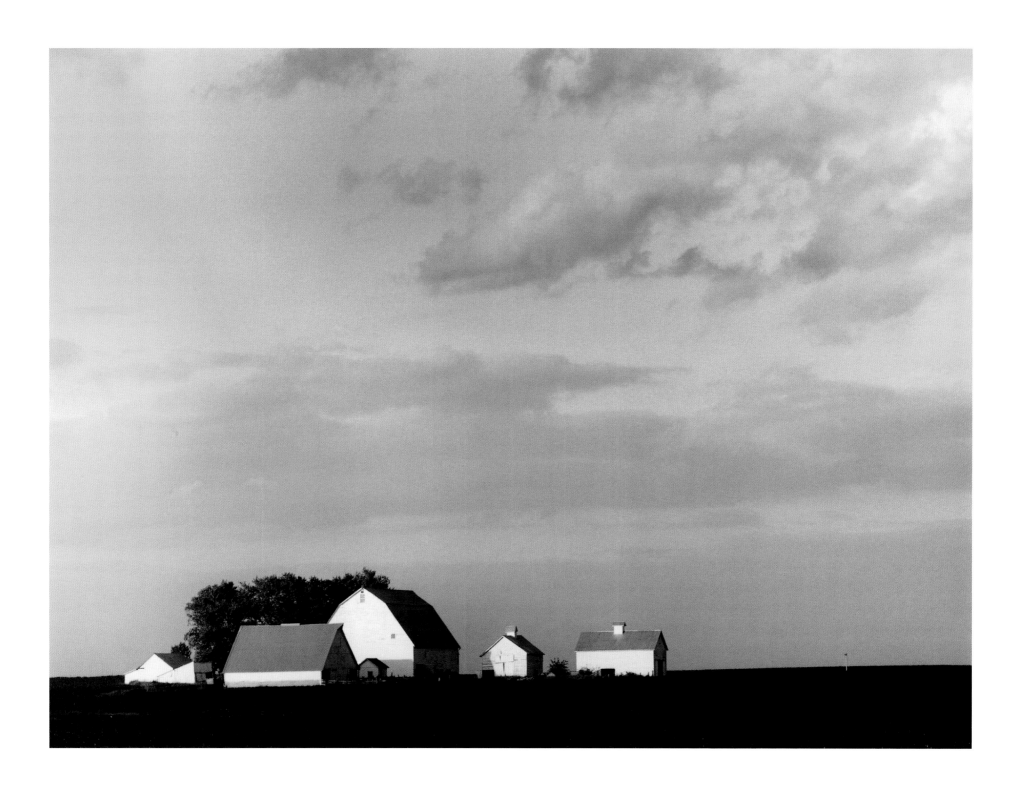

6 · La Salle County, Illinois (1981)

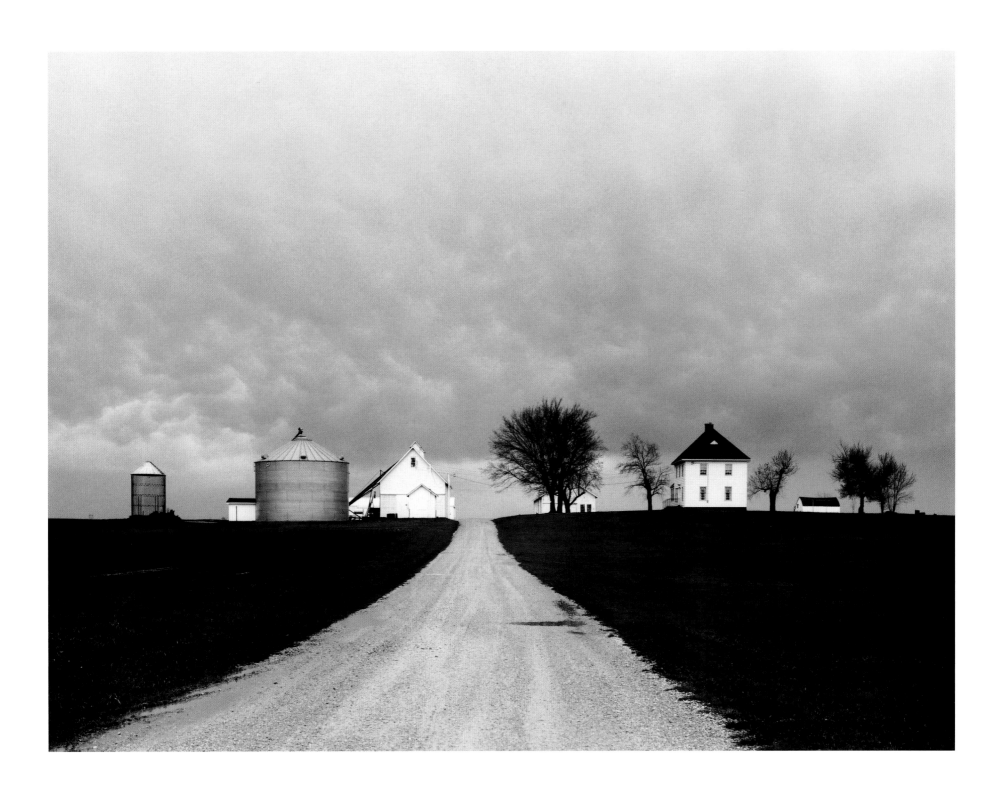

7 · Near Peotone, Will County, Illinois (1981)

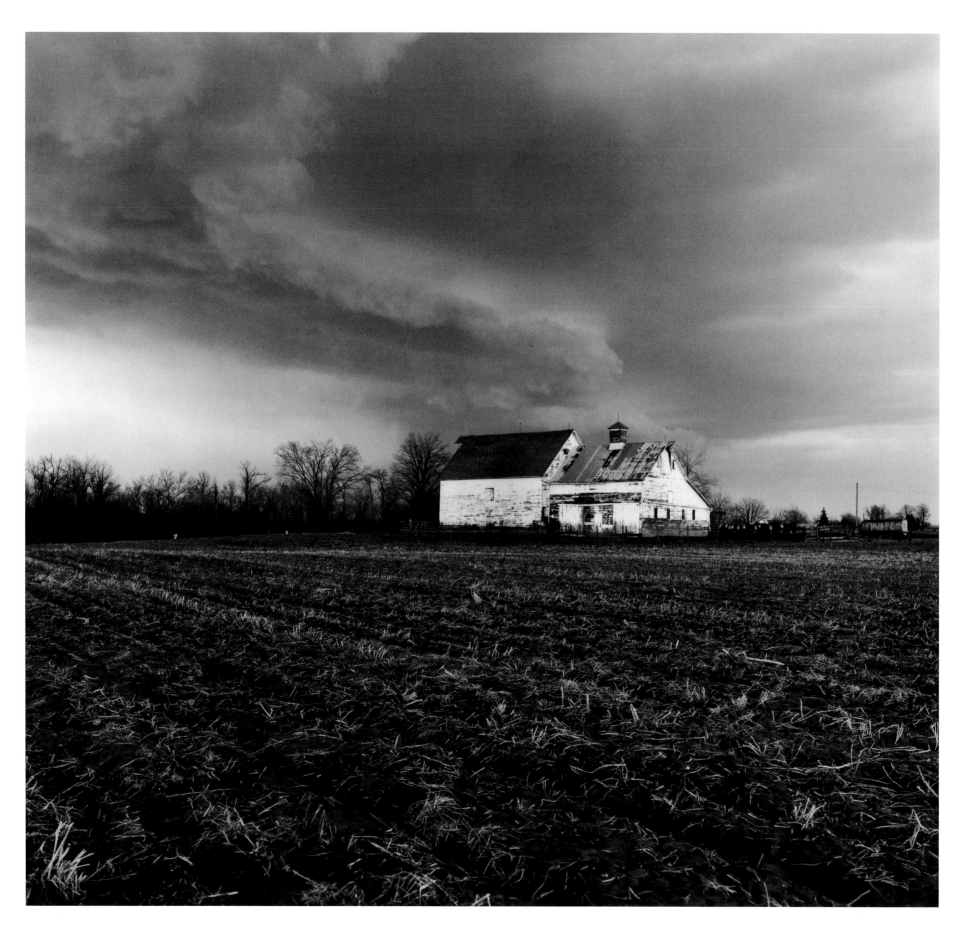

8 & 9 · Logan County, Illinois (1973)

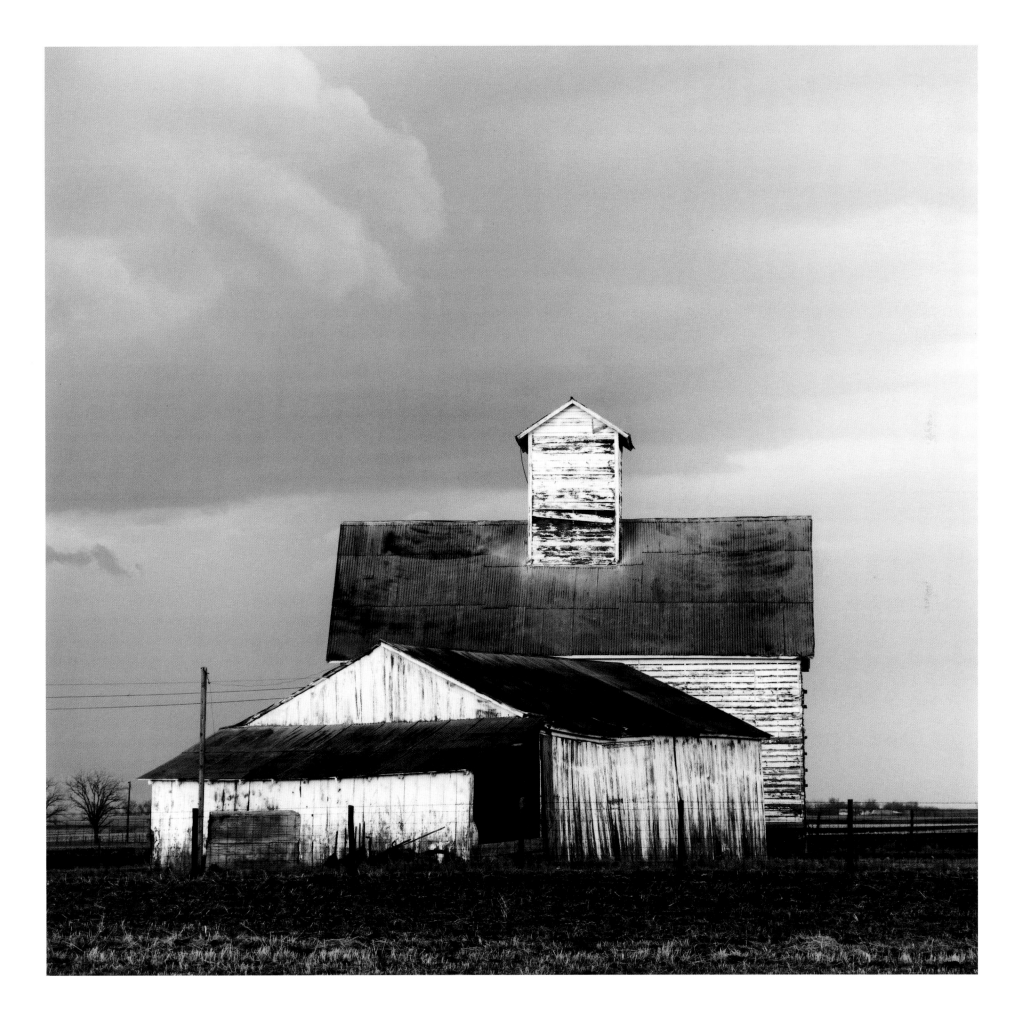

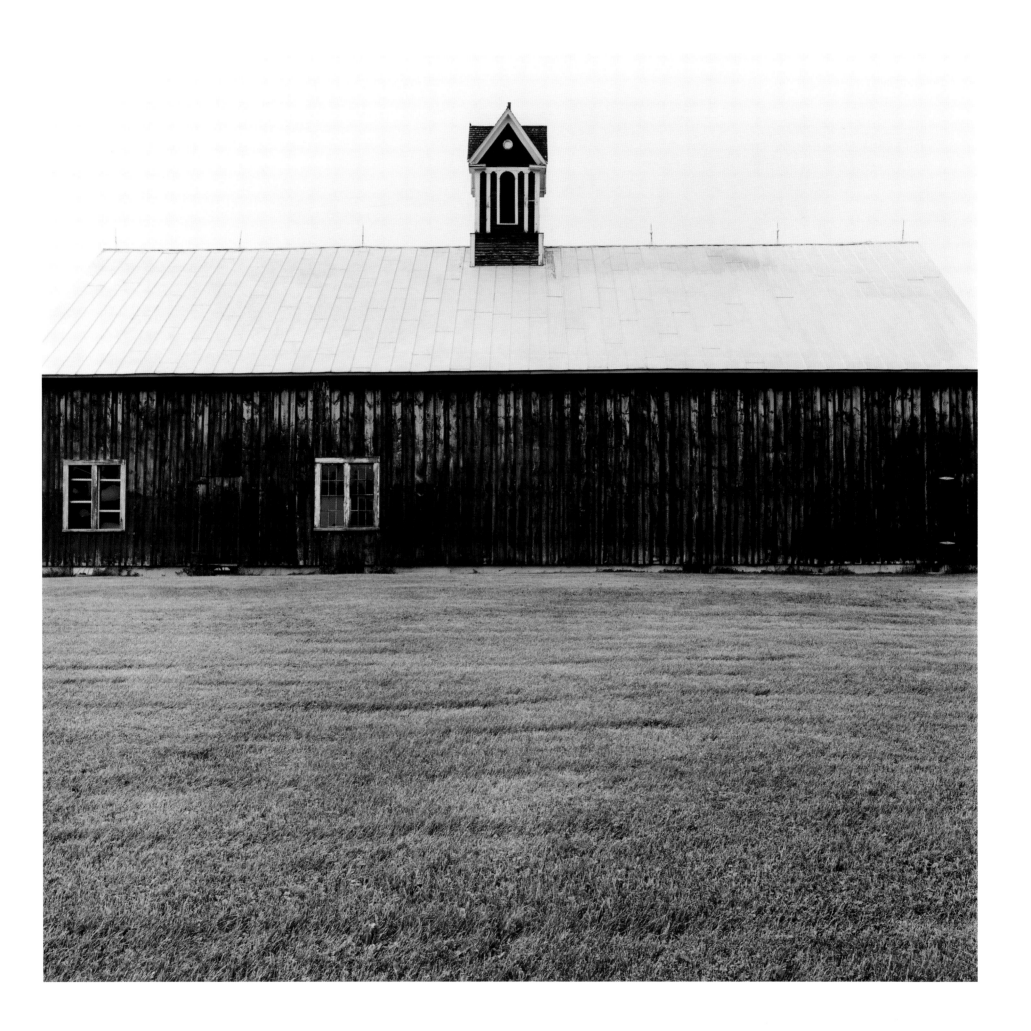

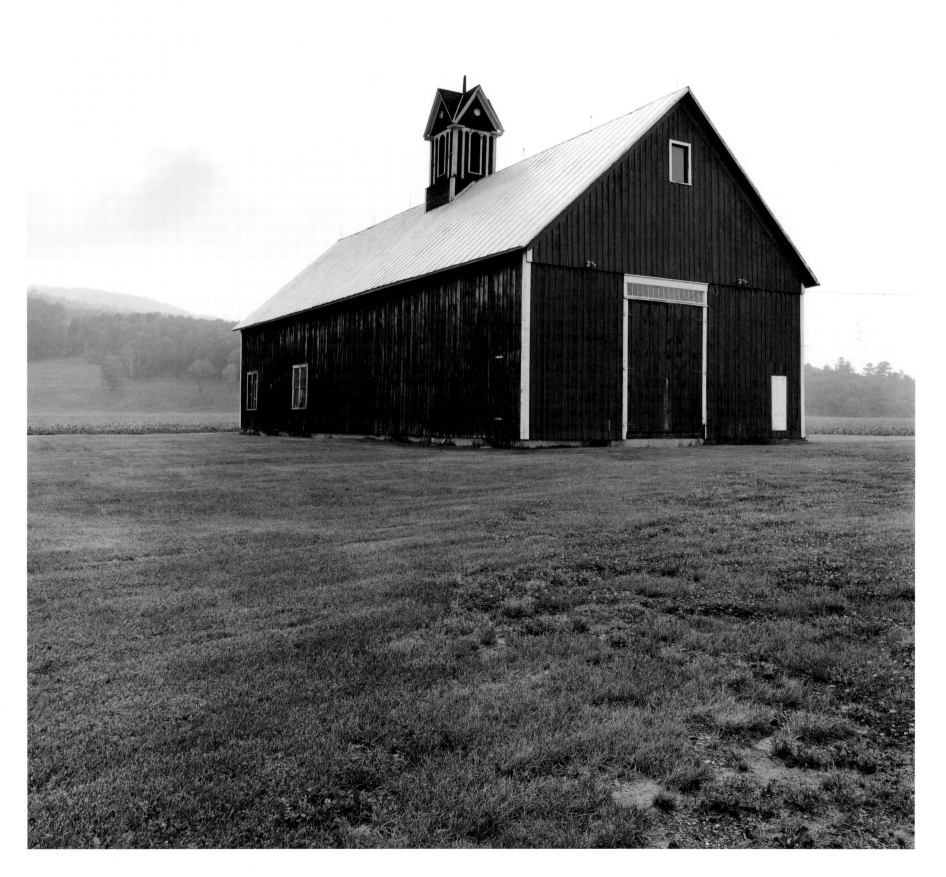

10 & 11 · Bradford, Orange County, Vermont (2001)

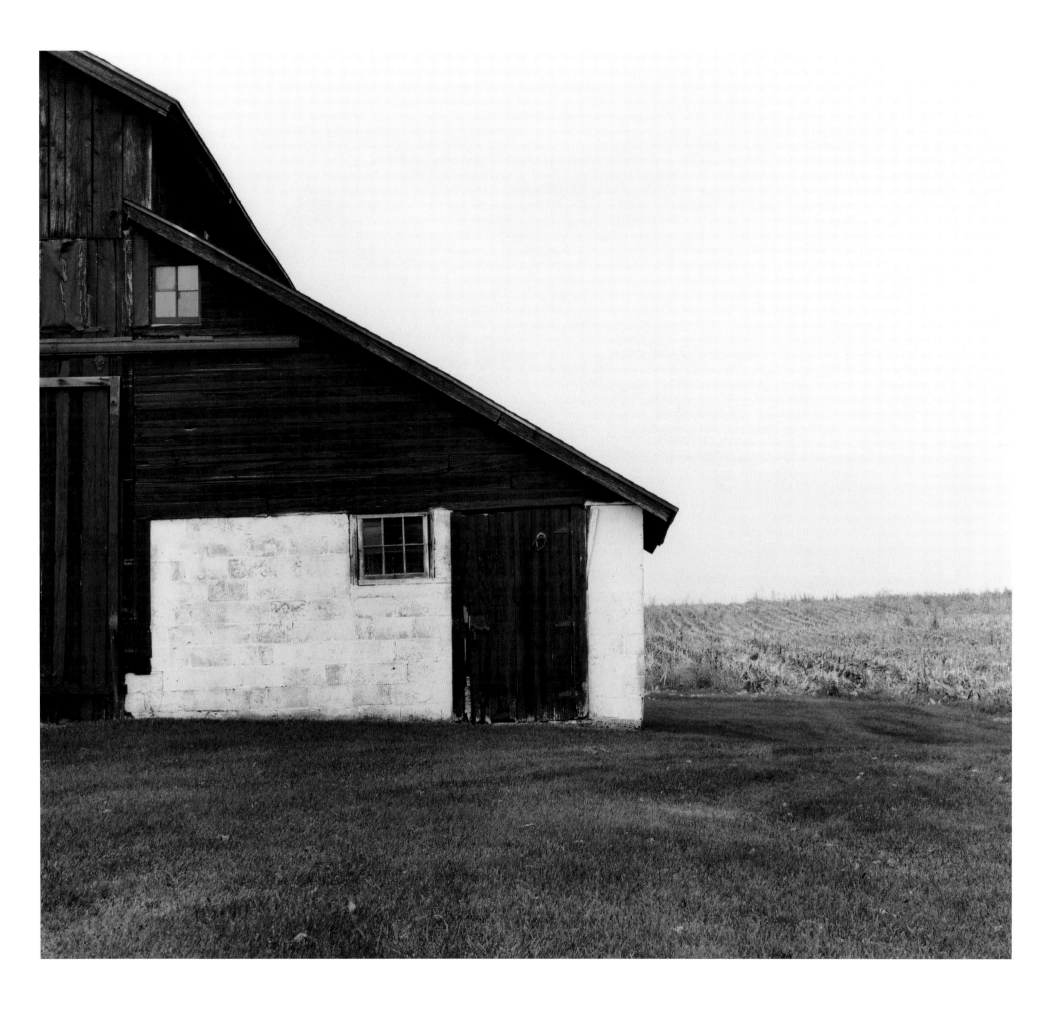

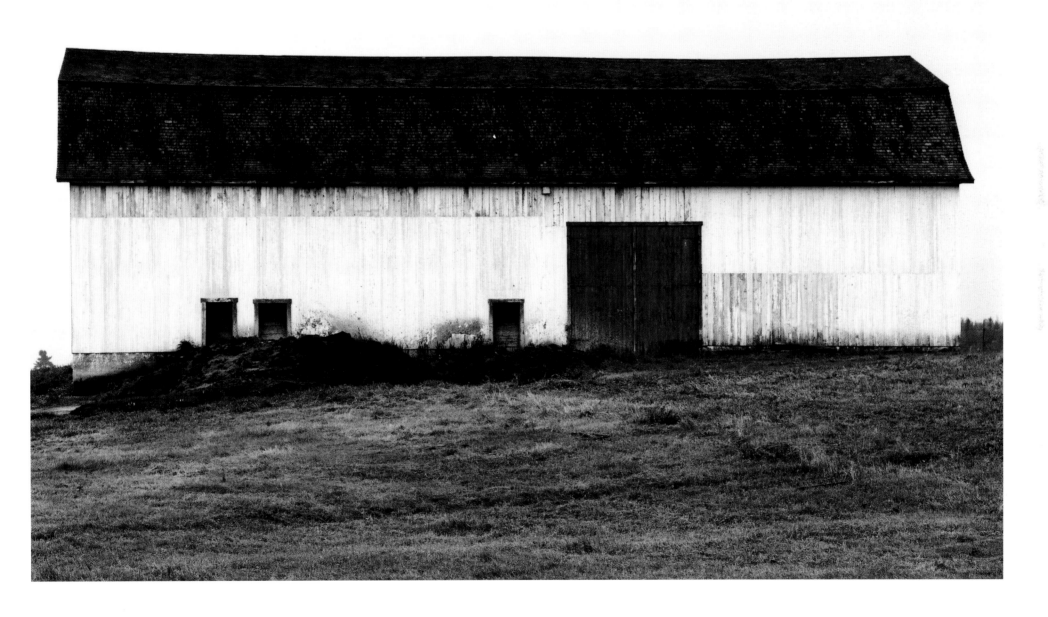

12 · Near Vriesland, Ottawa County, Michigan (1999)

13 · Near Tring Jonction, Quebec (1964)

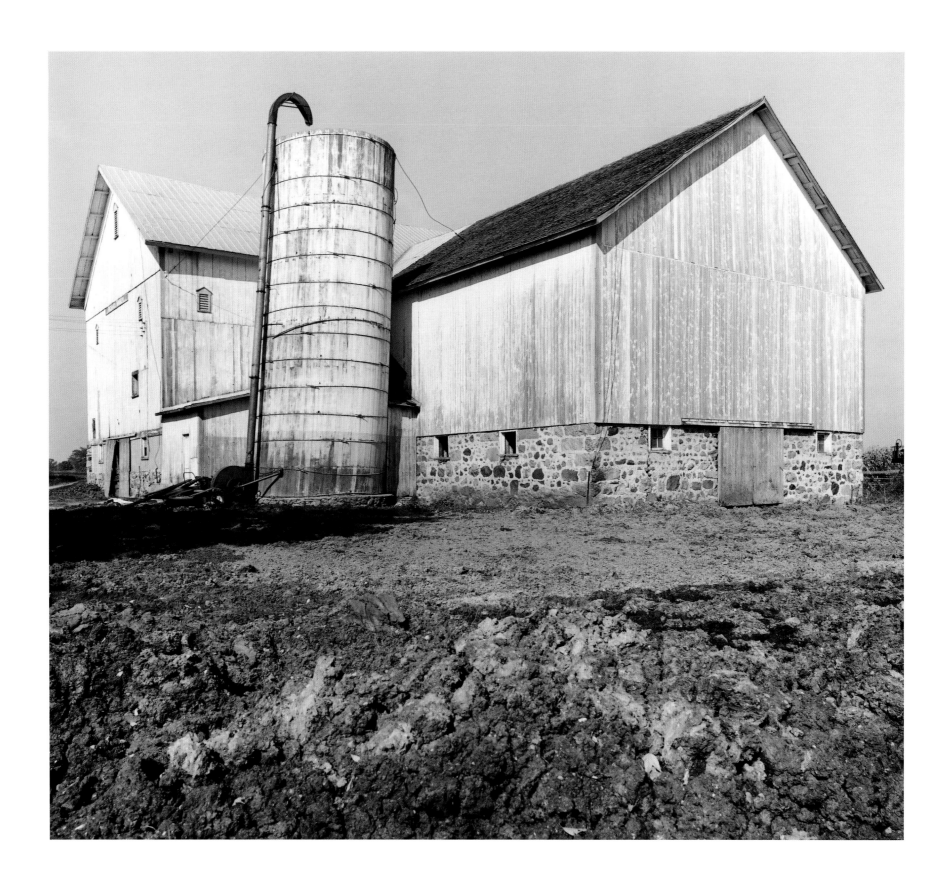

14 · Isabella County, Michigan (1975)

15 · Clarence Township, Erie County, New York (2001)

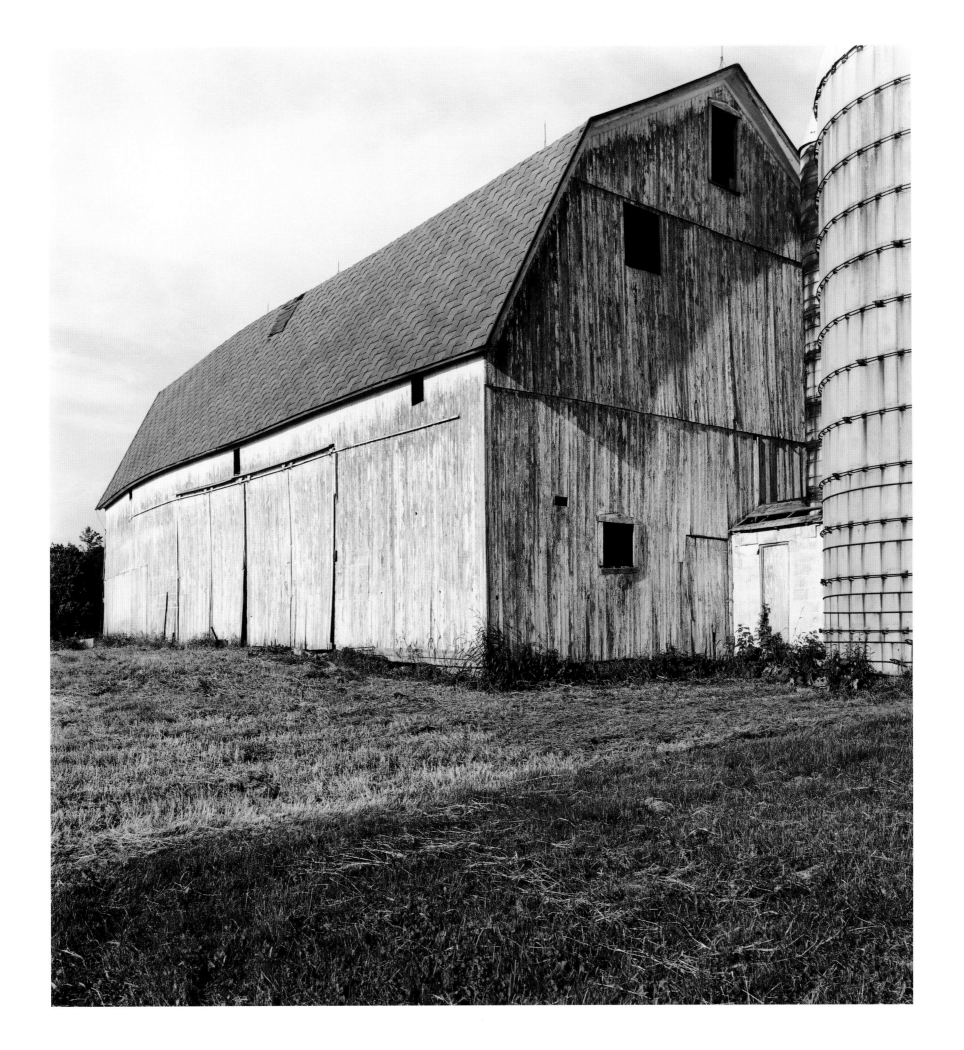

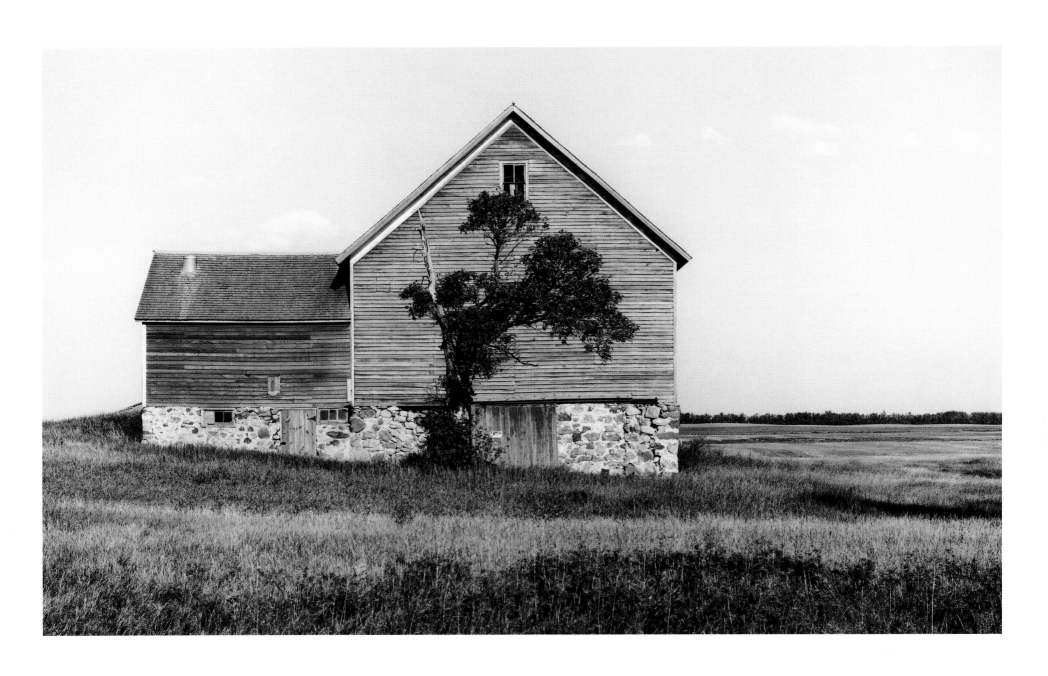

16 · Near Oriska, Barnes County, North Dakota (1973)

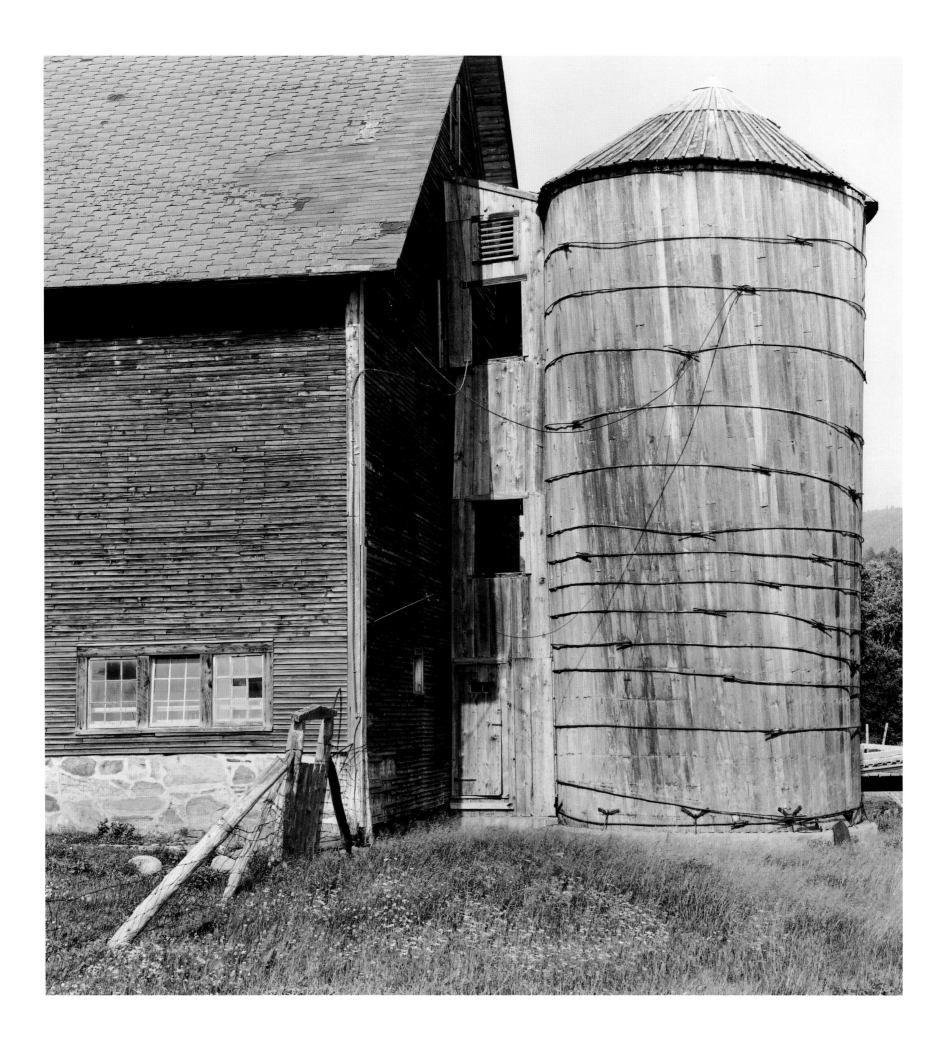

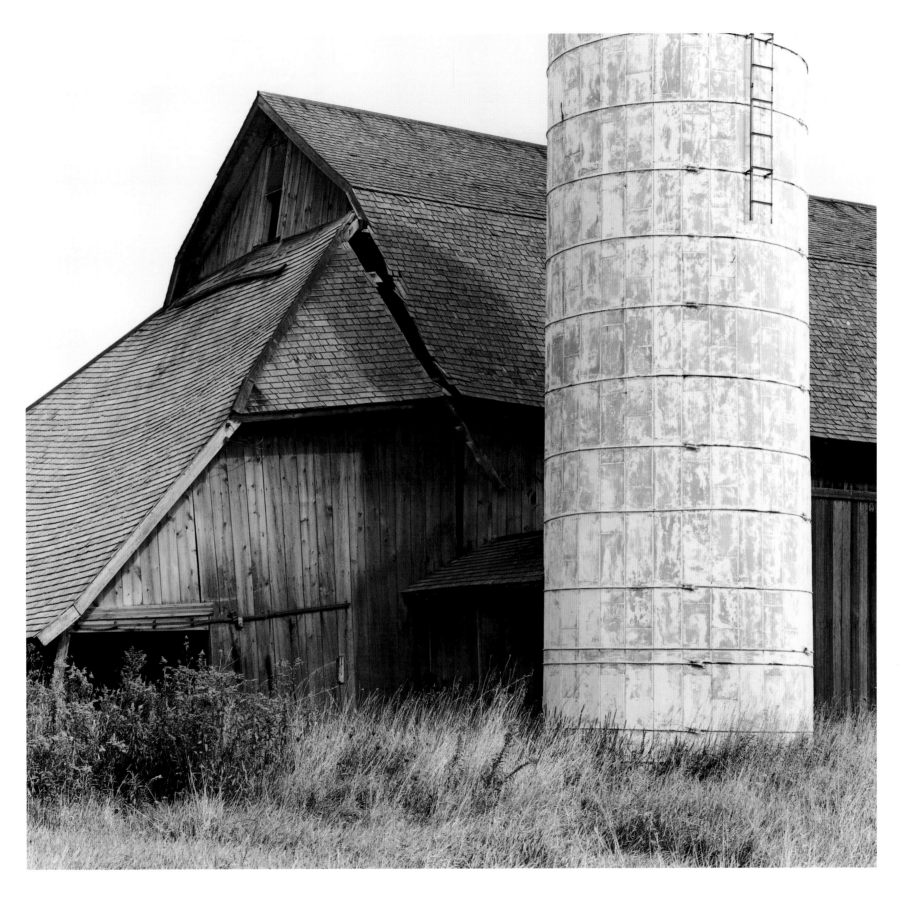

17 · Waitsfield Common, Washington County, Vermont (2001)

18 · Clare County, Michigan (1975)

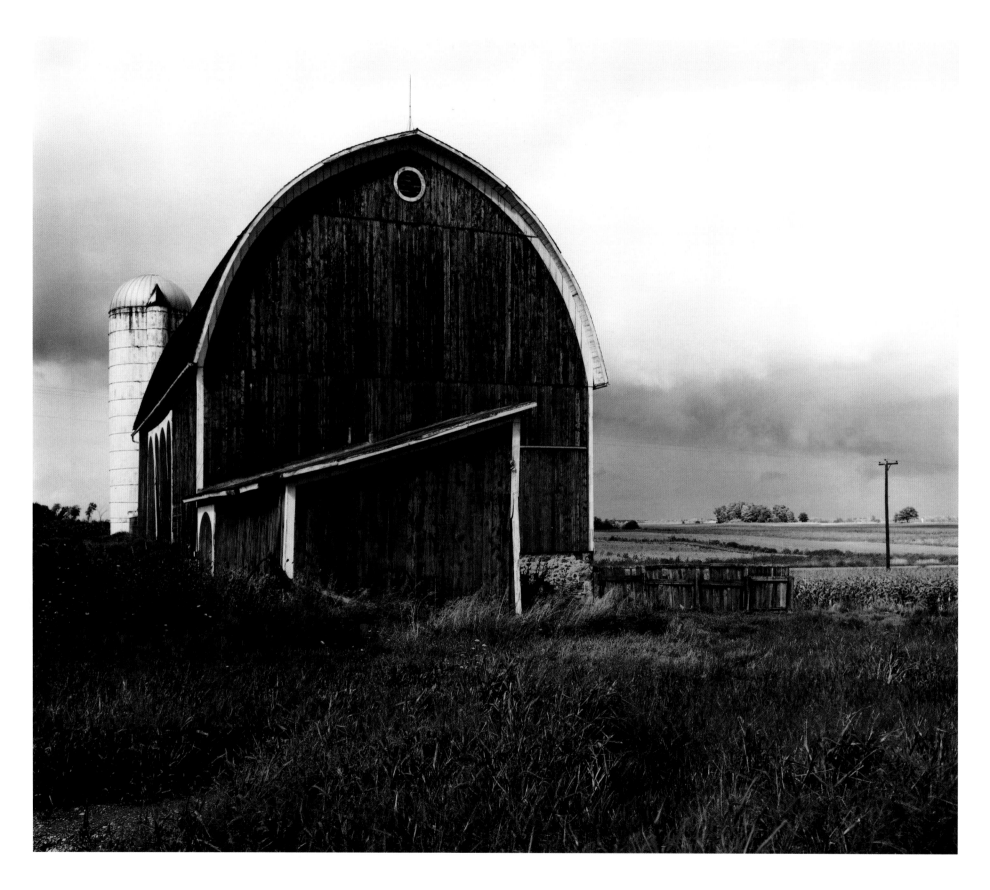

19 · Clare County, Michigan (1975)

20 · Isabella County, Michigan (1975)

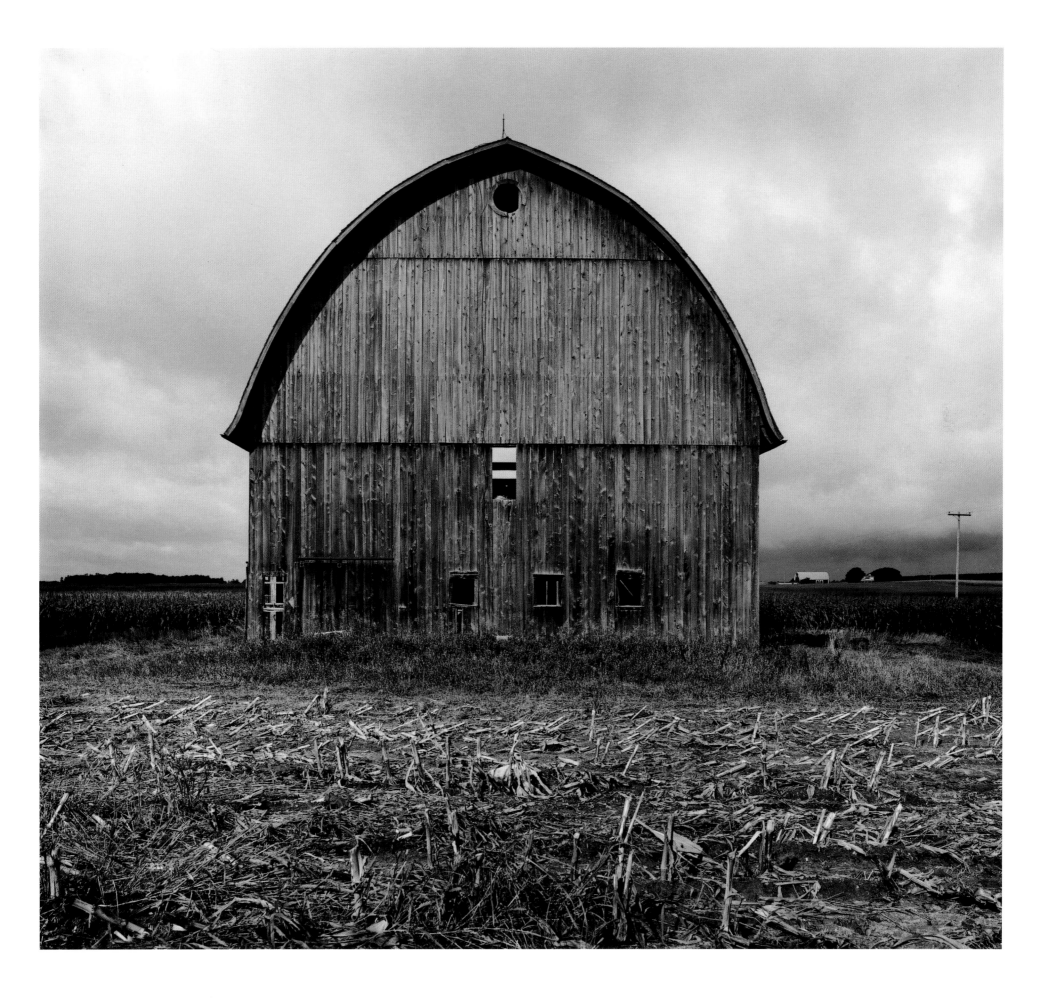

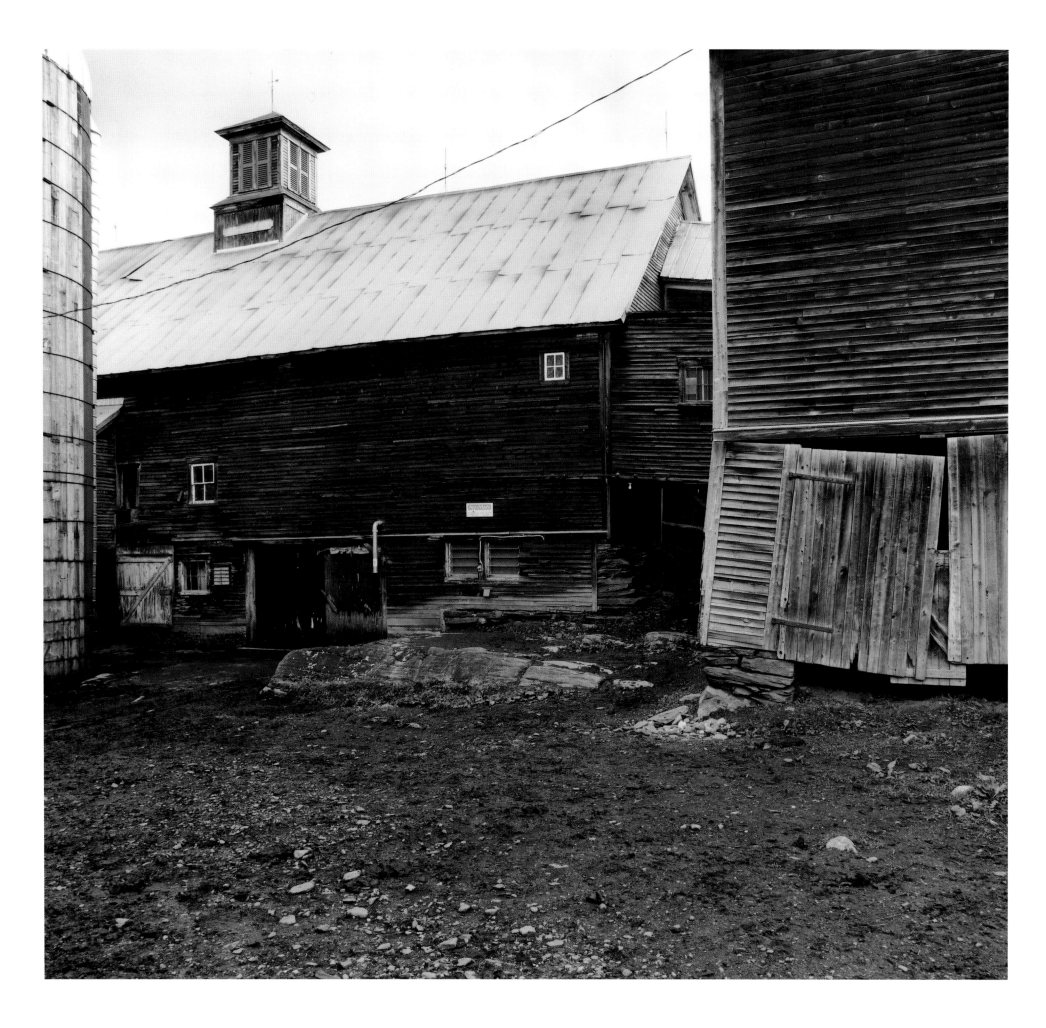

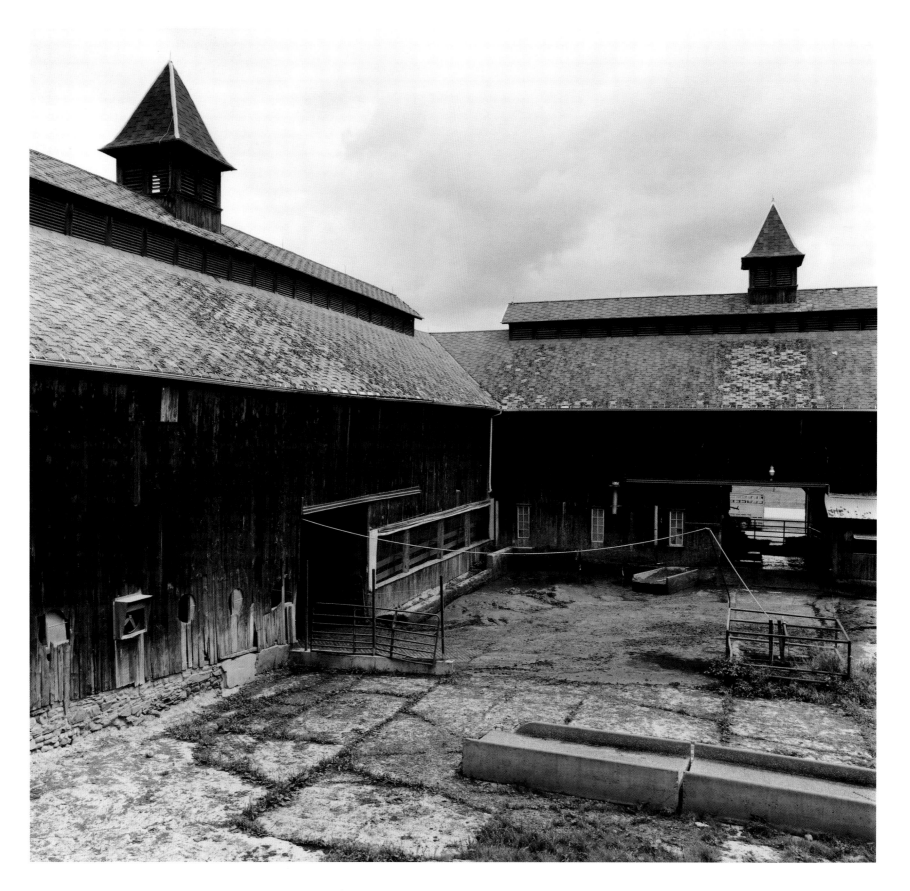

21 · East Montpelier Center, Washington County, Vermont (2001)

22 · West Sparta Township, Livingston County, New York (2001)

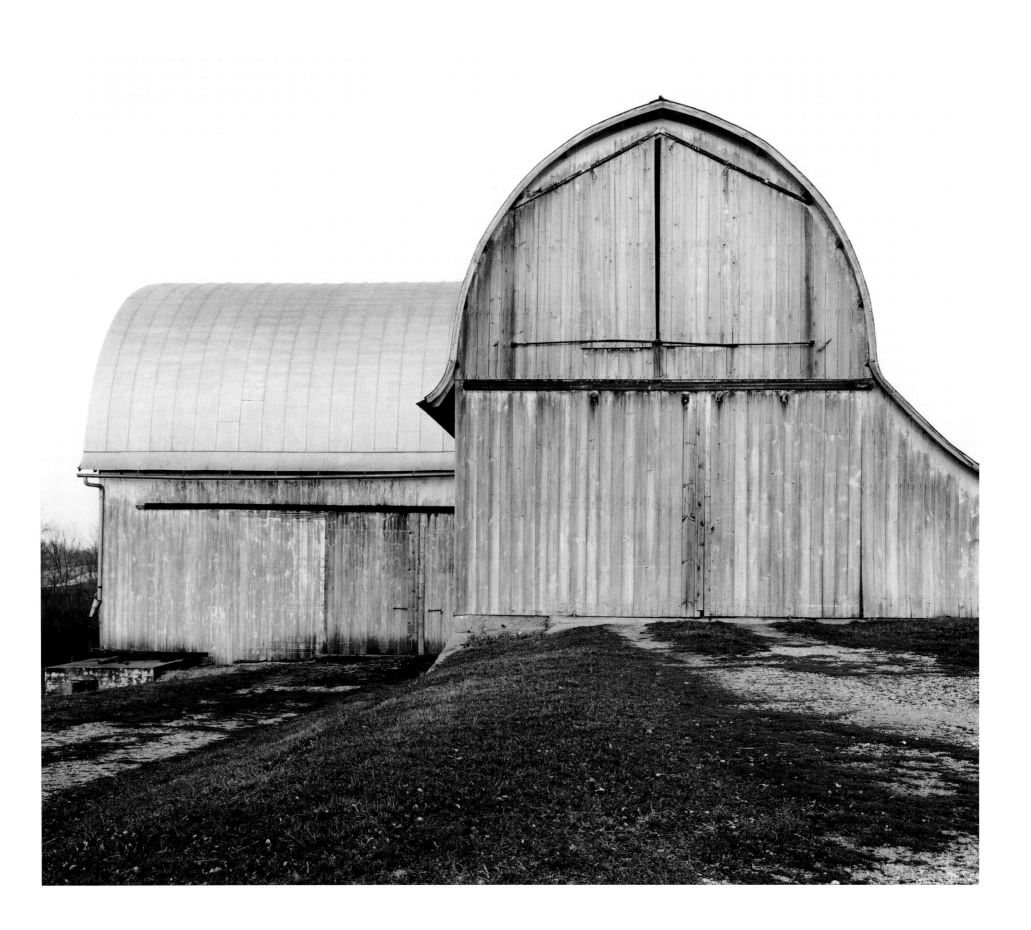

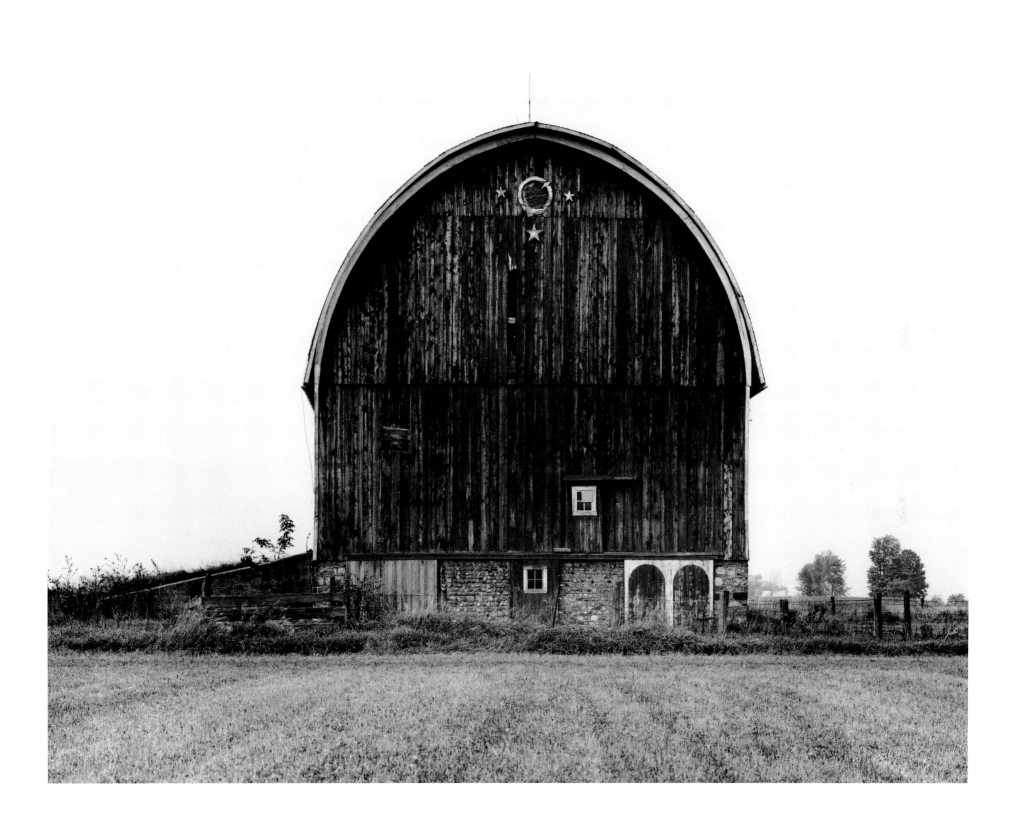

23 · Albion, Noble County, Indiana (2000)

24 · Isabella County, Michigan (1975)

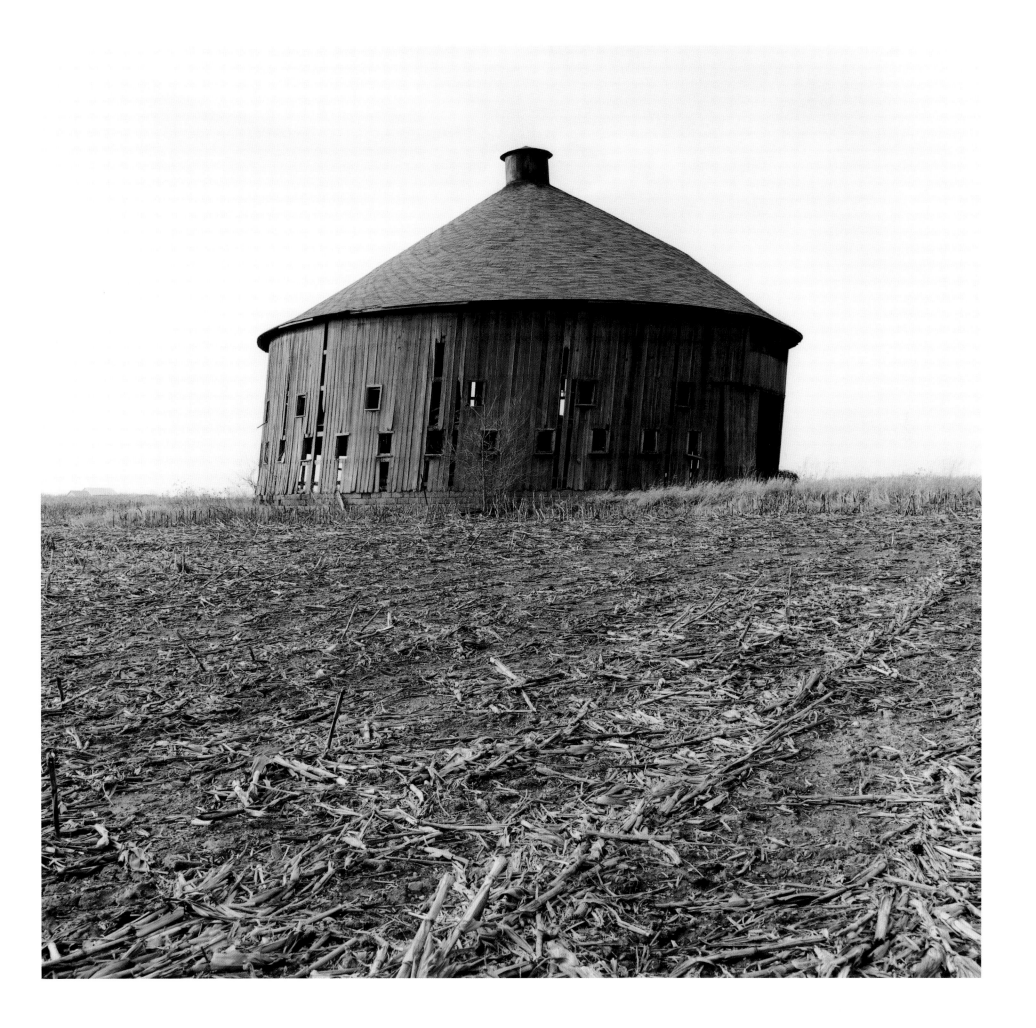

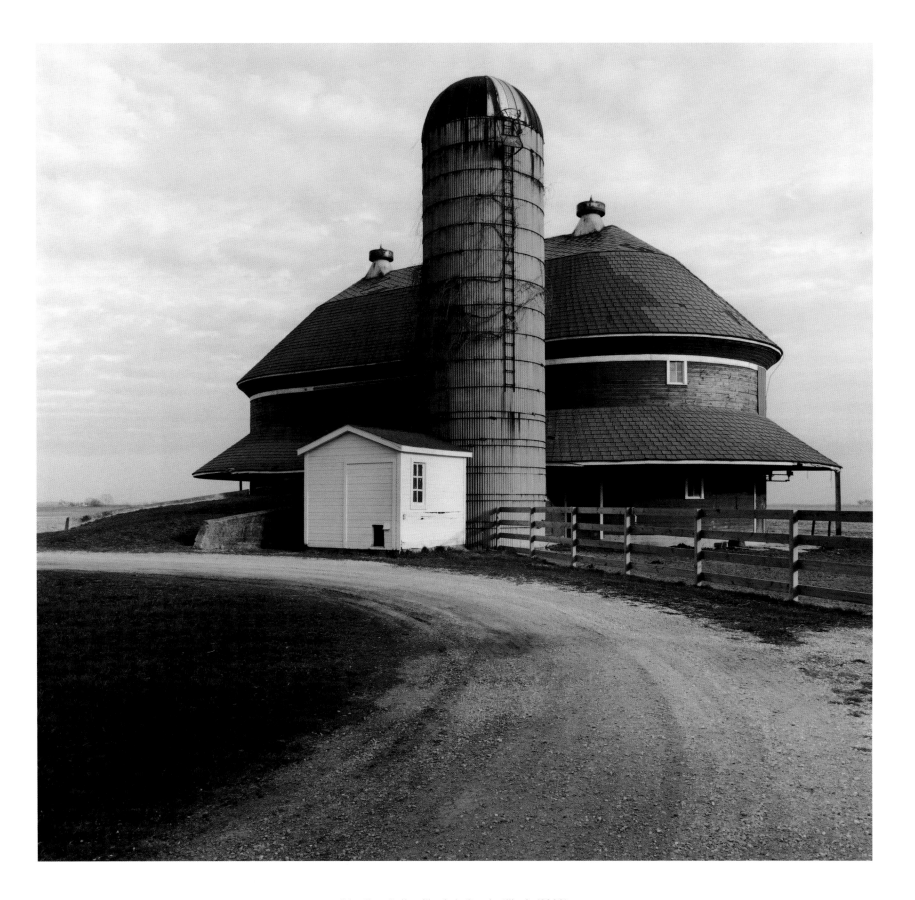

26 · Near Baileyville, Ogle County, Illinois (2000)

27 · Mazomanie Township, Dane County, Wisconsin (2000)

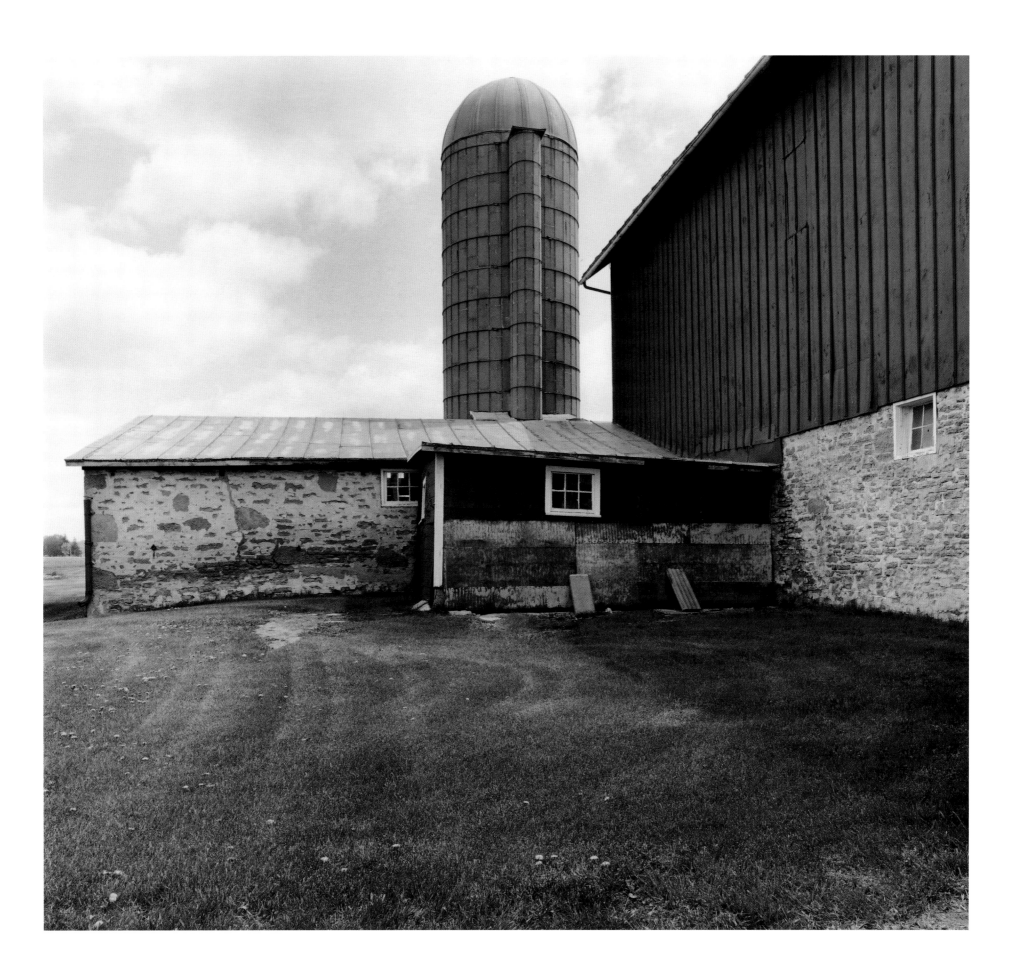

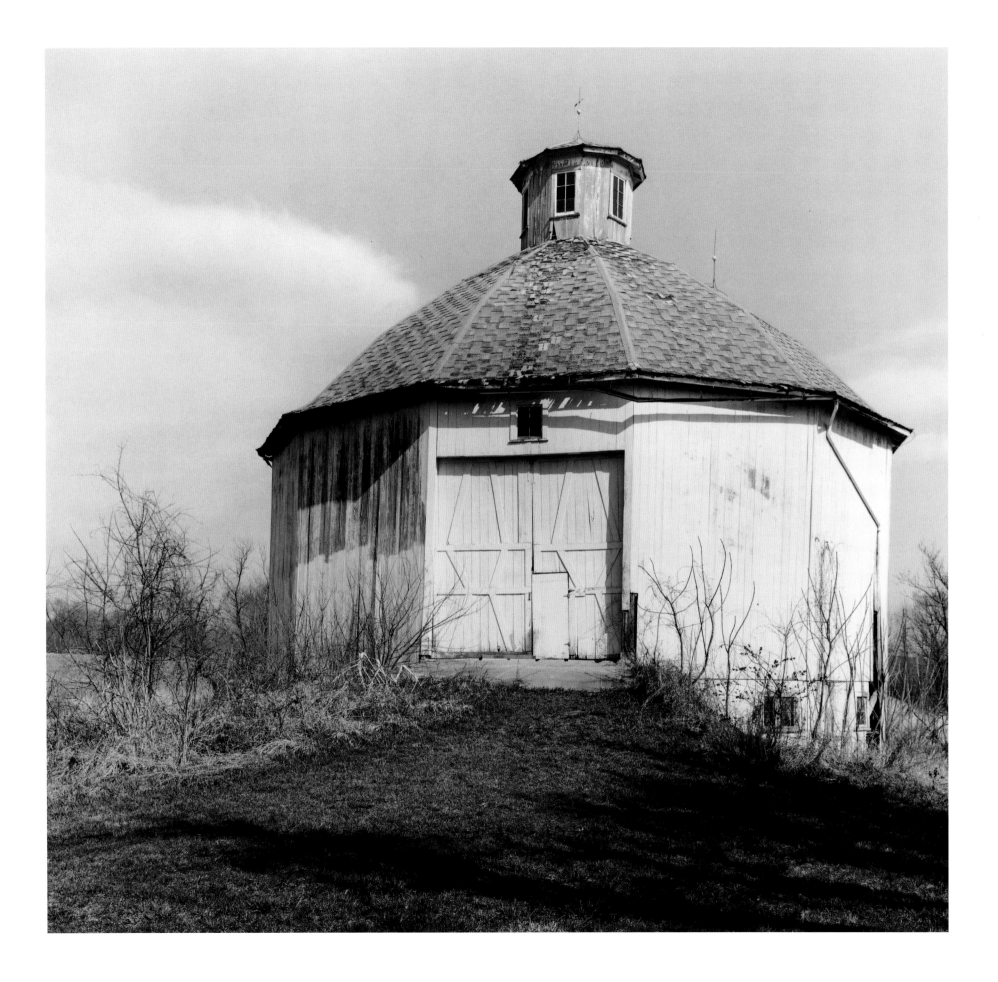

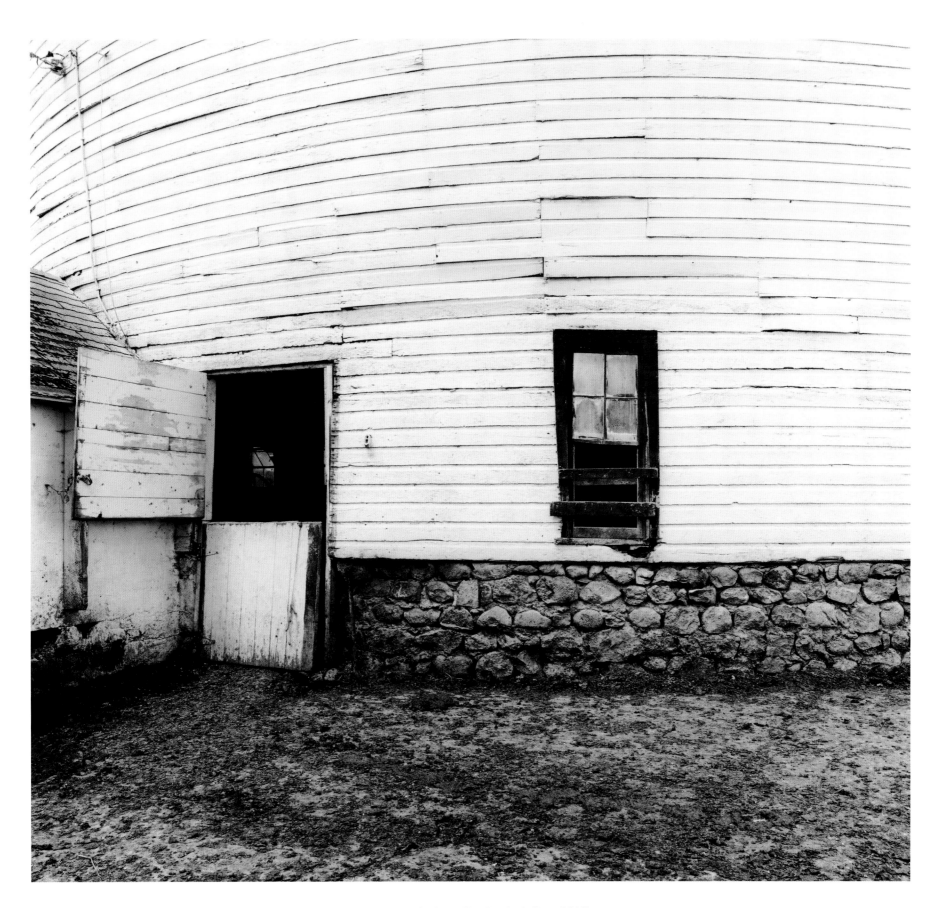

28 · Near Rochester, Fulton County, Indiana (2000)

29 · Van Decar, Isabella County, Michigan (1999)

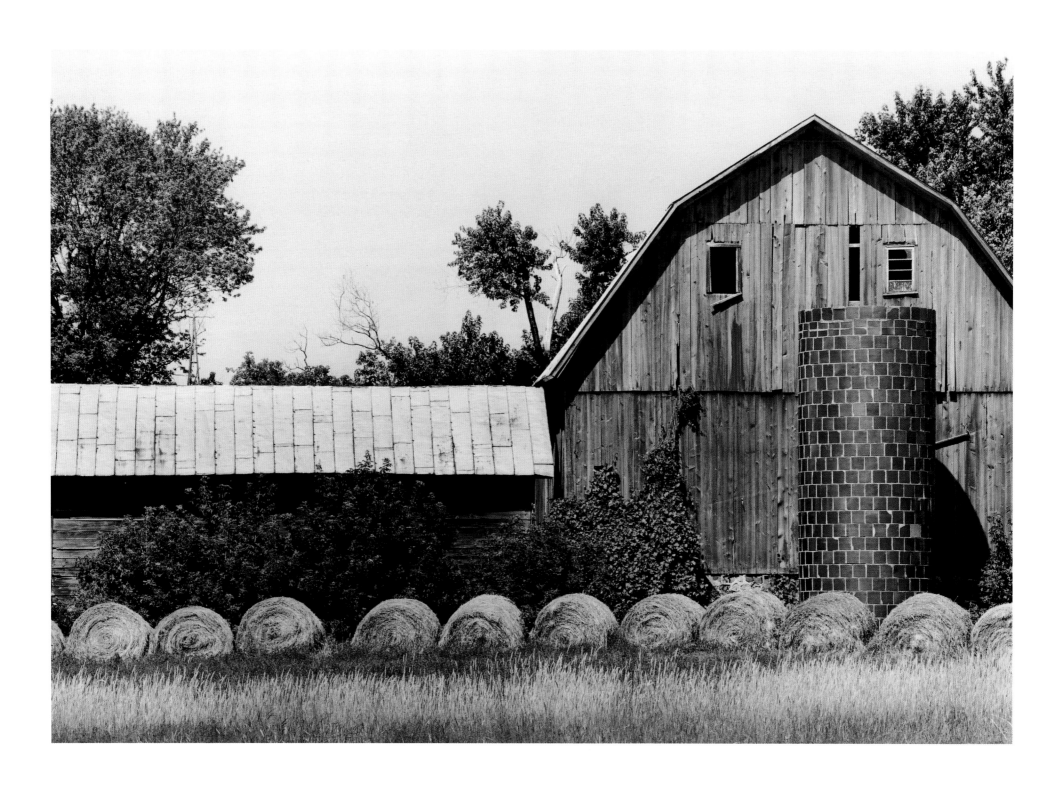

30 · Isabella County, Michigan (1999)

31 · Dubuque County, Iowa (2000)

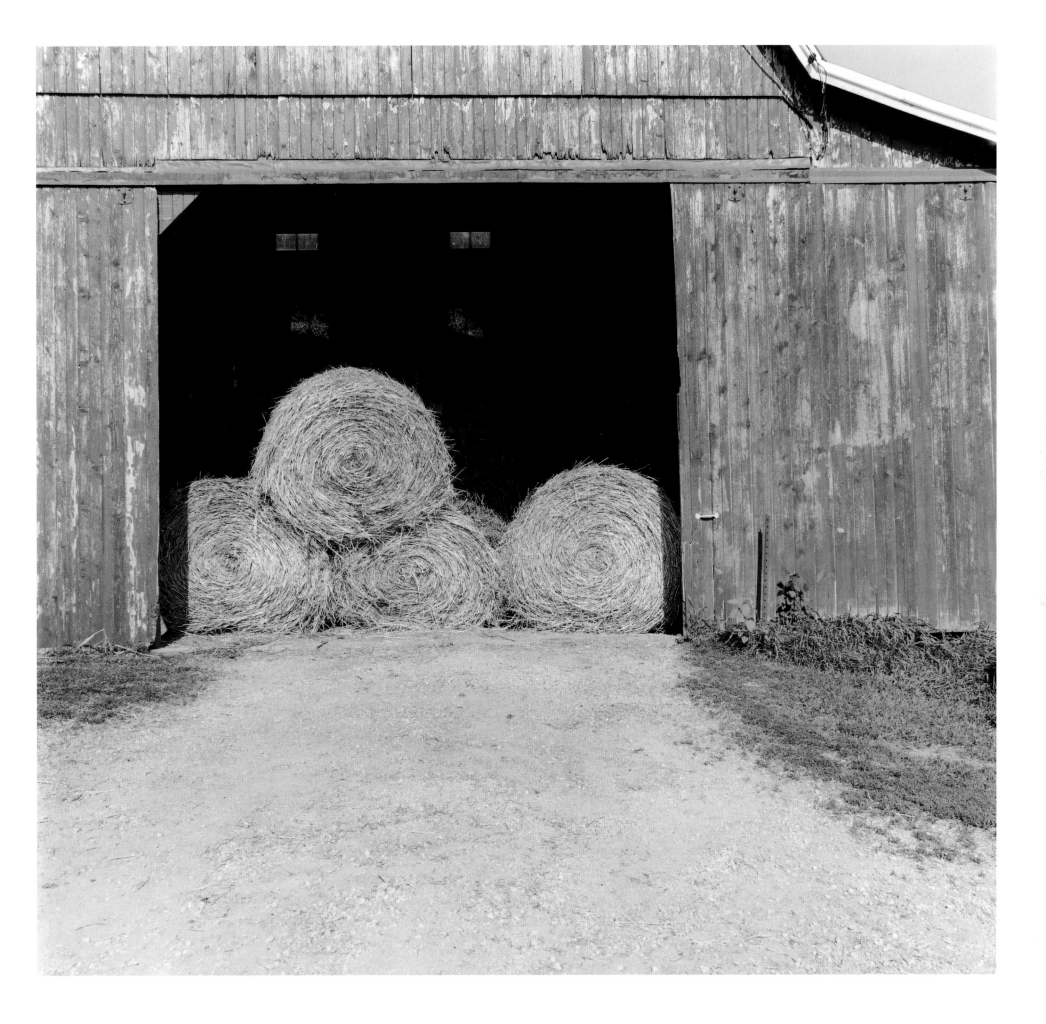

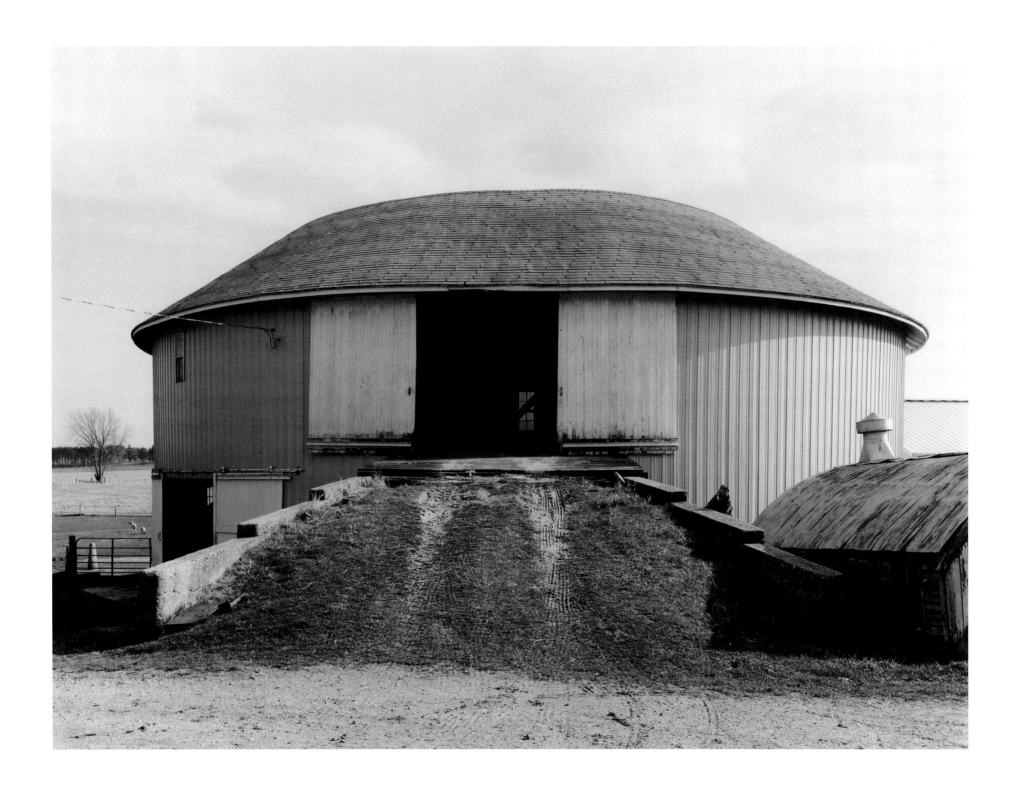

32 & 33 · Maryland Township, Ogle County, Illinois (2000)

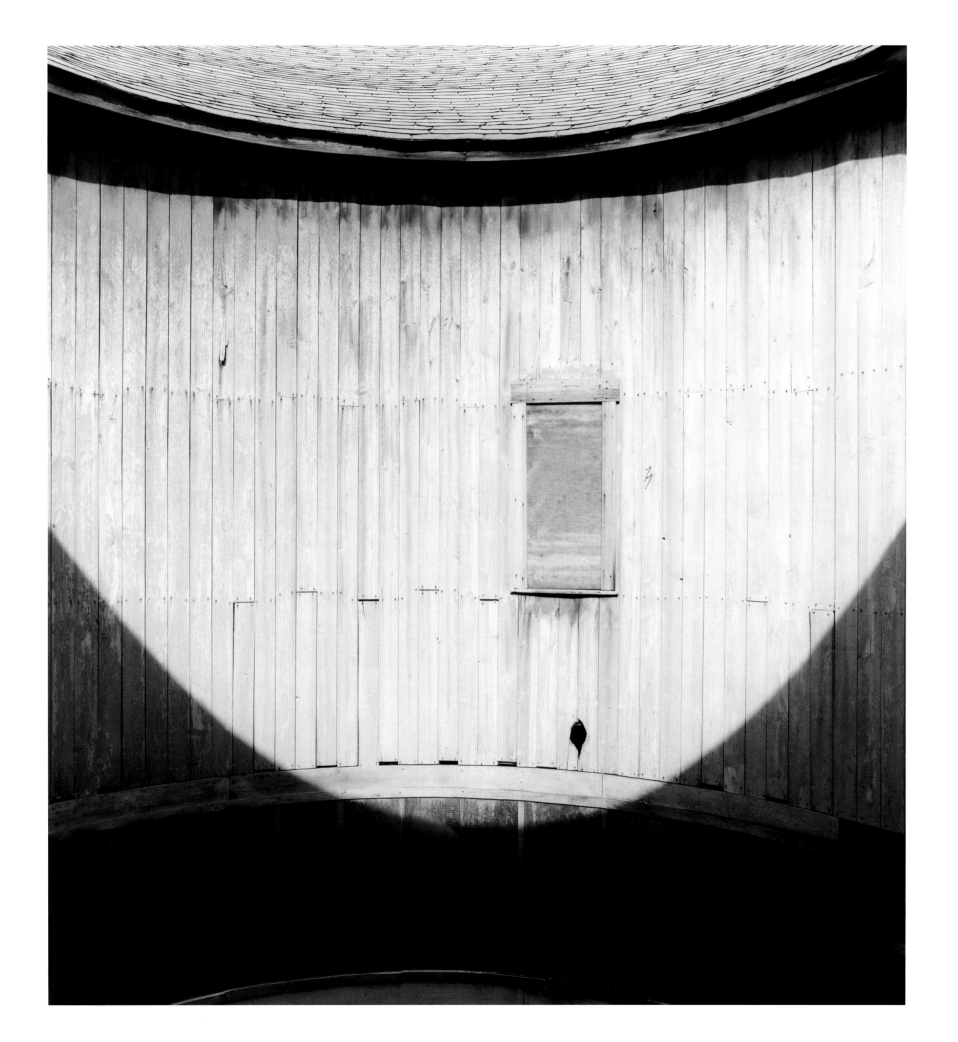

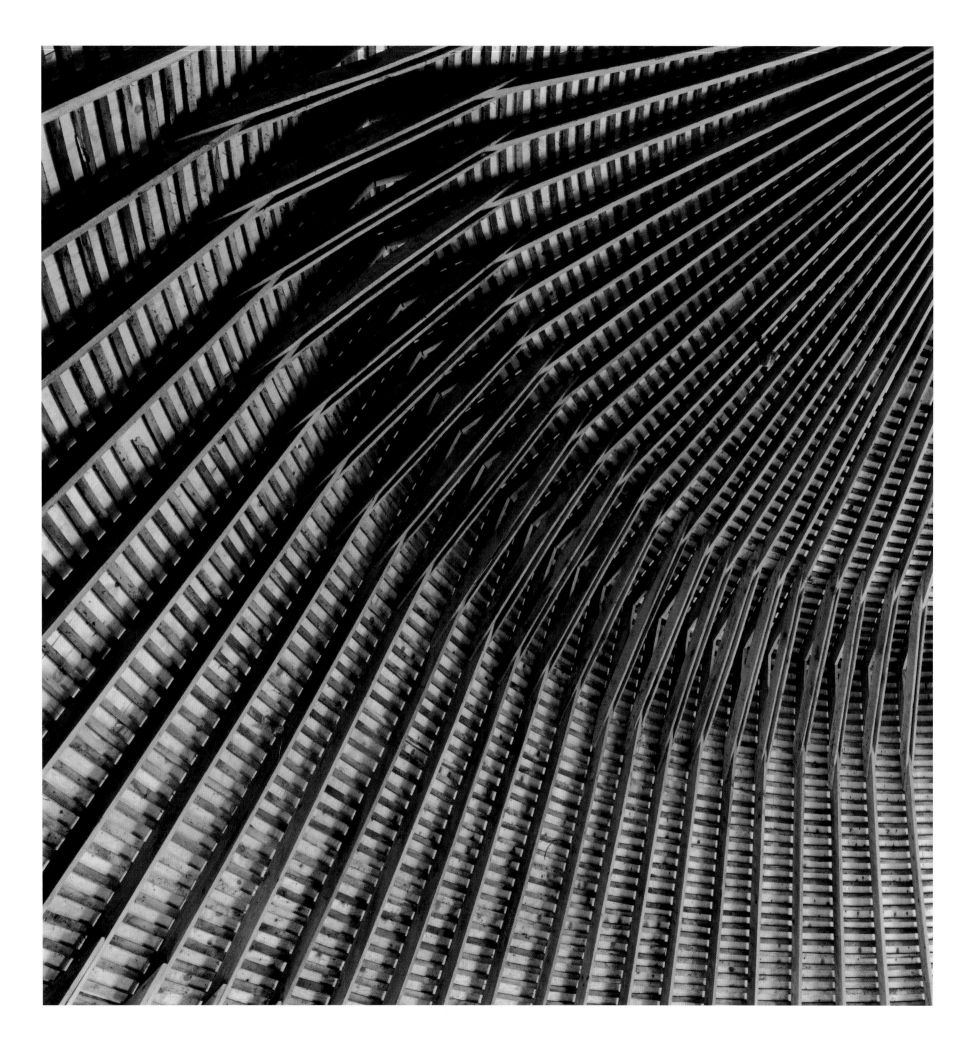

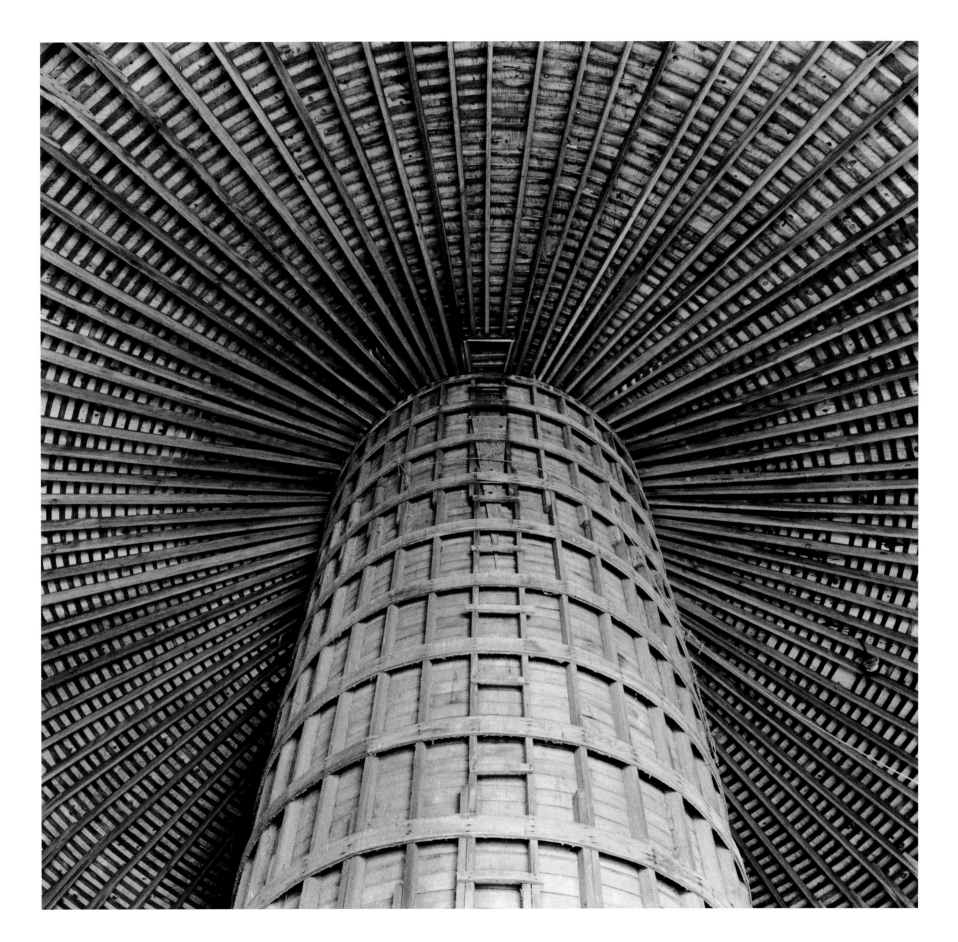

34 & 35 · Angola, Steuben County, Indiana (2000)

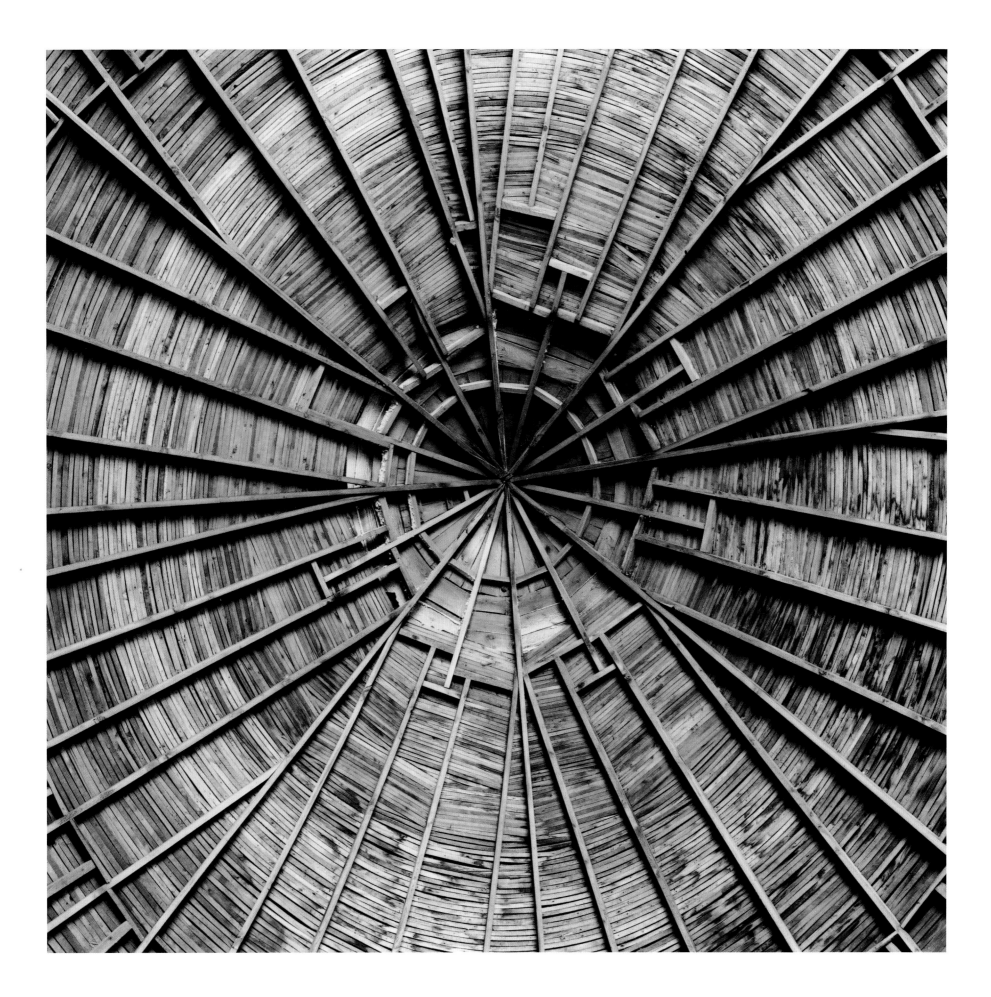

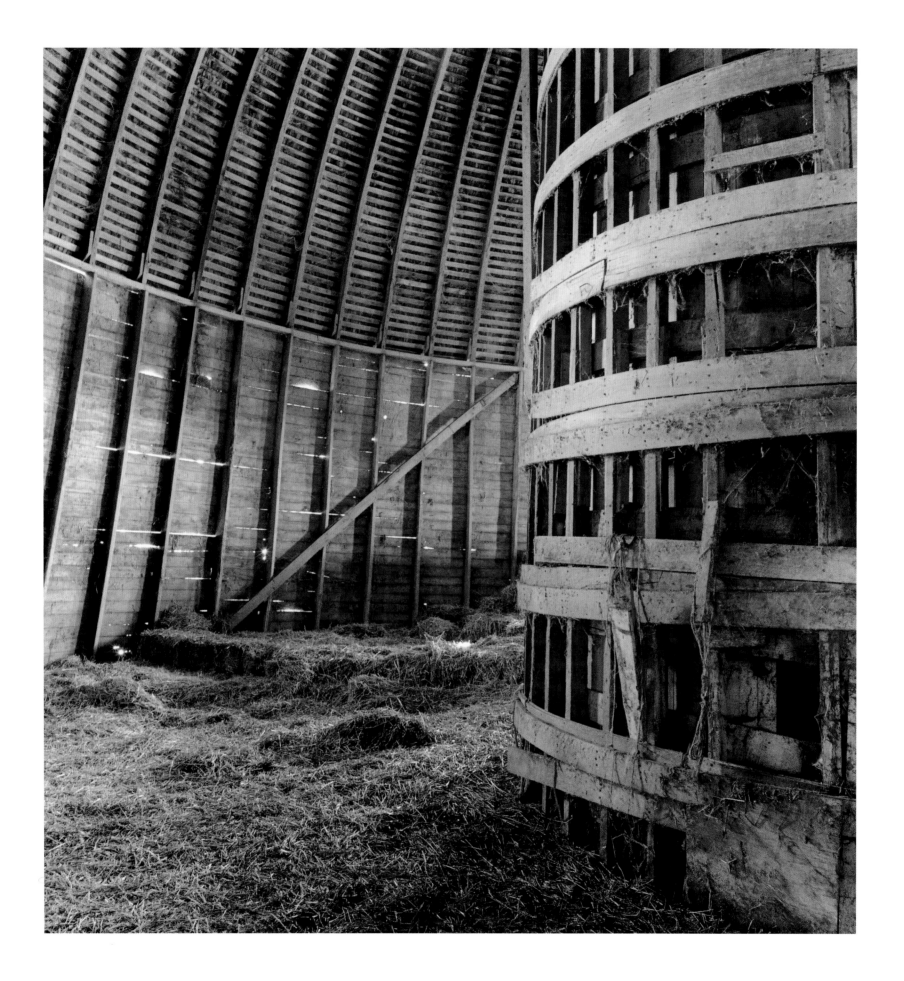

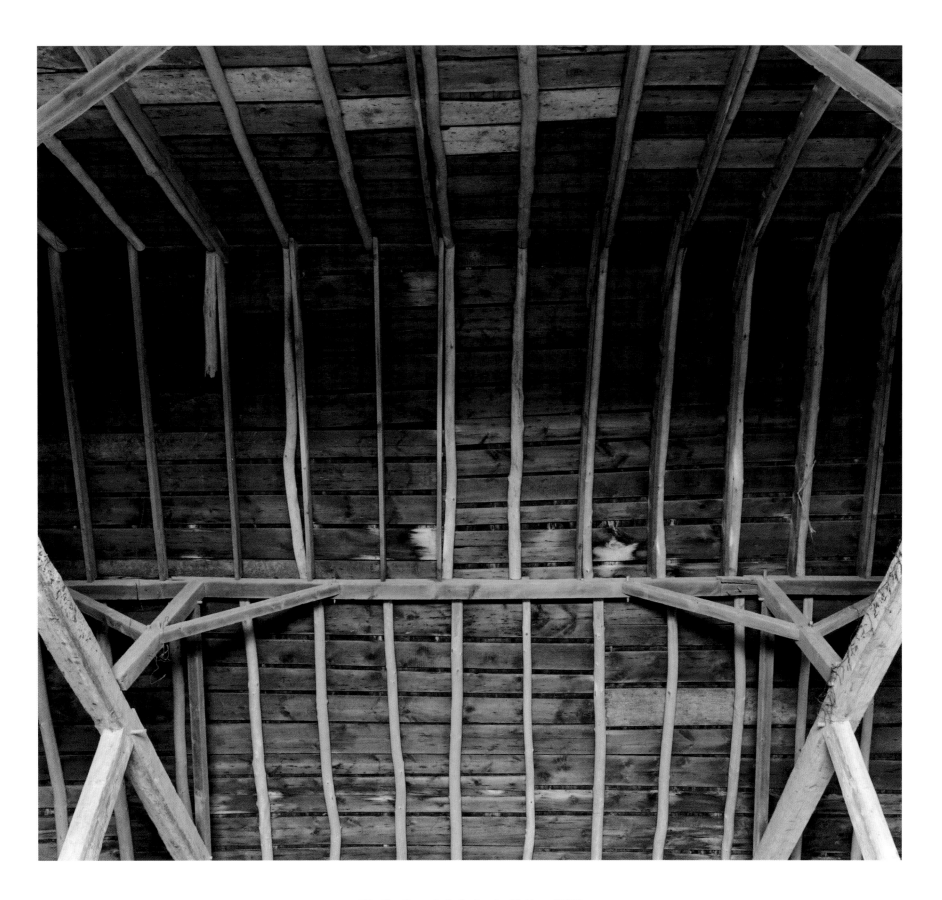

37 · Van Decar, Isabella County, Michigan (1999)

38 · White Oak Springs Township, Lafayette County, Wisconsin (2000)

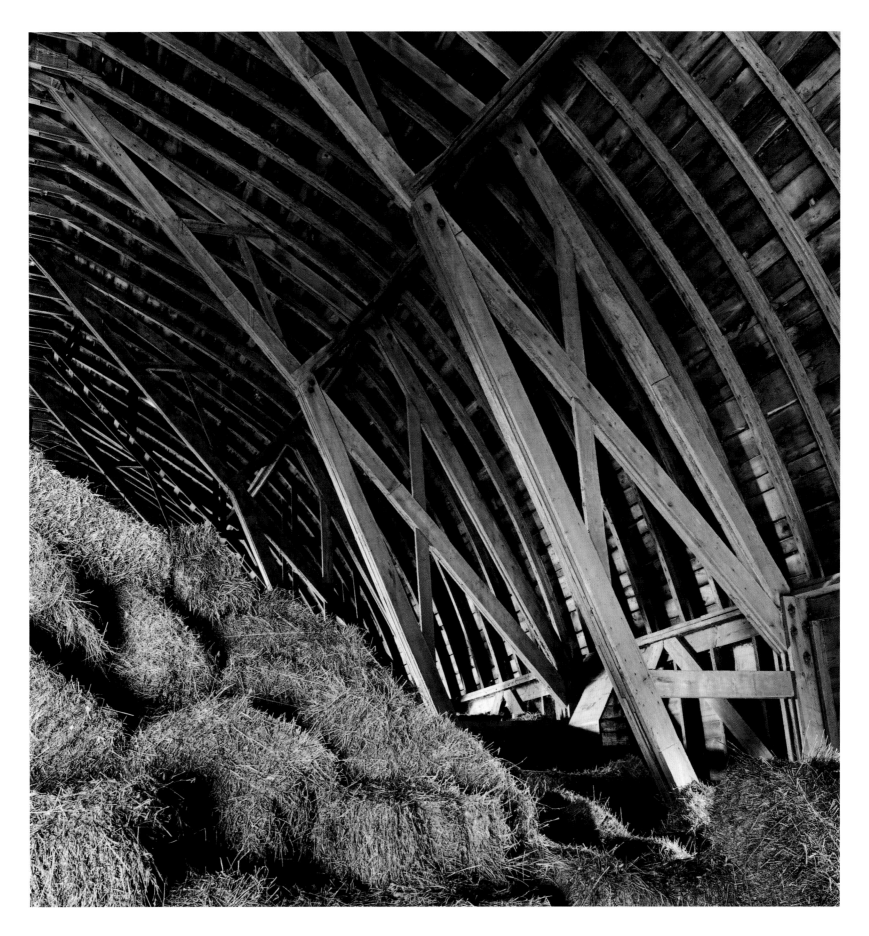

39 · Clare County, Michigan (1975)

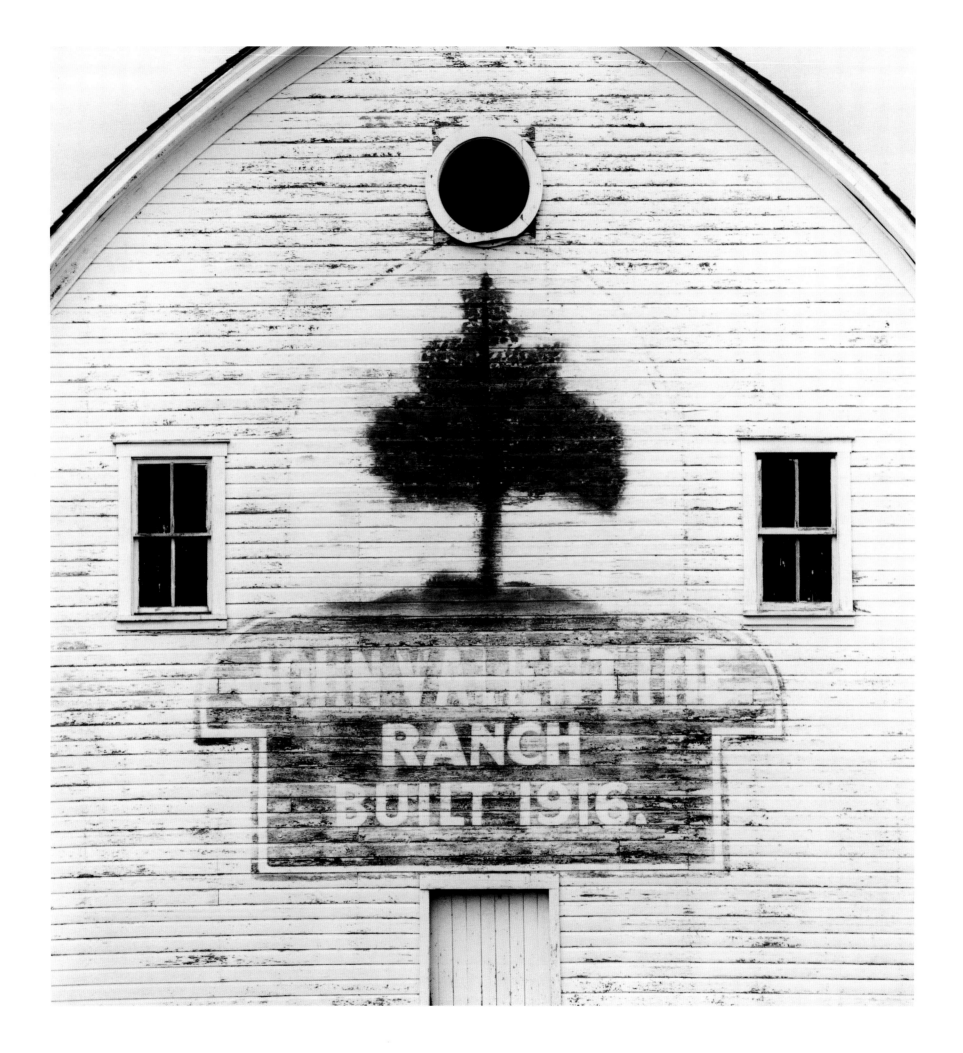

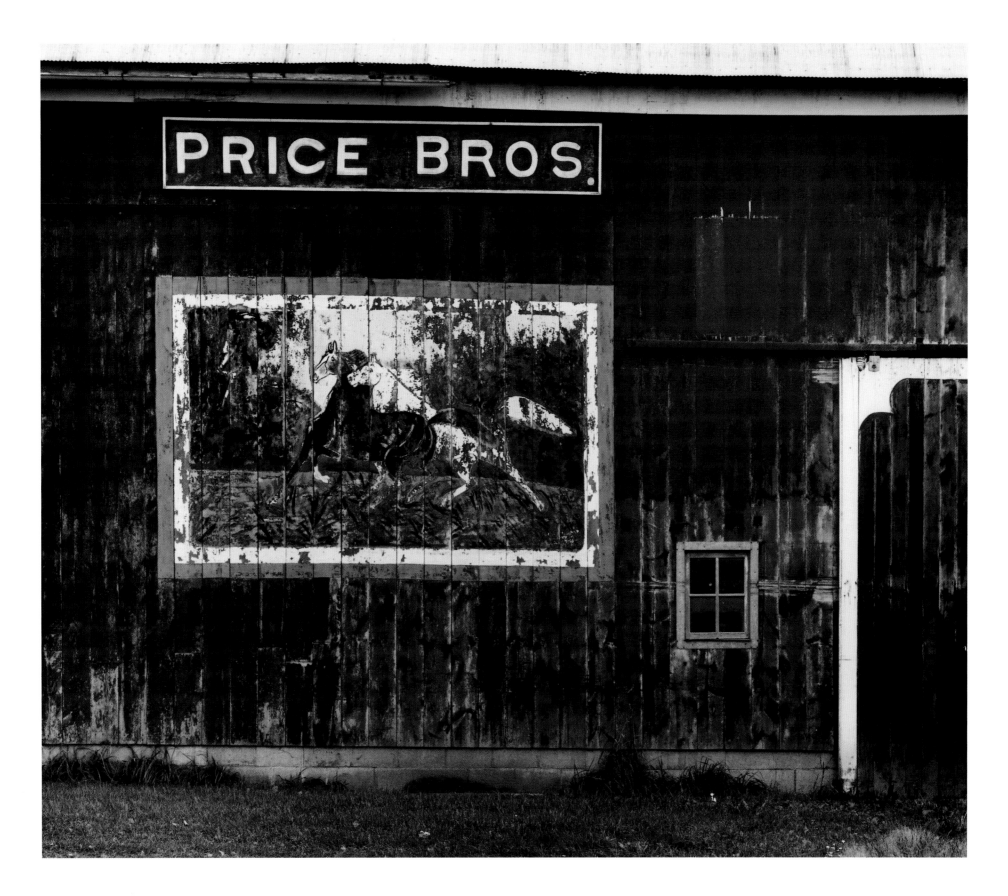

40 · Judith Basin County, Montana (1968)

41 · La Grange County, Indiana (1975)

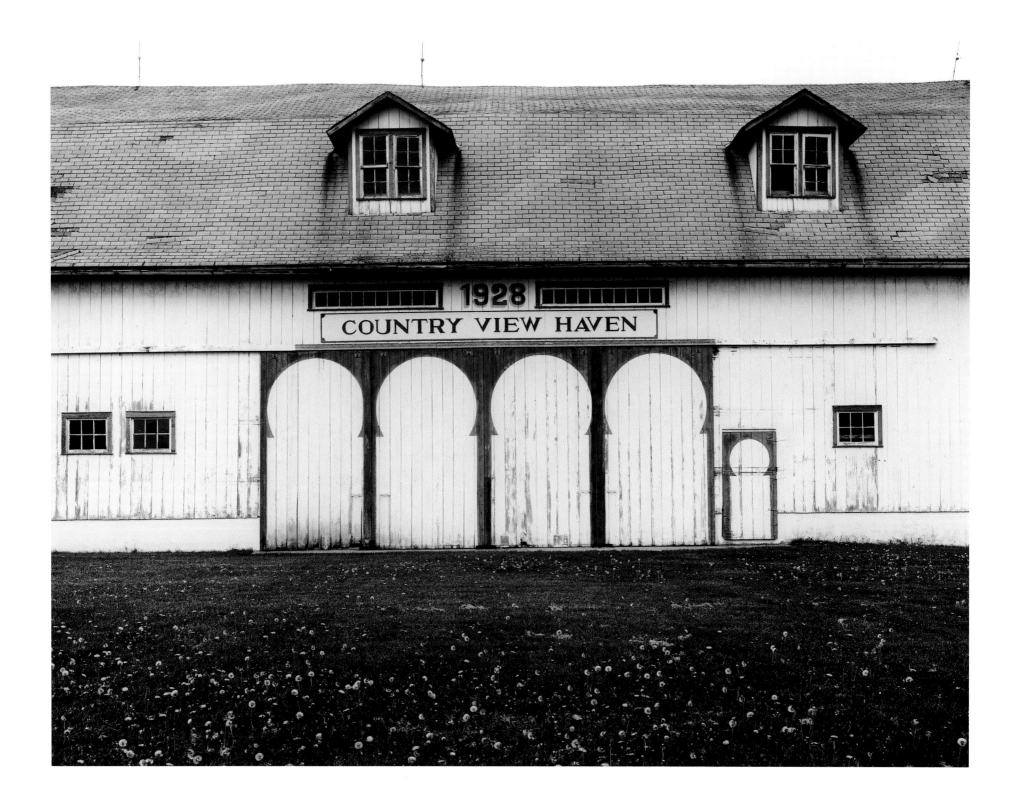

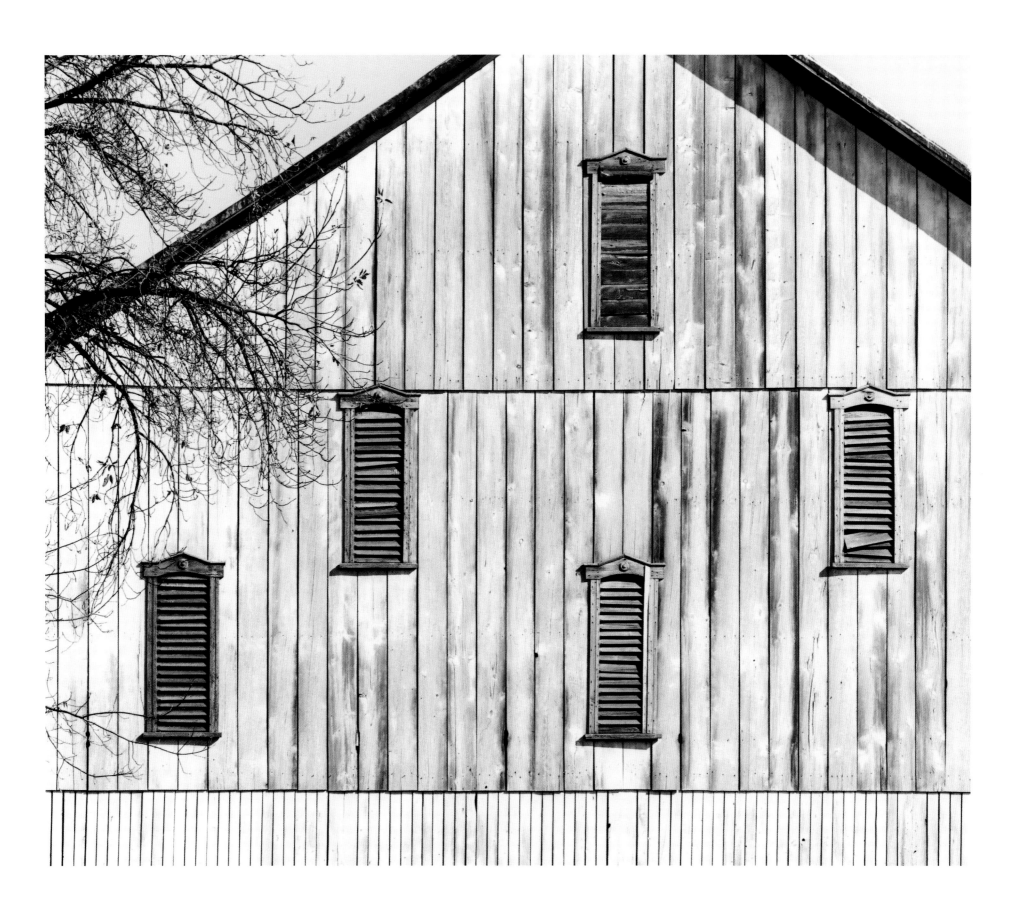

43 · Near Sharpsburg, Maryland (1965)

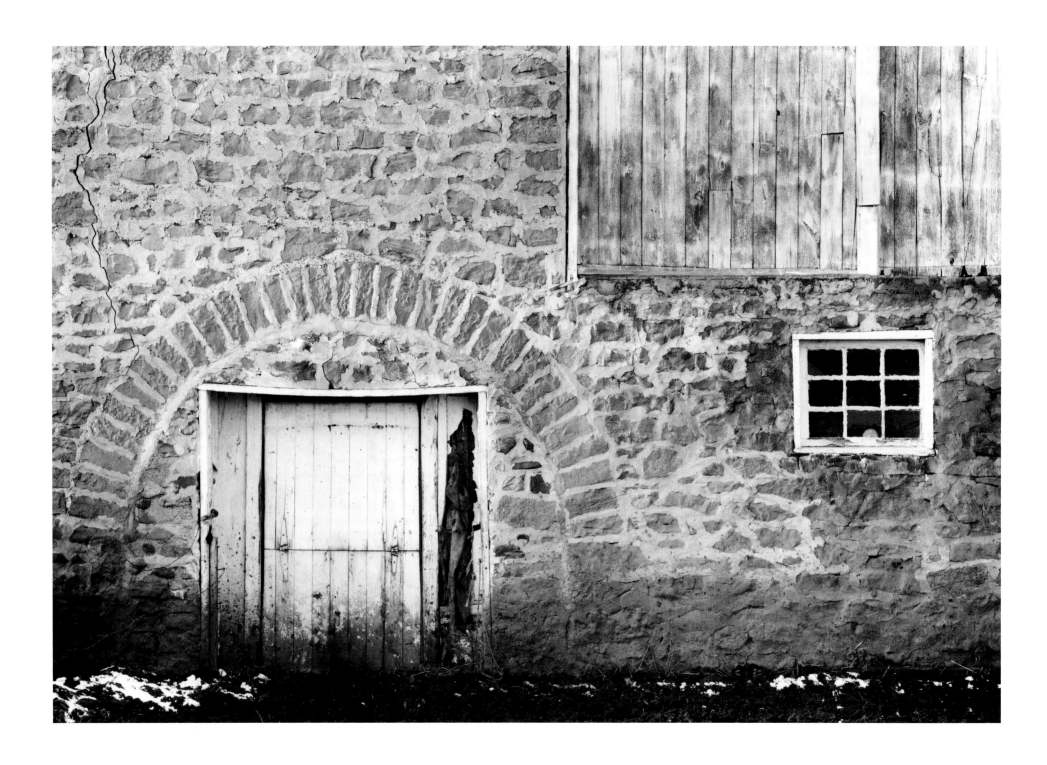

44 · Town of Marion, Wayne County, New York (1966)

45 · Oley Township, Berks County, Pennsylvania (2002)

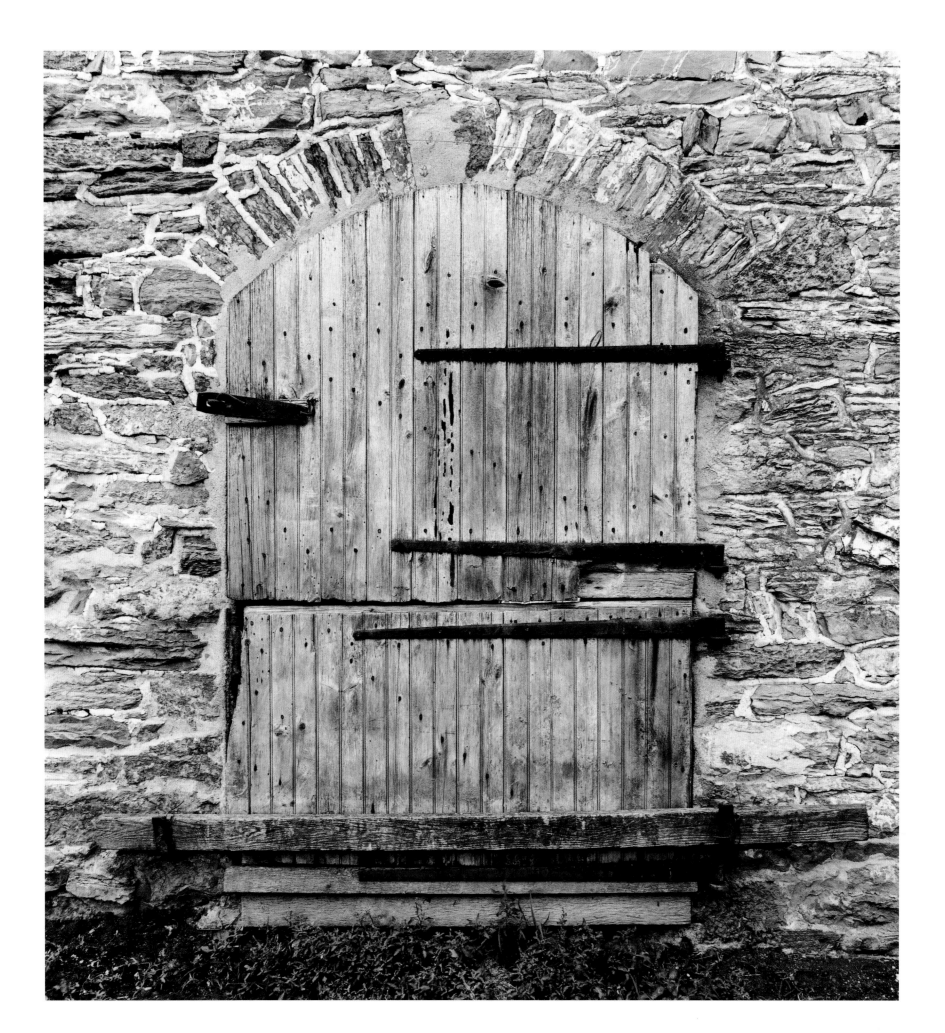

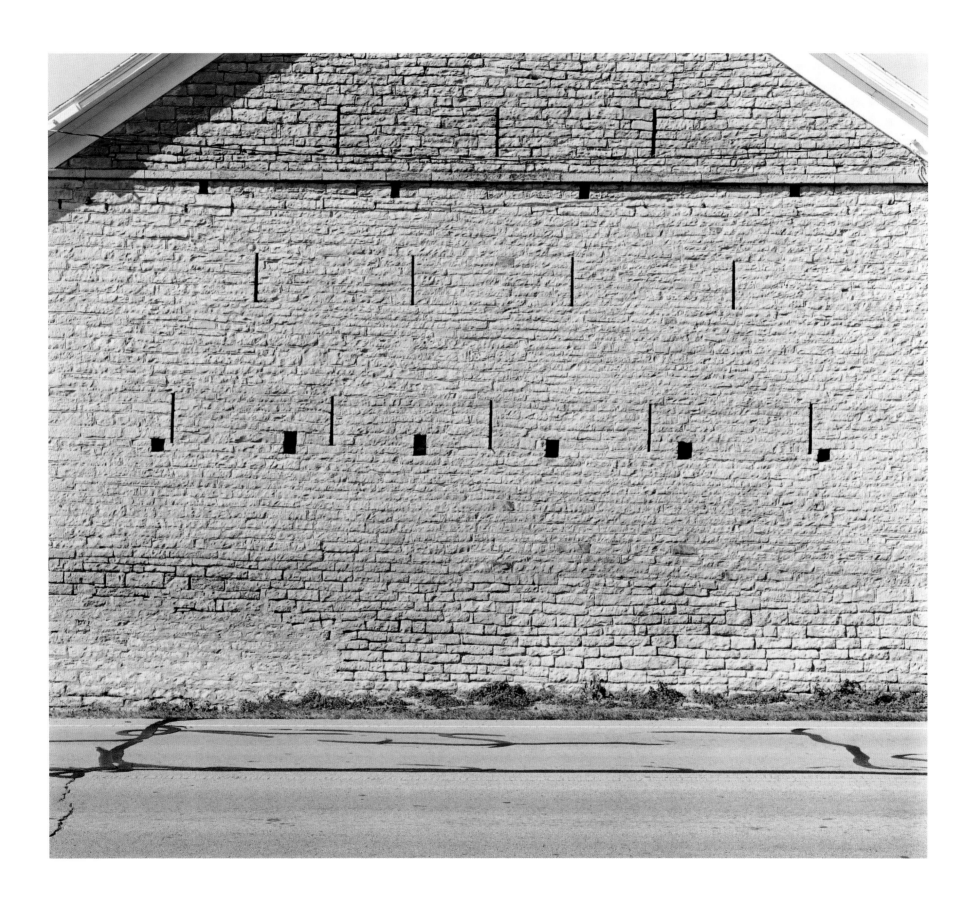

46 · Near Plainfield, Will County, Illinois (2000)

47 · Near Oswego, Kendall County, Illinois (2000)

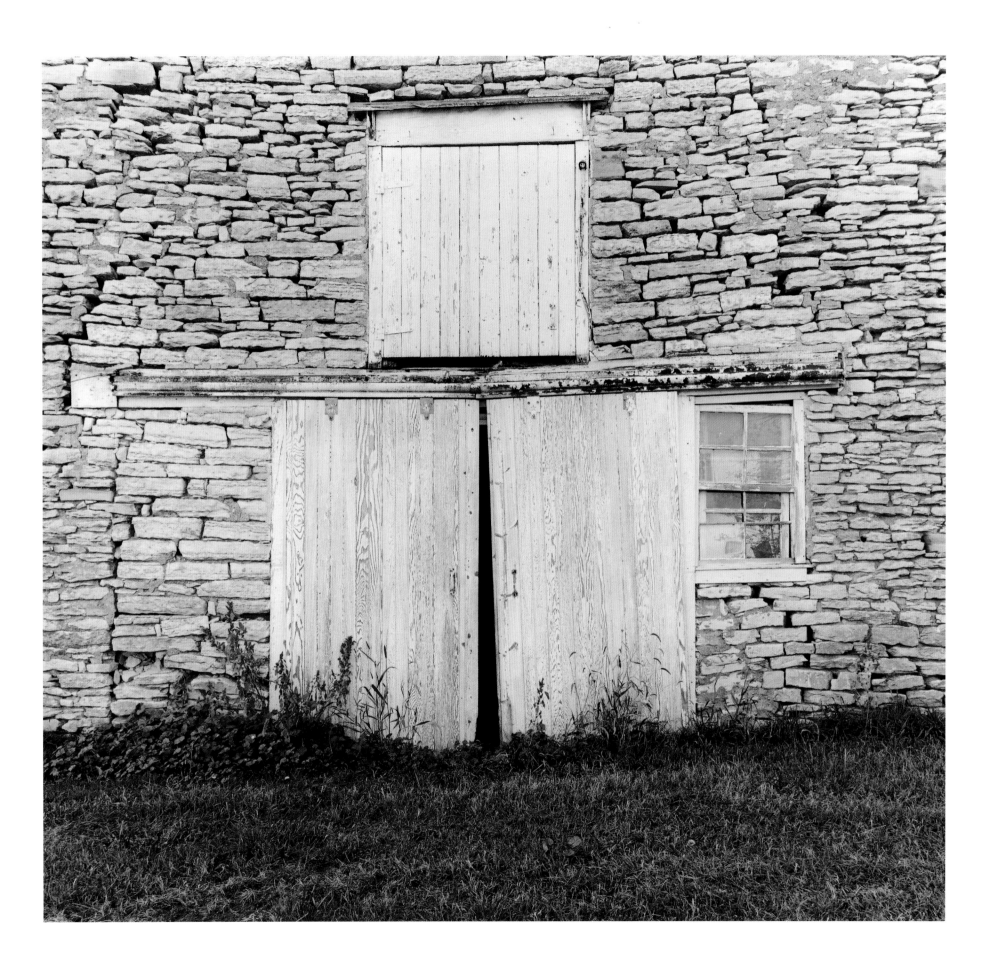

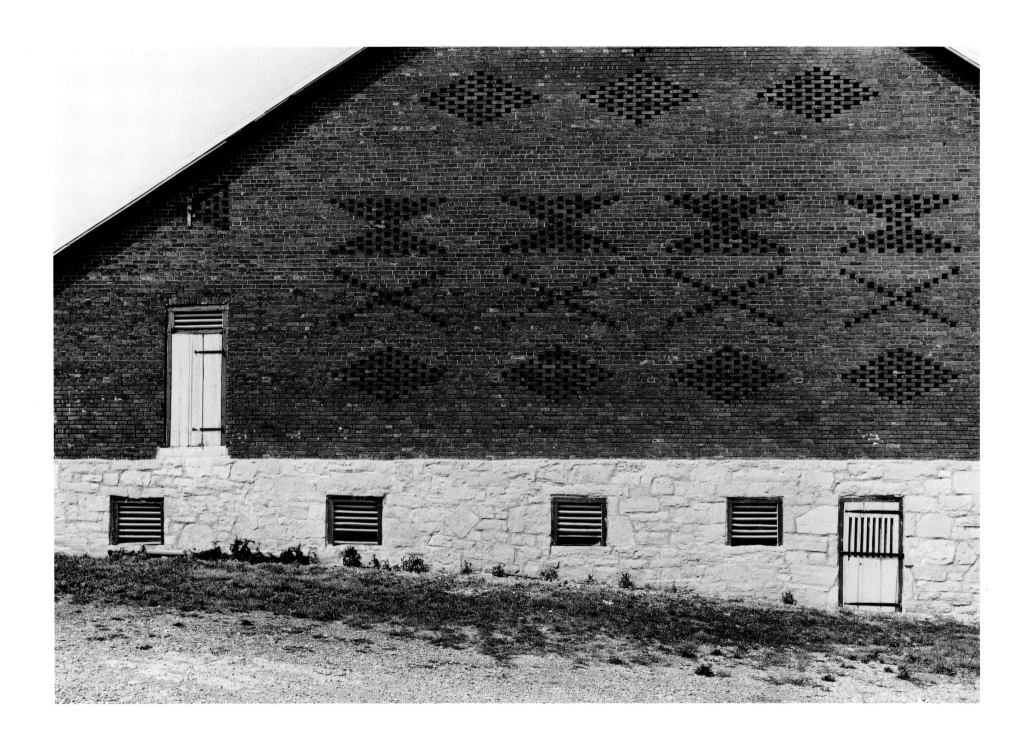

48 · Near Upton, Franklin County, Pennsylvania (2002)

49 · Mazomania Township, Dane County, Wisconsin (2002)

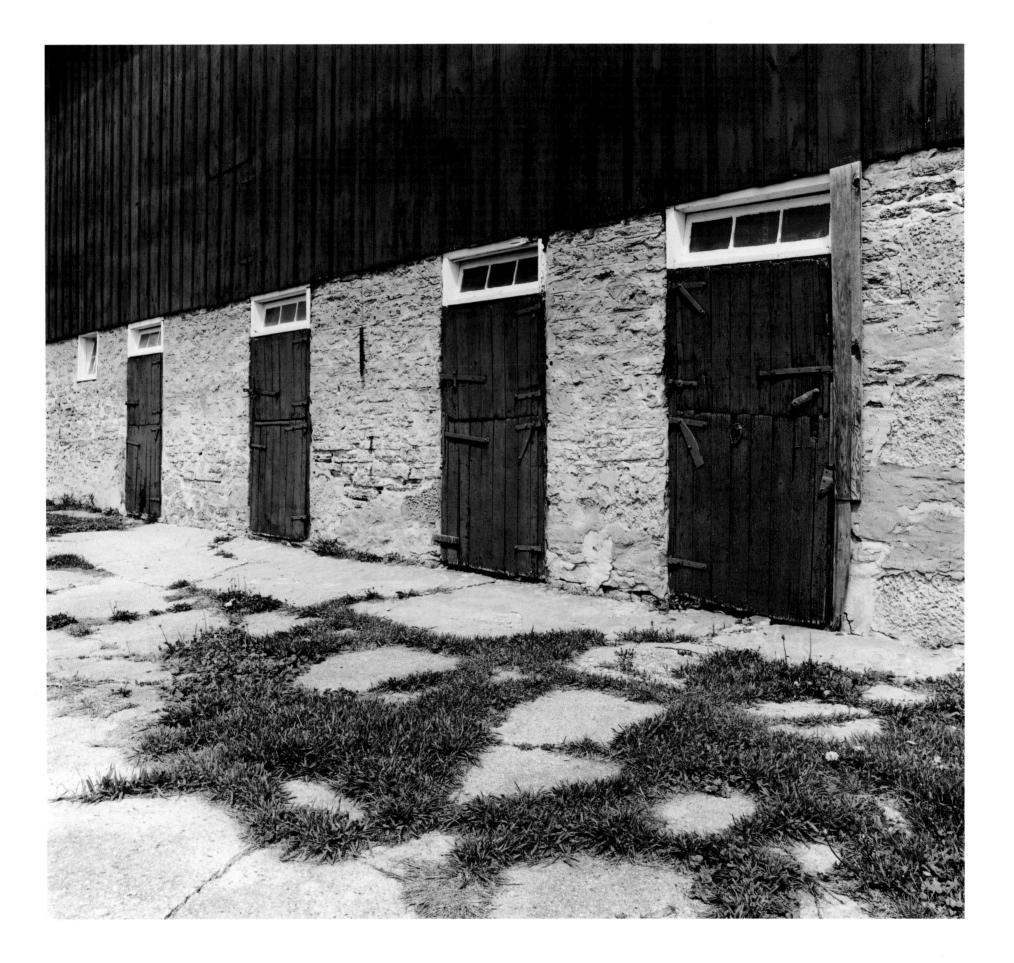

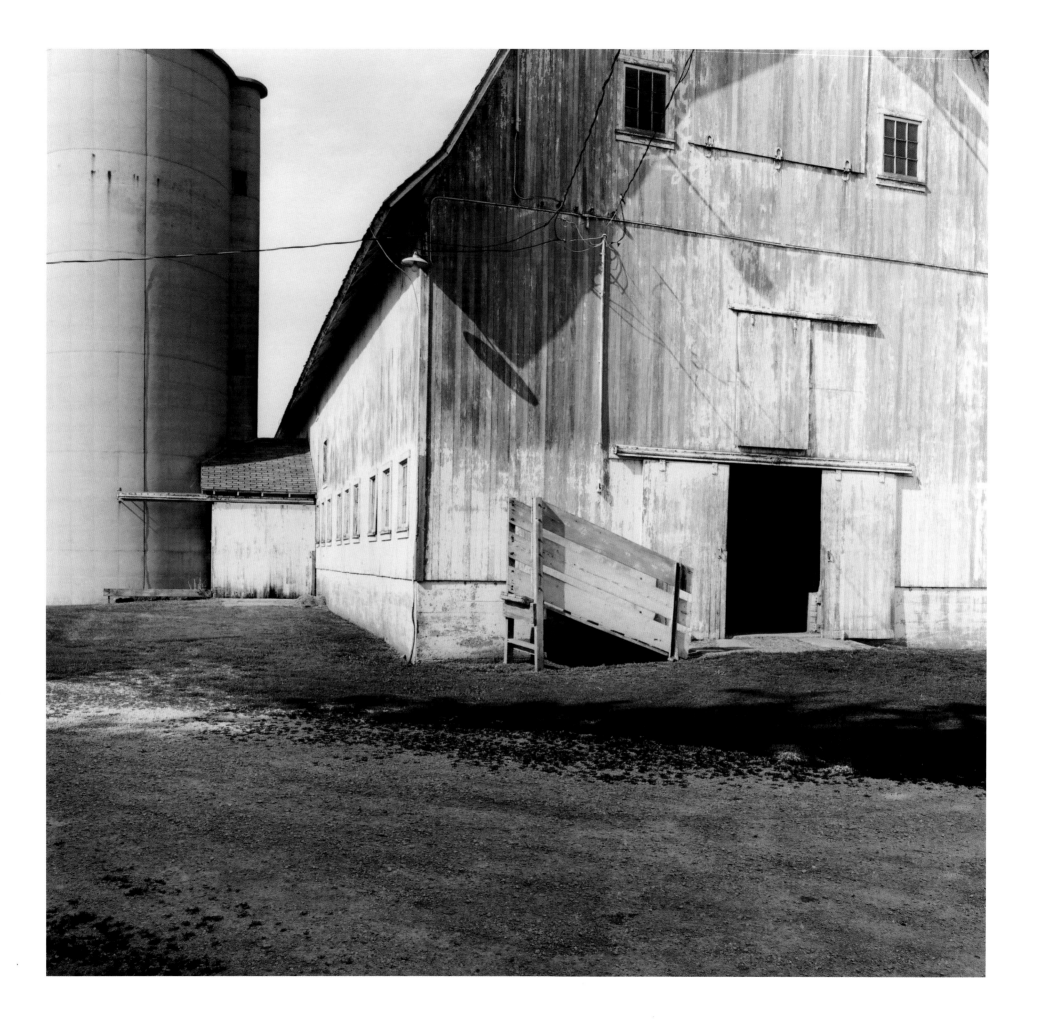

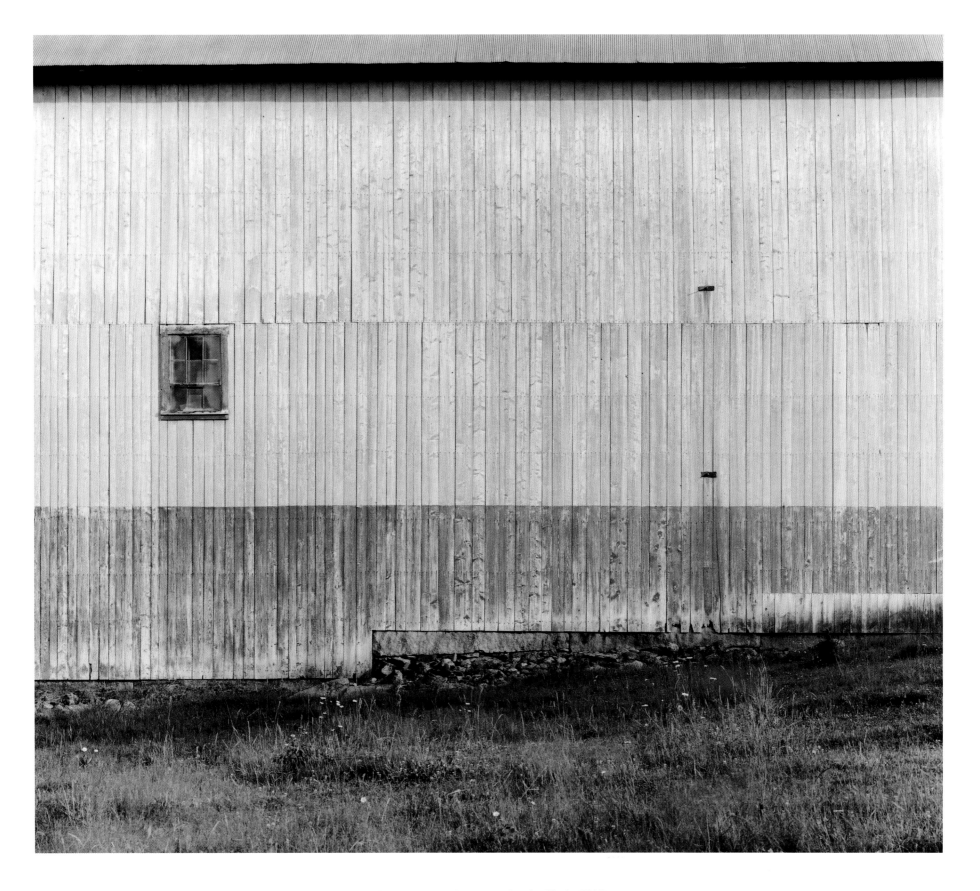

50 · Near Harvard, McHenry County, Illinois (2000)

51 · Peacham, Caledonia County, Vermont (2001)

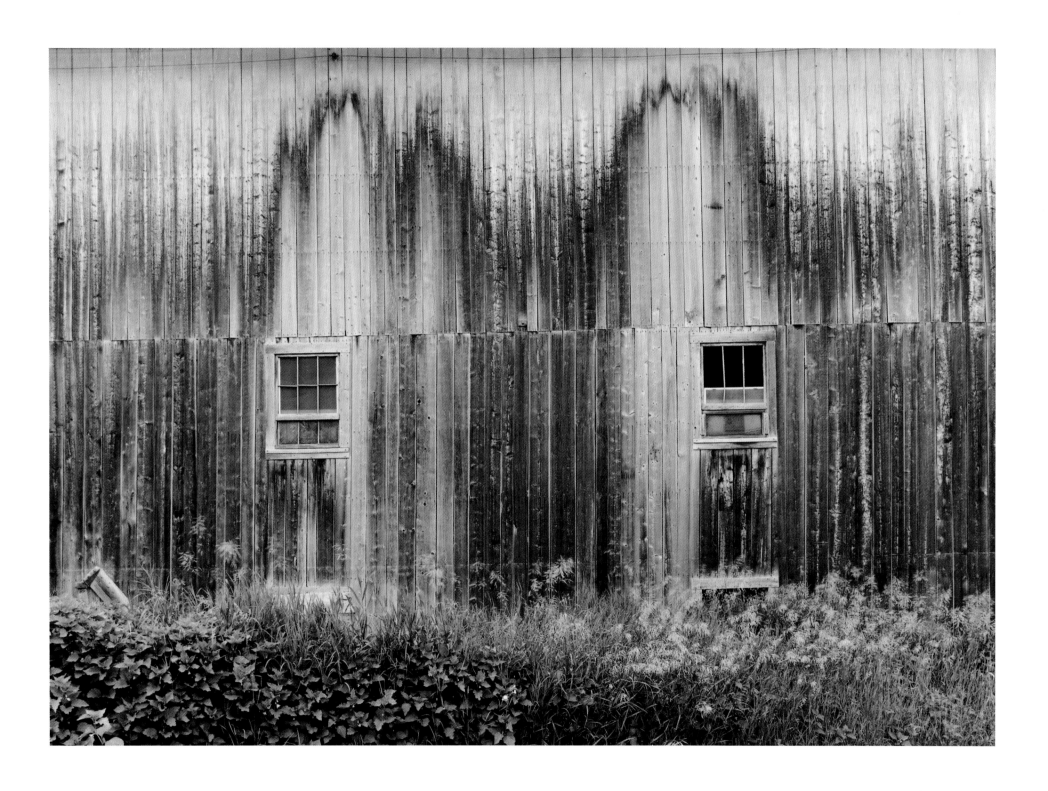

52 · Peacham, Caledonia County, Vermont (2001)

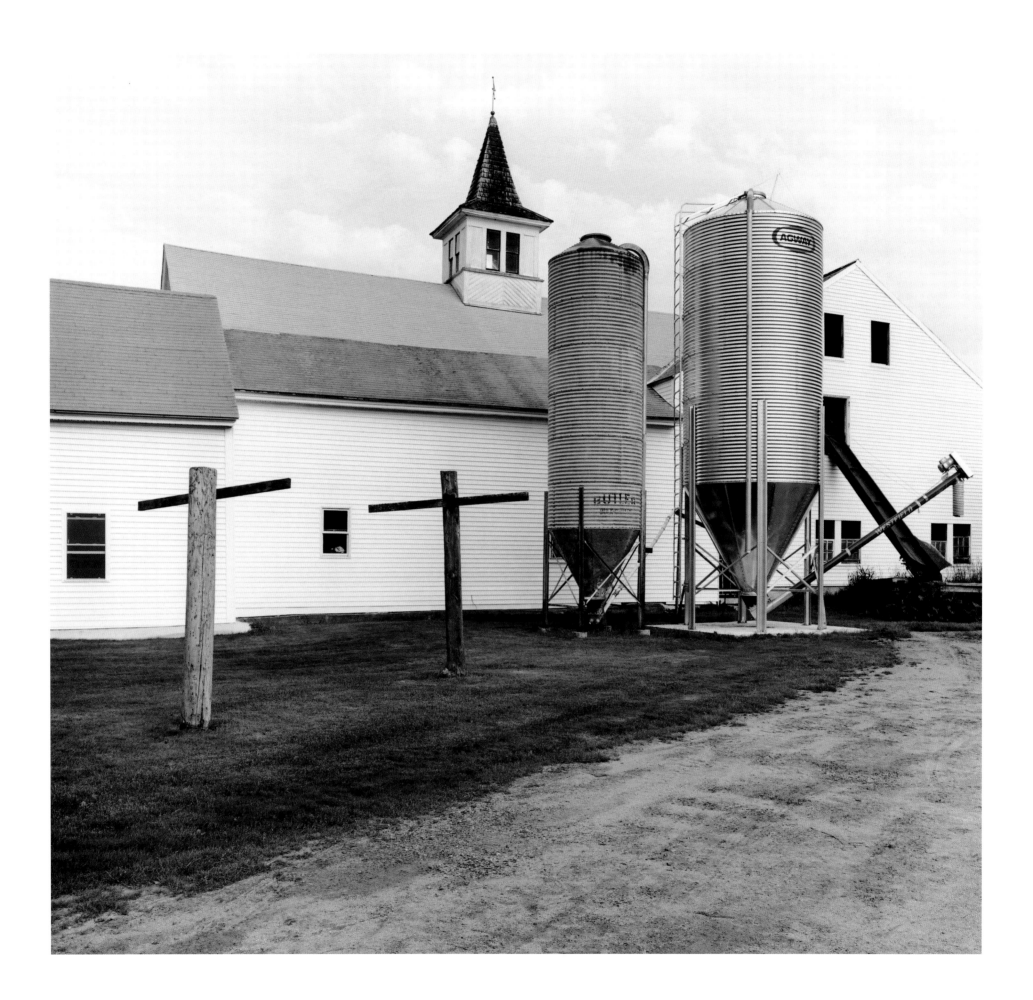

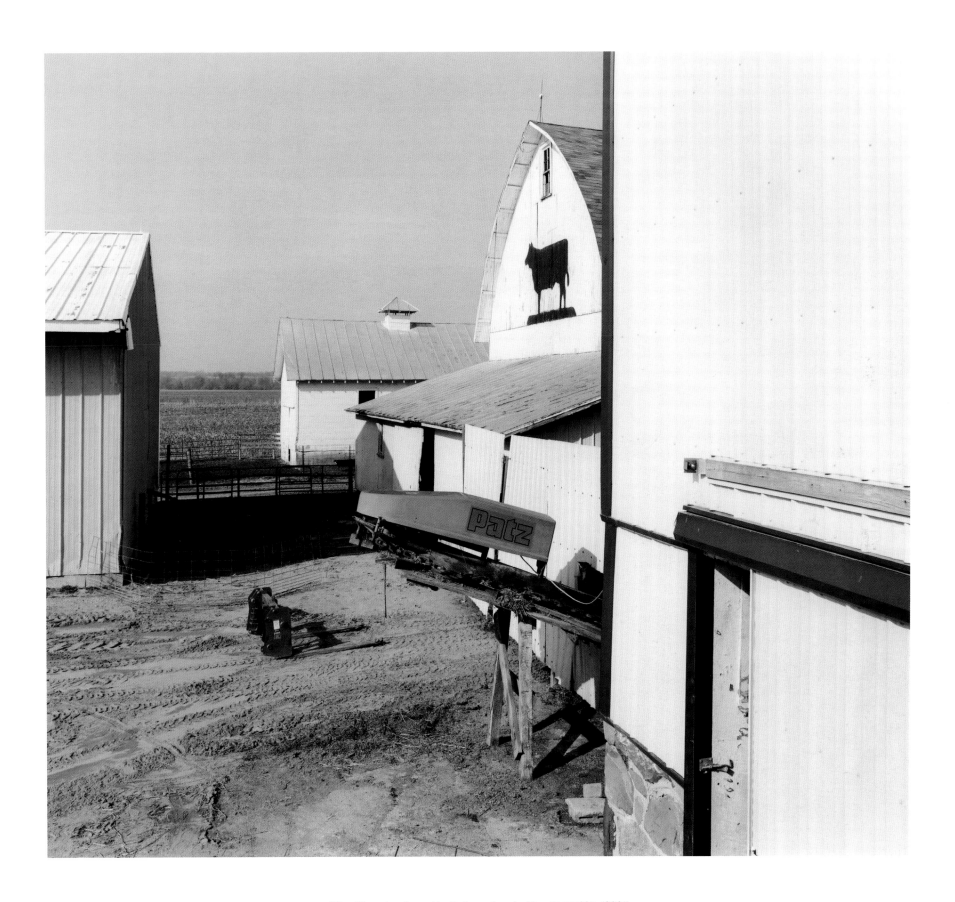

53 · Gilmanton Township, Belknap County, New Hampshire (2001)

54 · Near Wolcottville, Noble County, Indiana (2000)

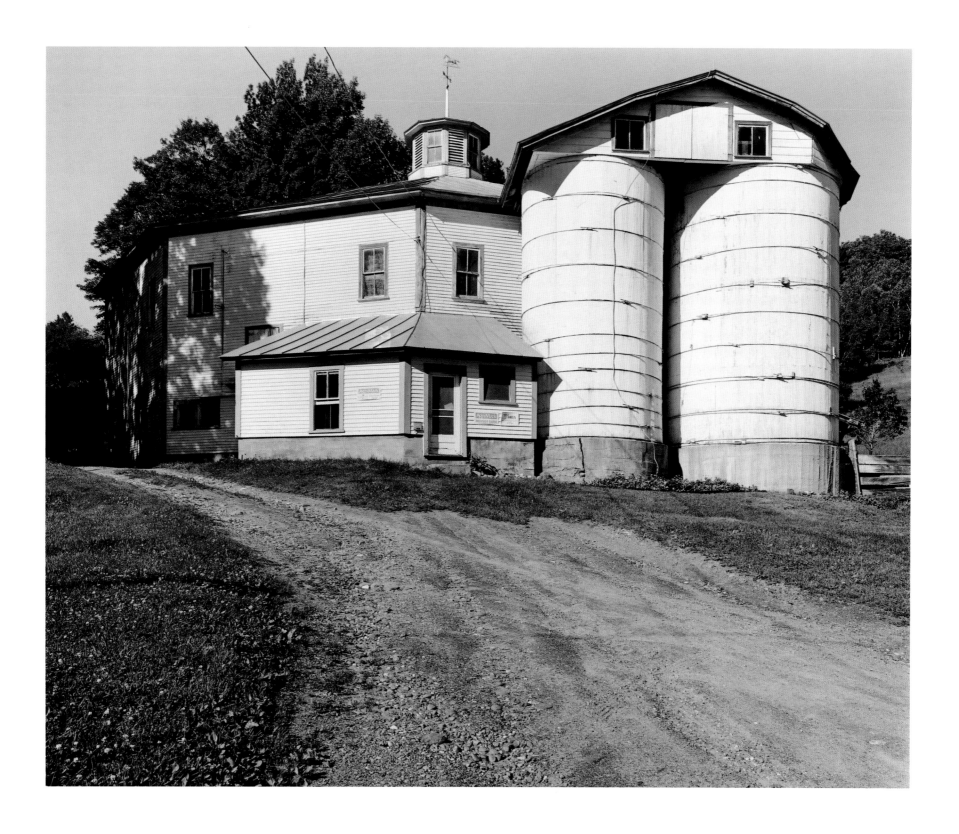

55 · Town of Sharon, Windsor County, Vermont (2001)

56 · Quincy Township, Franklin County, Pennsylvania (2002)

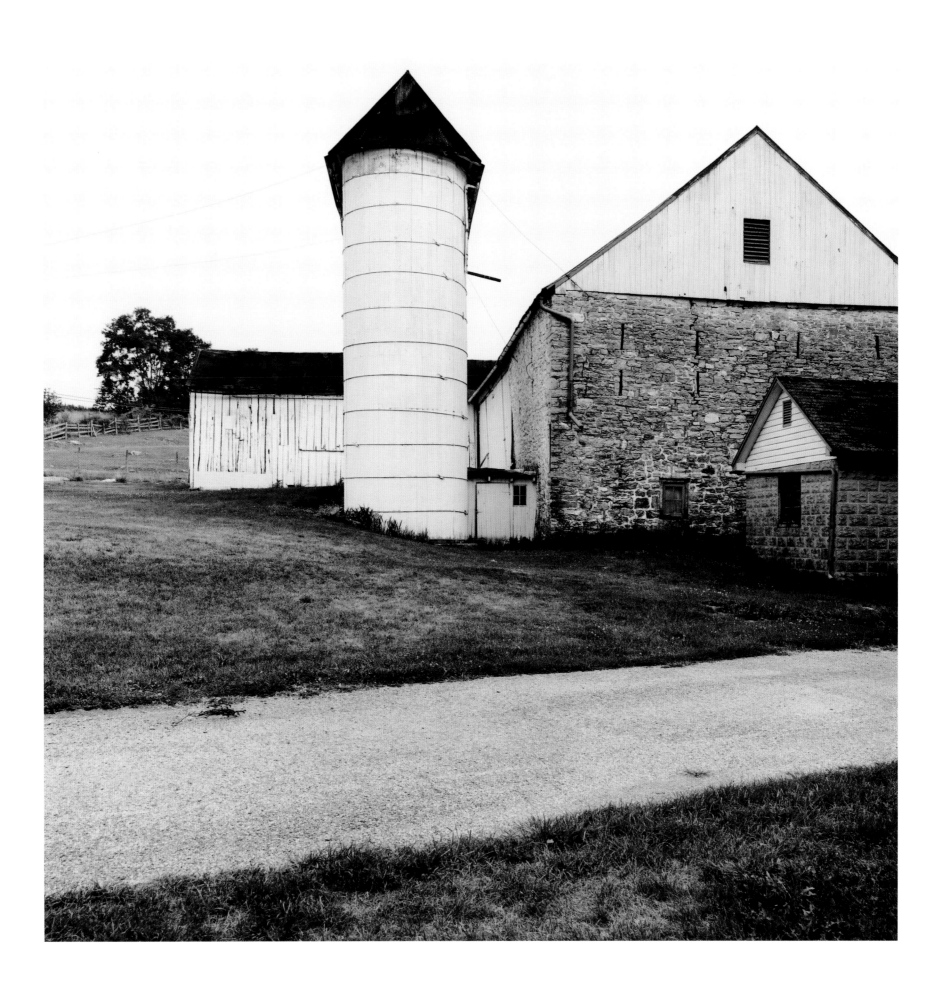

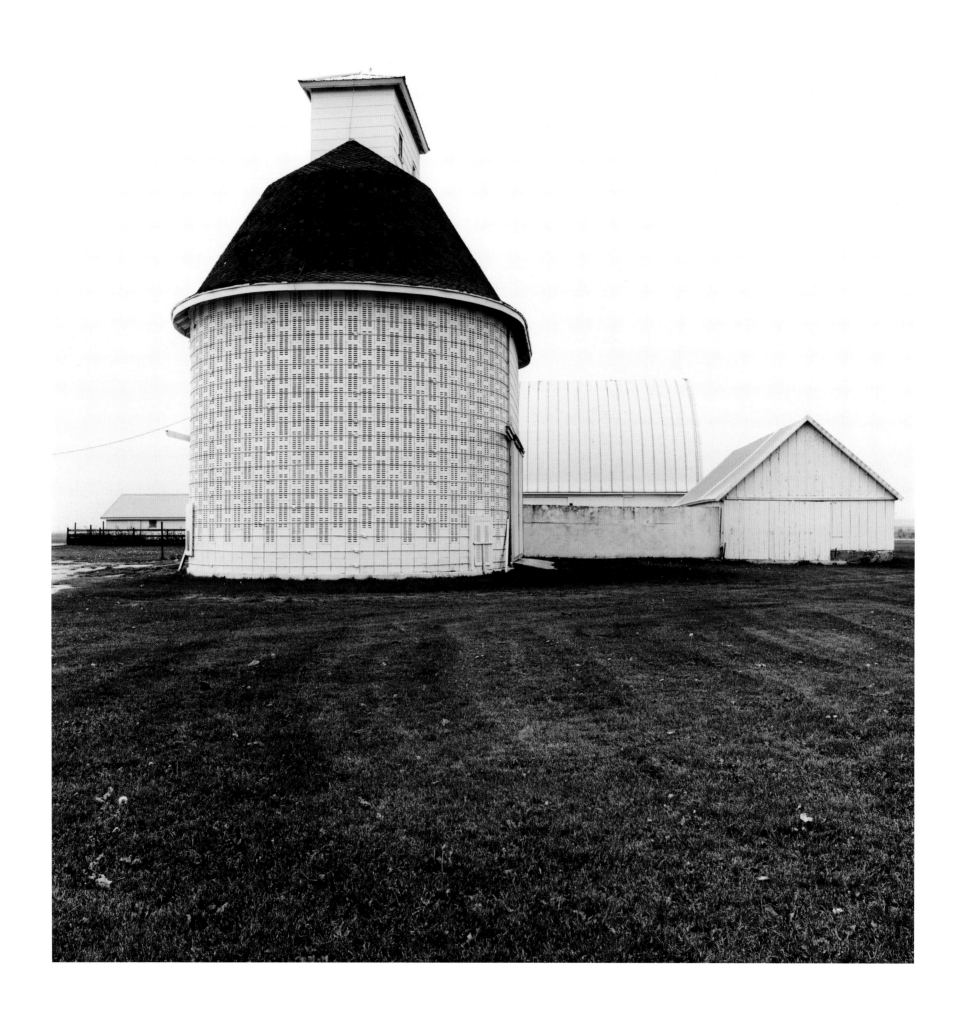

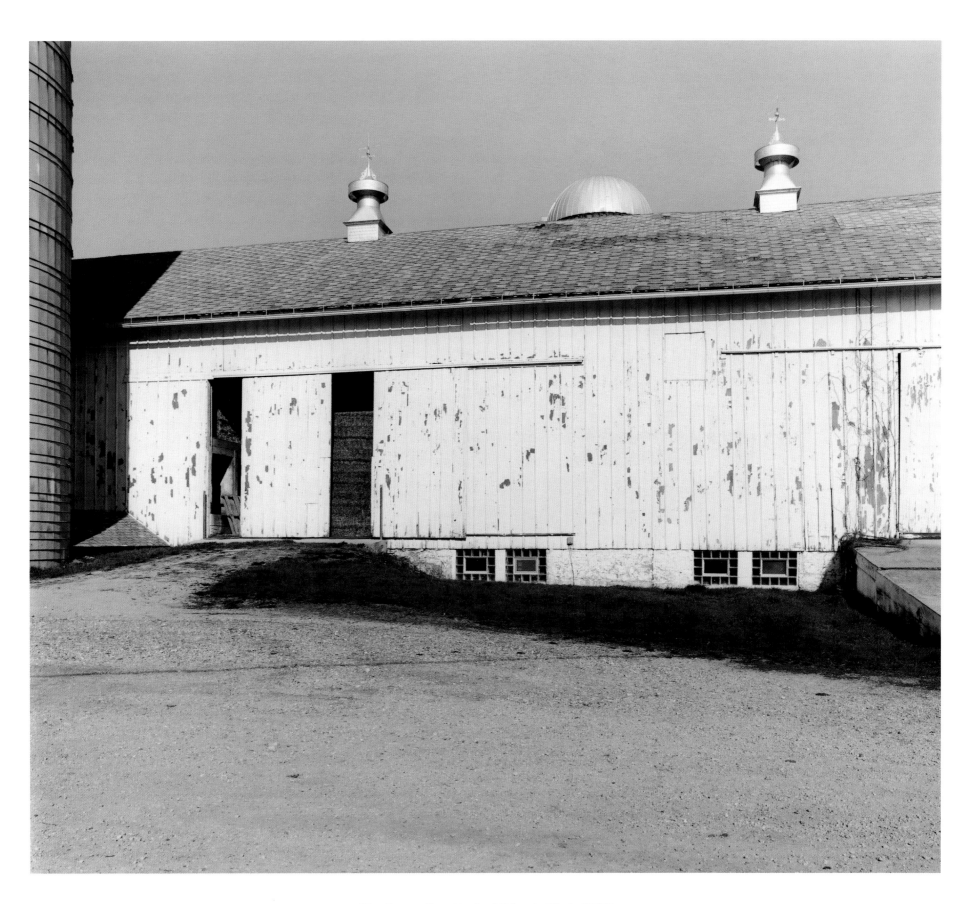

57 · Naausay Township, Kendall County, Illinois (2000)

58 · Juda, Green County, Wisconsin (2000)

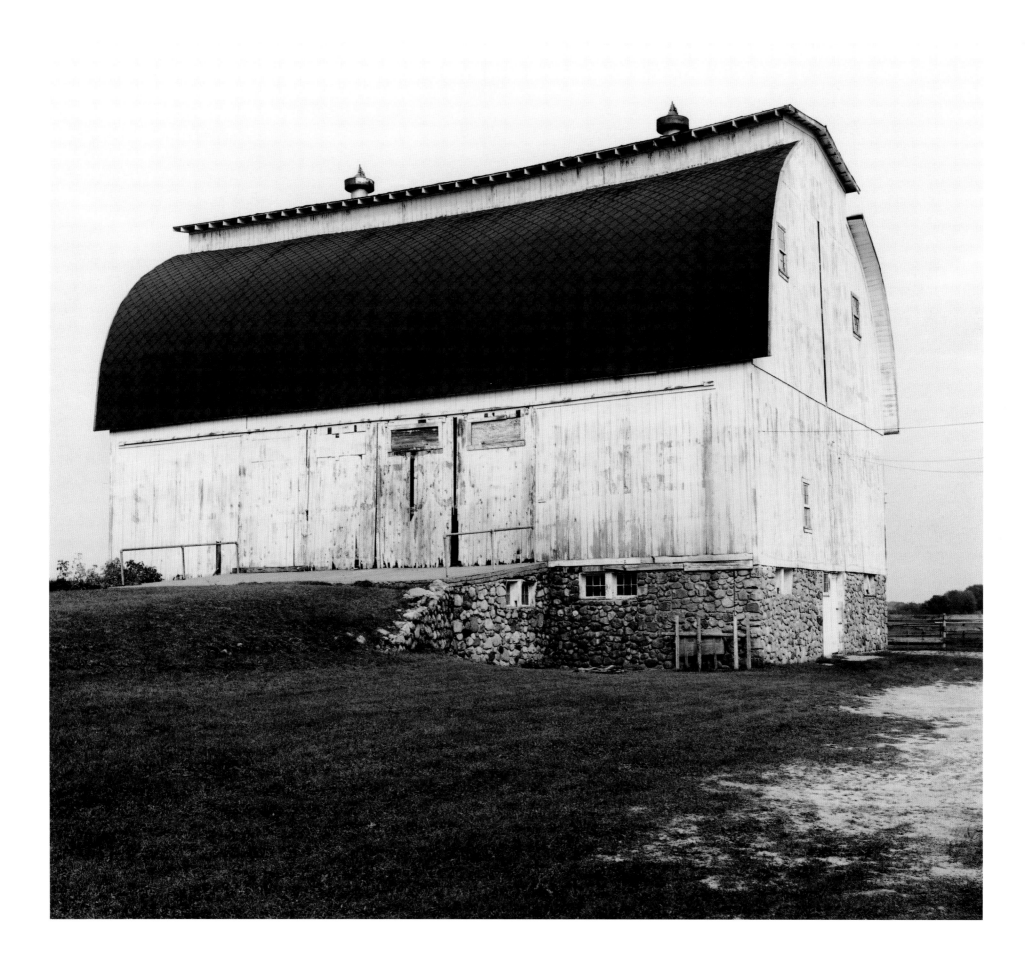

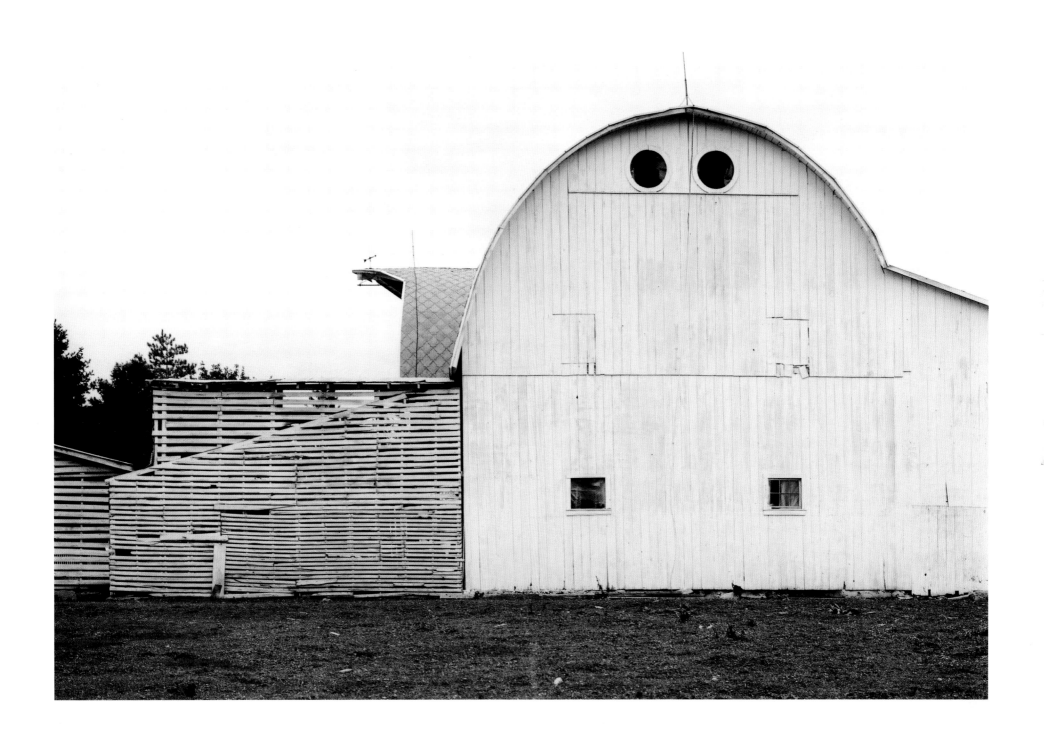

59 · Clare County, Michigan (1975)

60 · Isabella County, Michigan (1975)

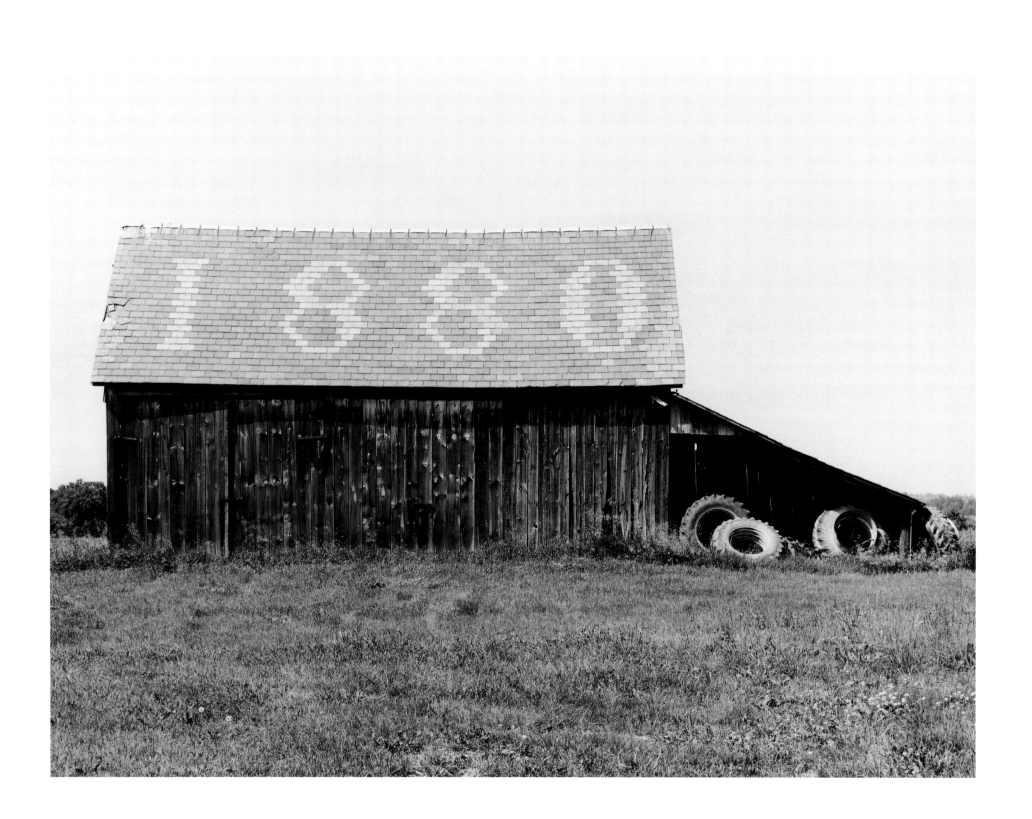

61 · Near Orwell, Addison County, Vermont (2001)

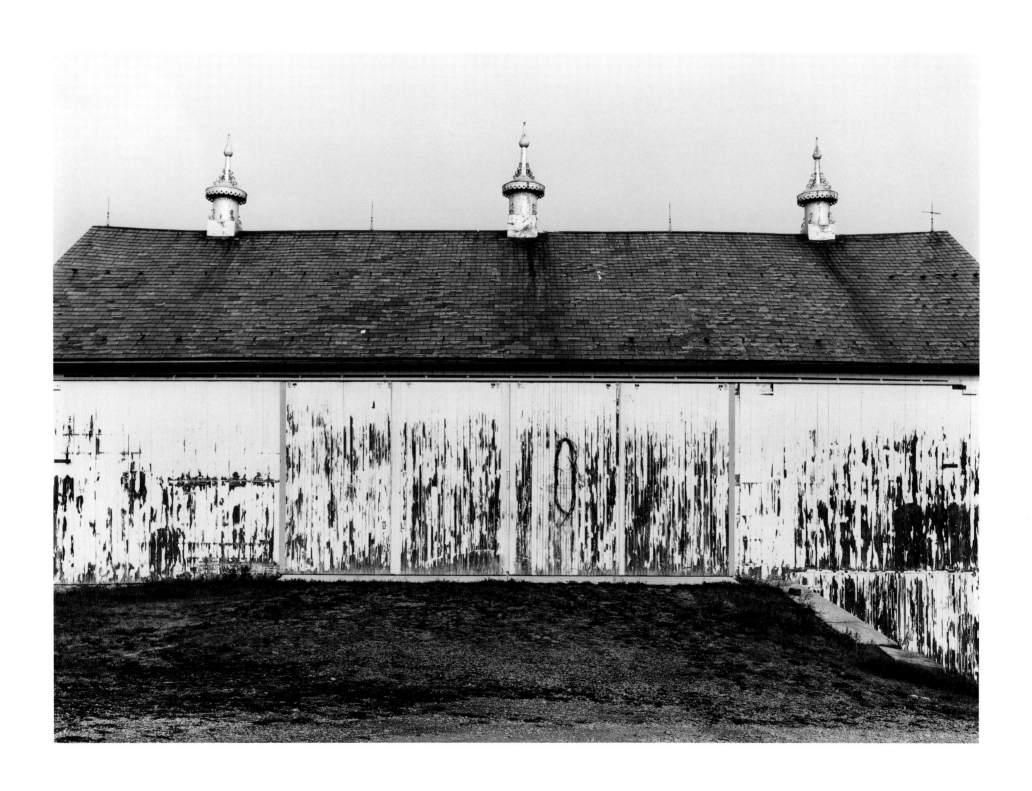

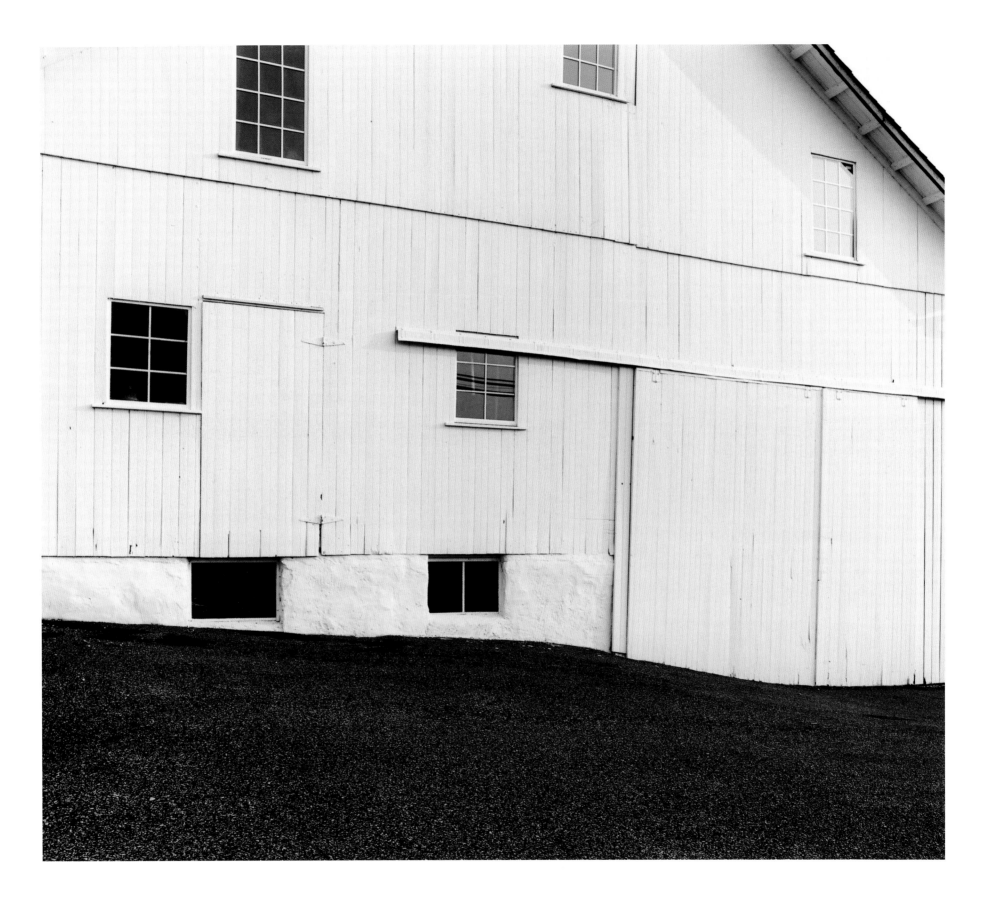

63 · Gordonsville, Lancaster County, Pennsylvania (2002)

64 · Leacock Township, Lancaster County, Pennsylvania (2002)

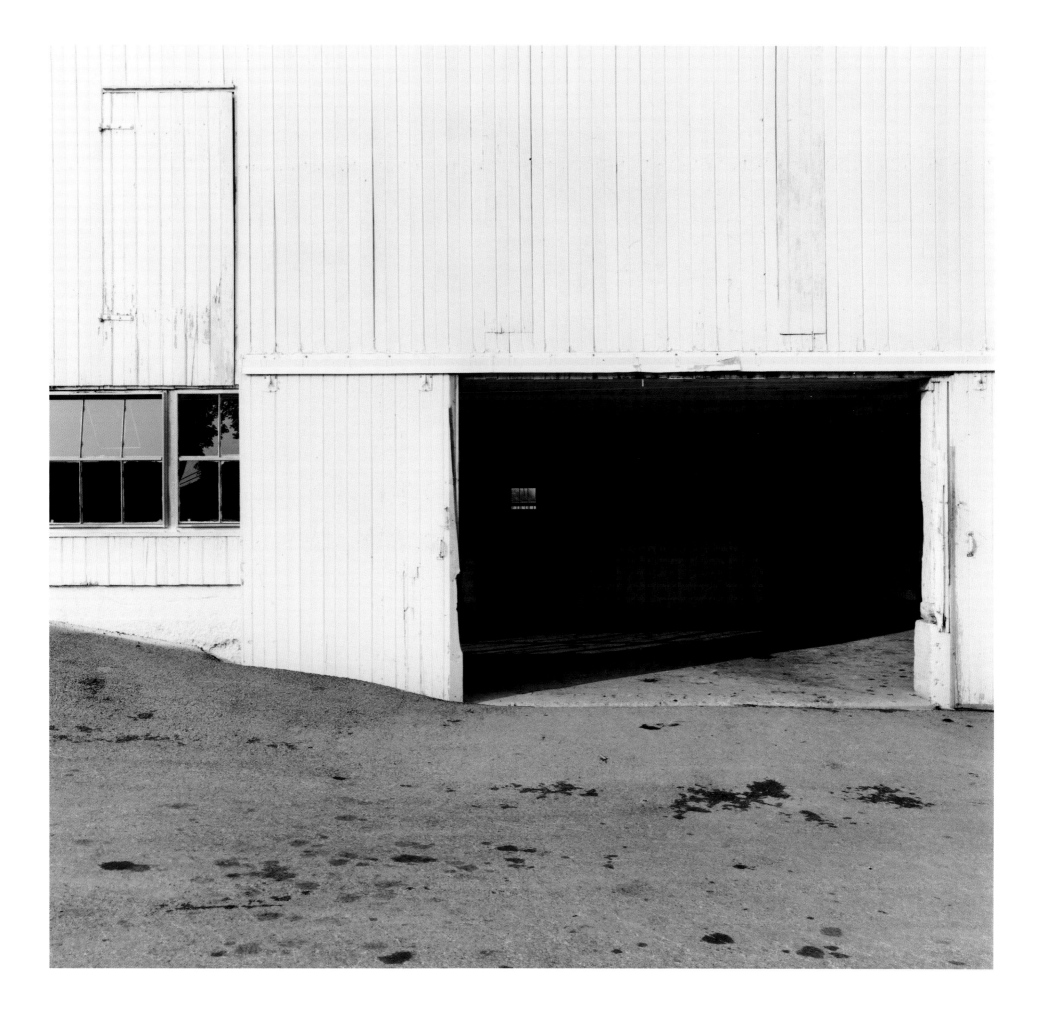

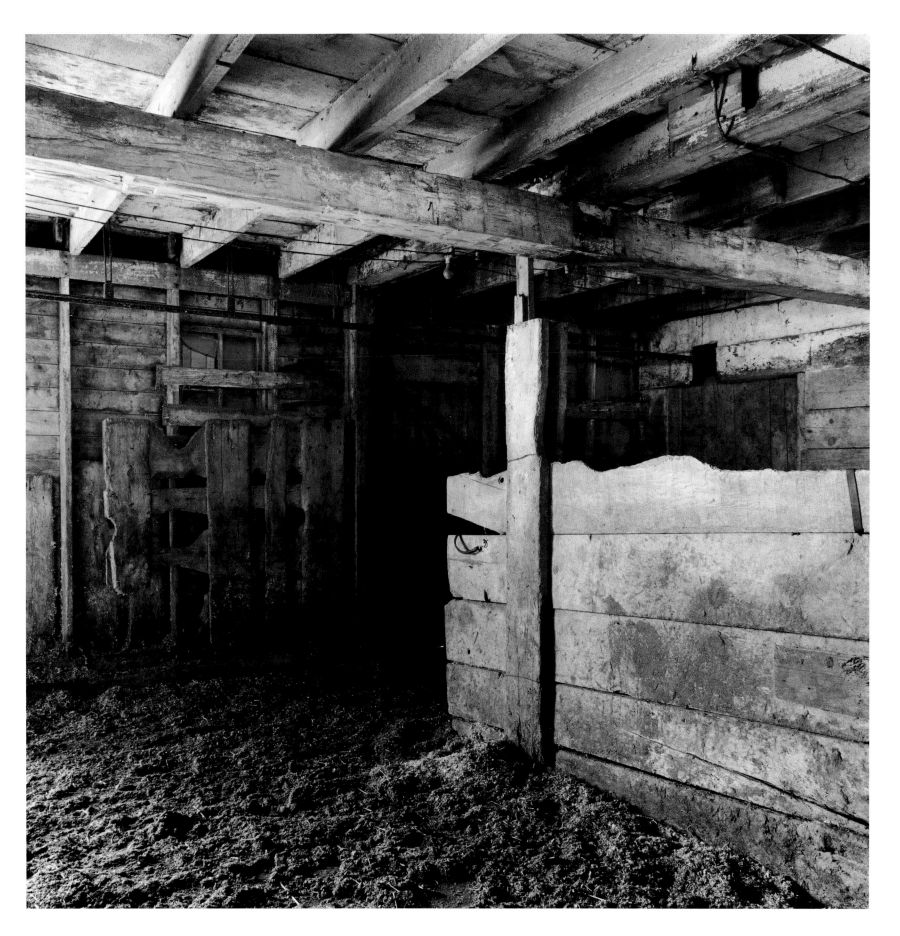

65 · Near Baileyville, Ogle County, Illinois (2000)

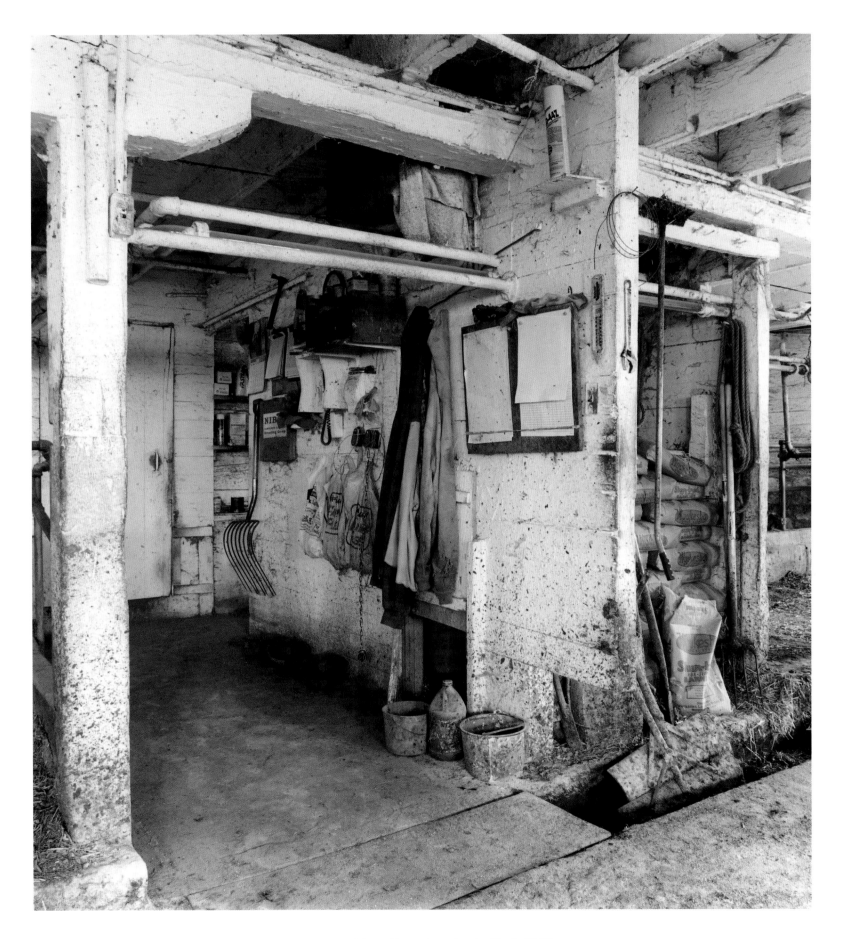

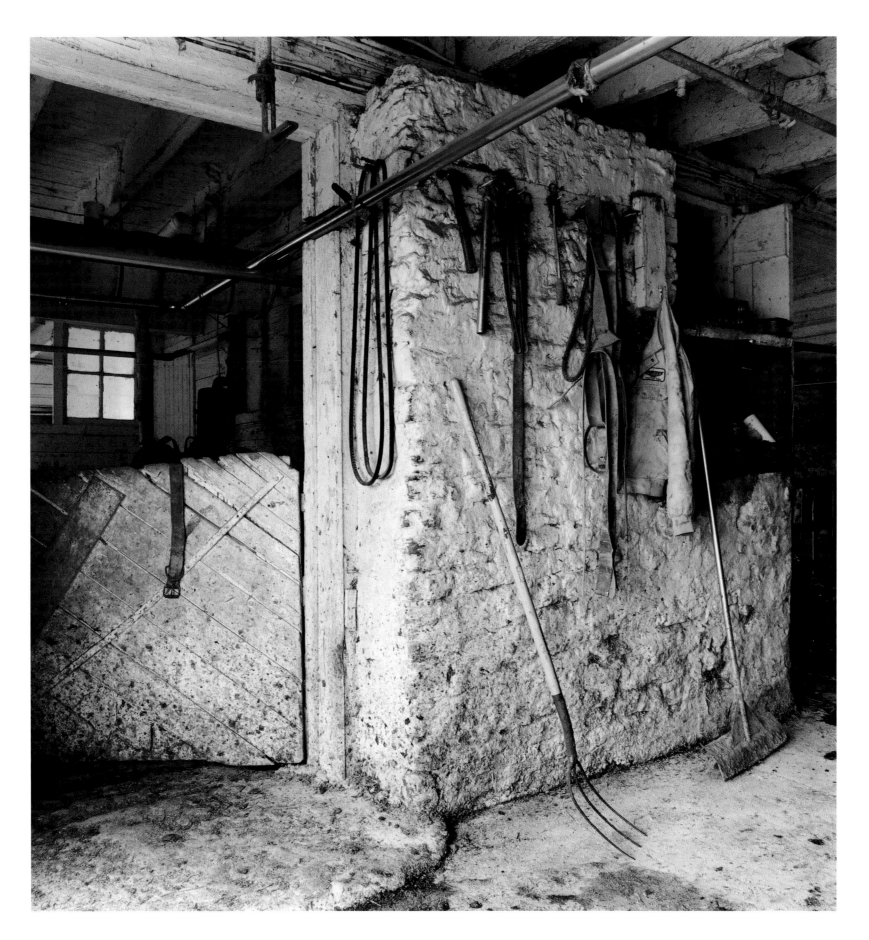

67 · Juda, Green County, Wisconsin (2000)

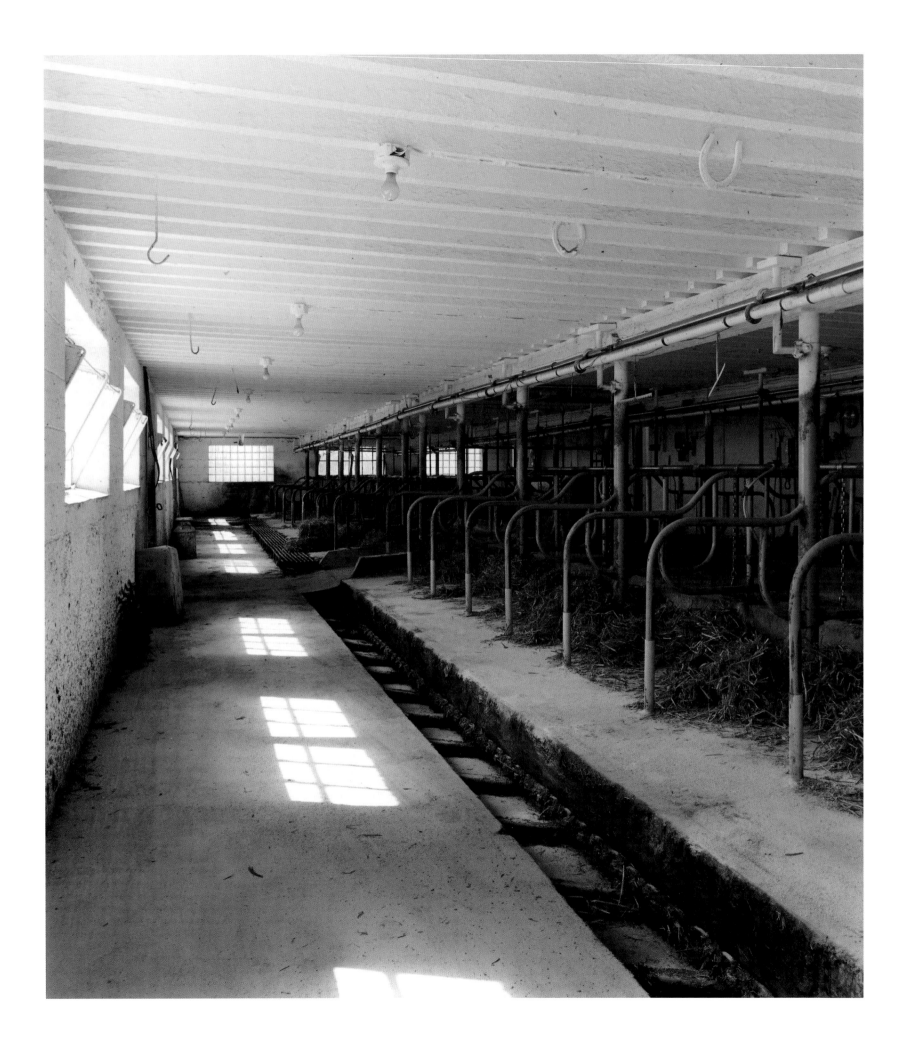

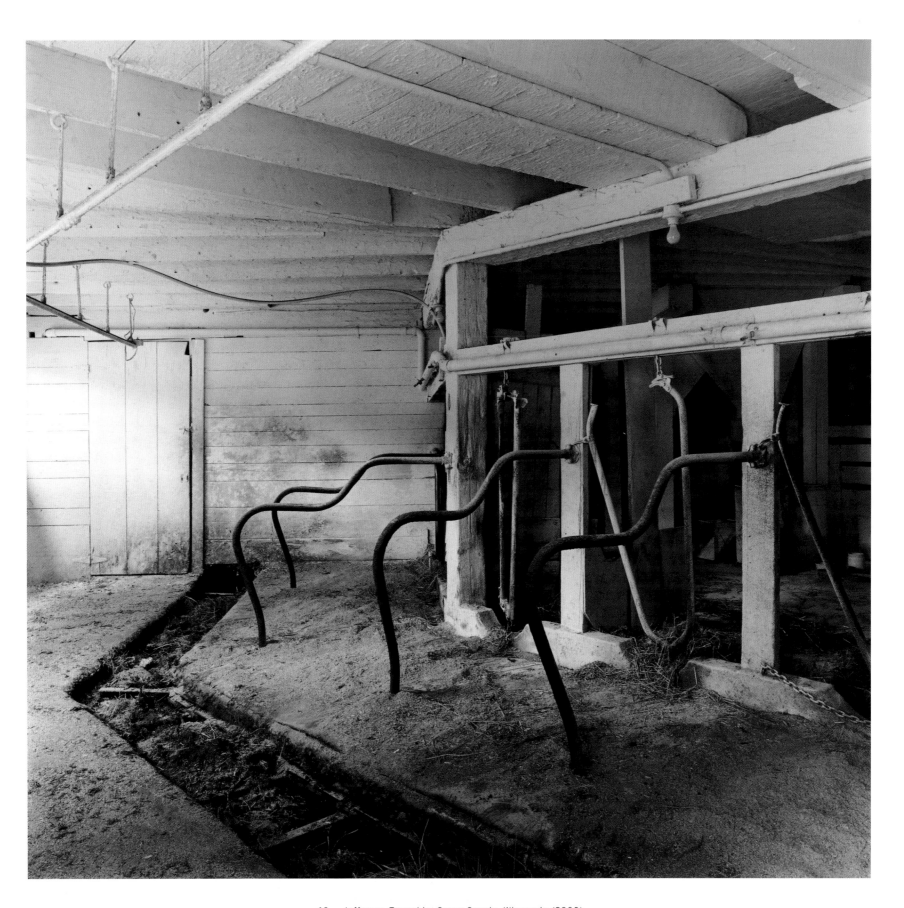

68 · Jefferson Township, Green County, Wisconsin (2000)

69 · Town of Sharon, Windsor County, Vermont (2001)

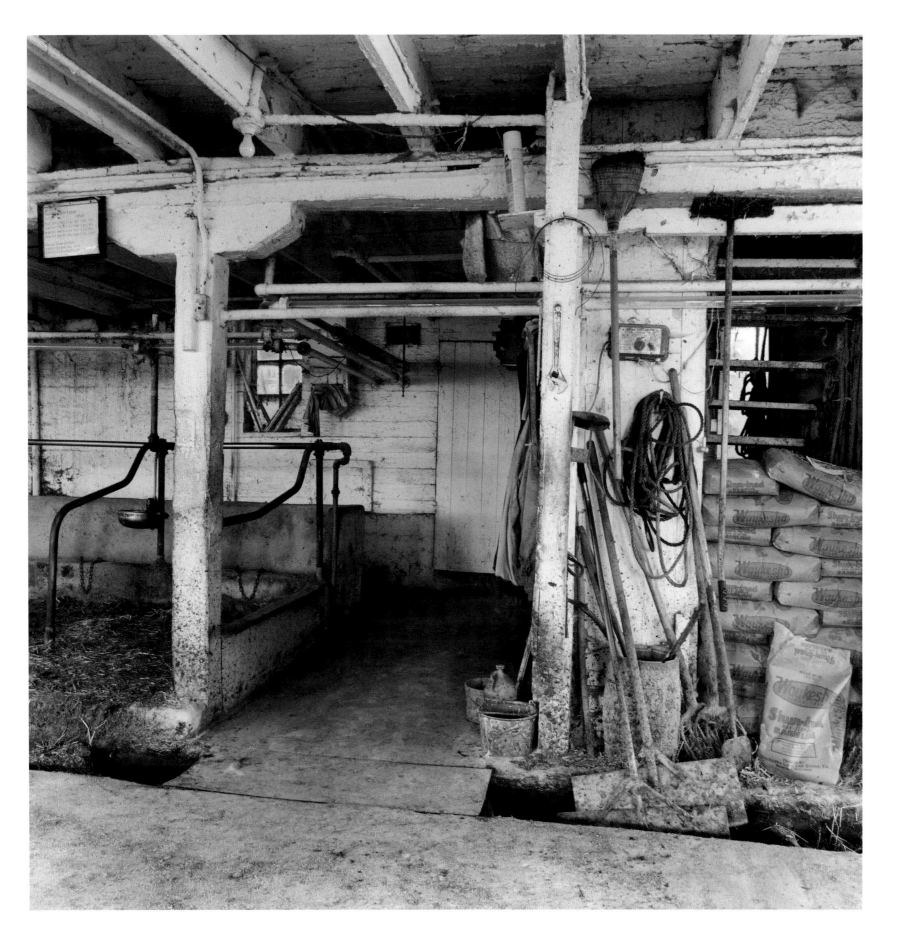

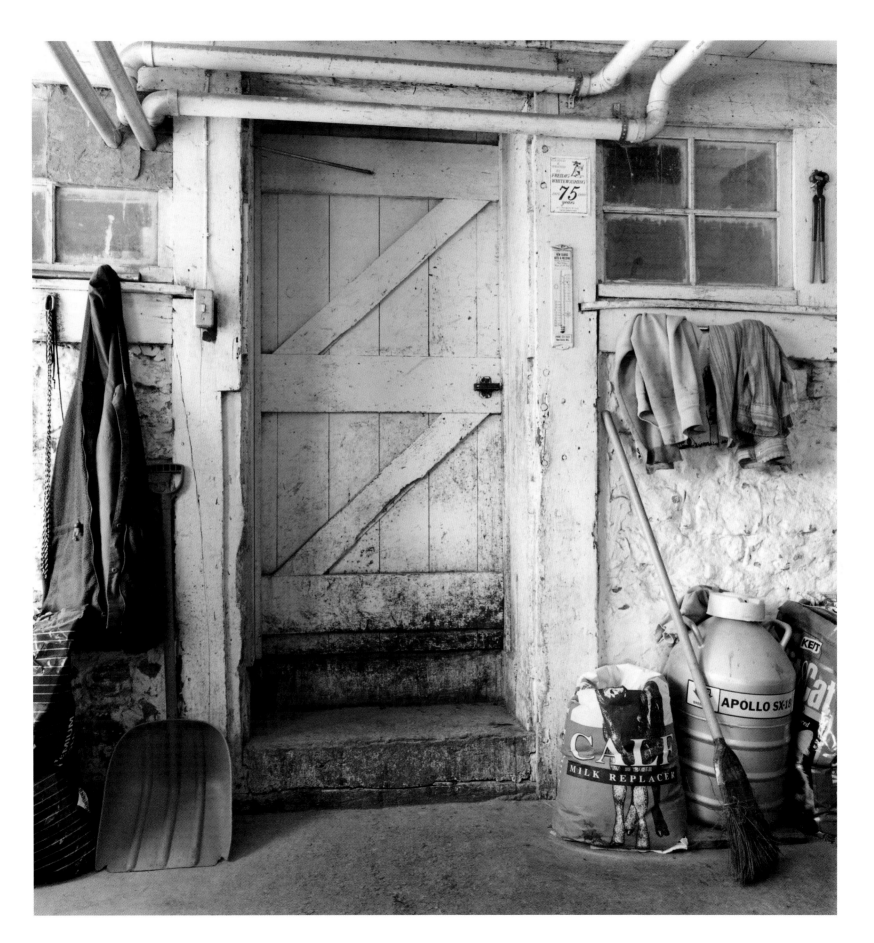

71 · New Glarus Township, Green County, Wisconsin (2000)

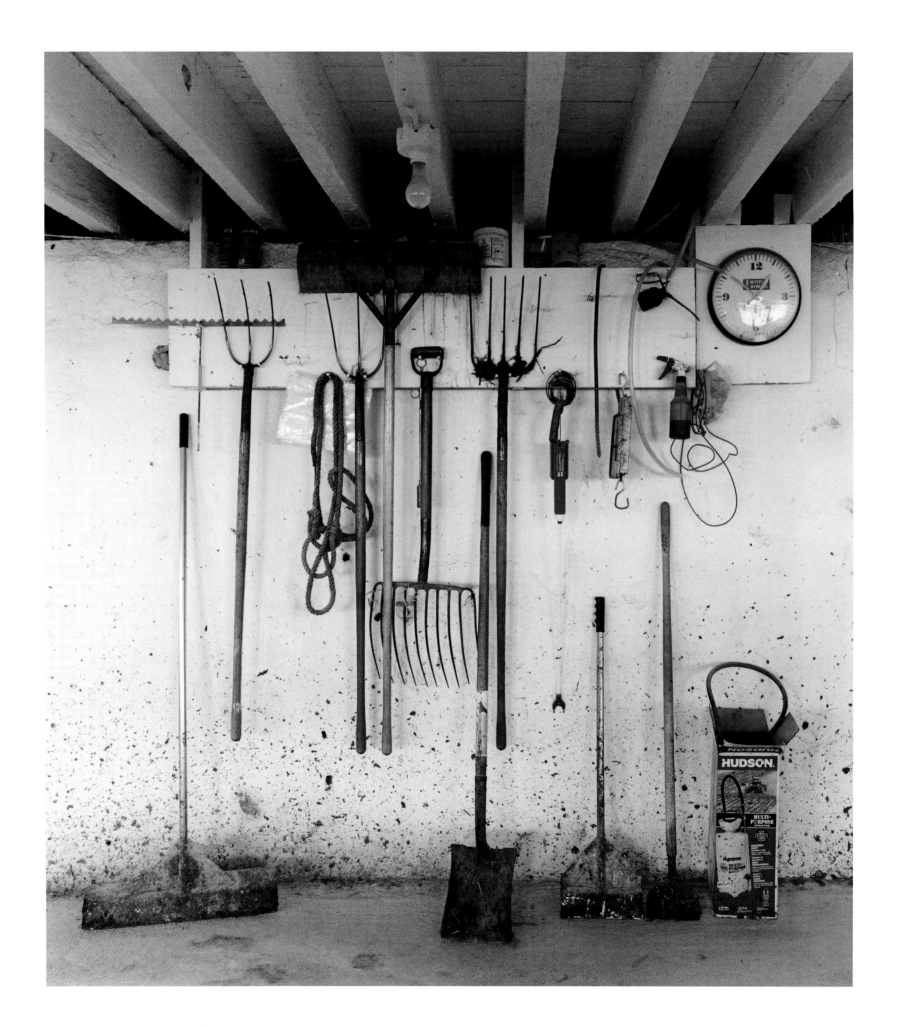

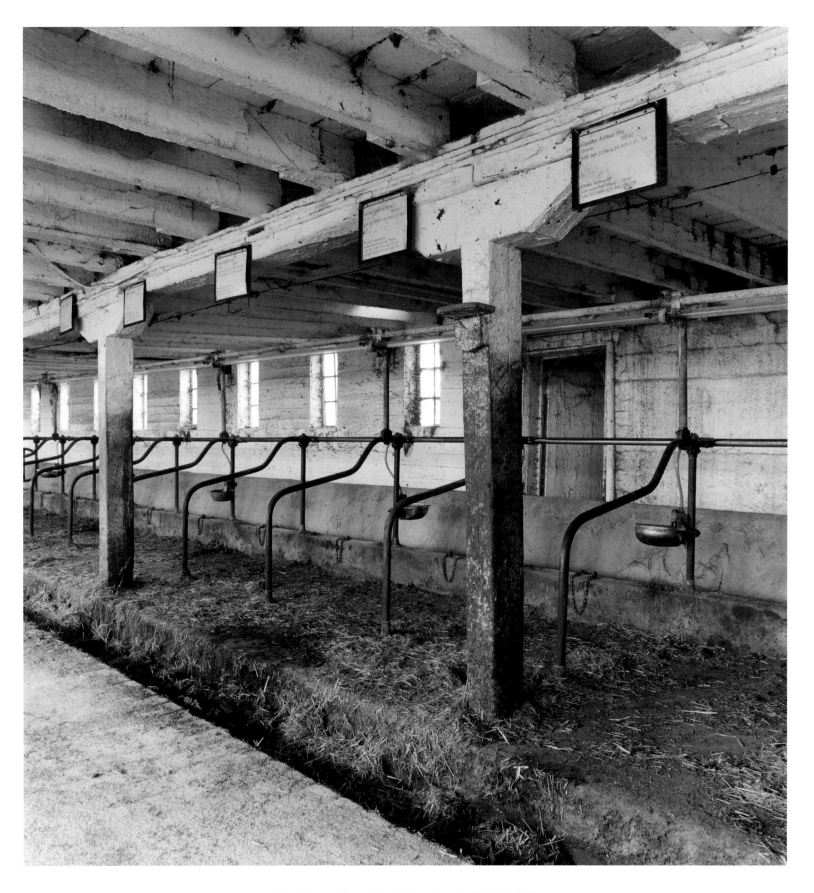

73 · Richmond Township, McHenry County, Illinois (2000)

74 · Juda, Green County, Wisconsin (2000)

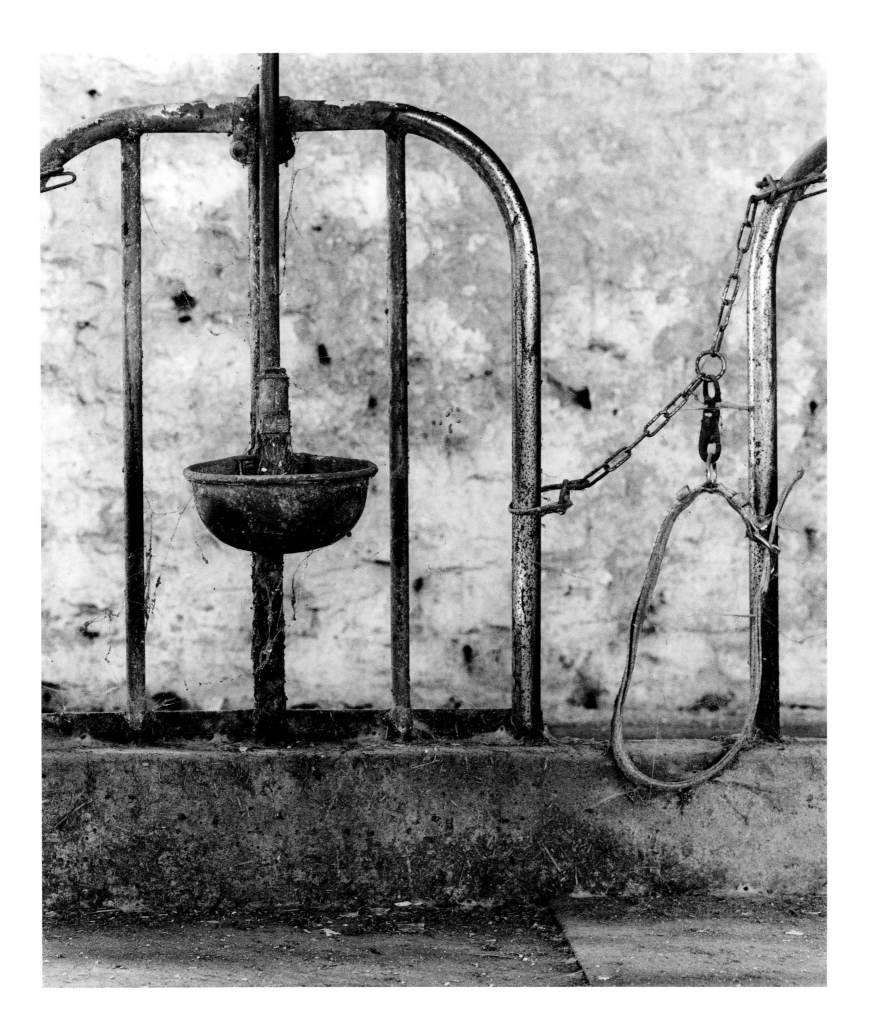

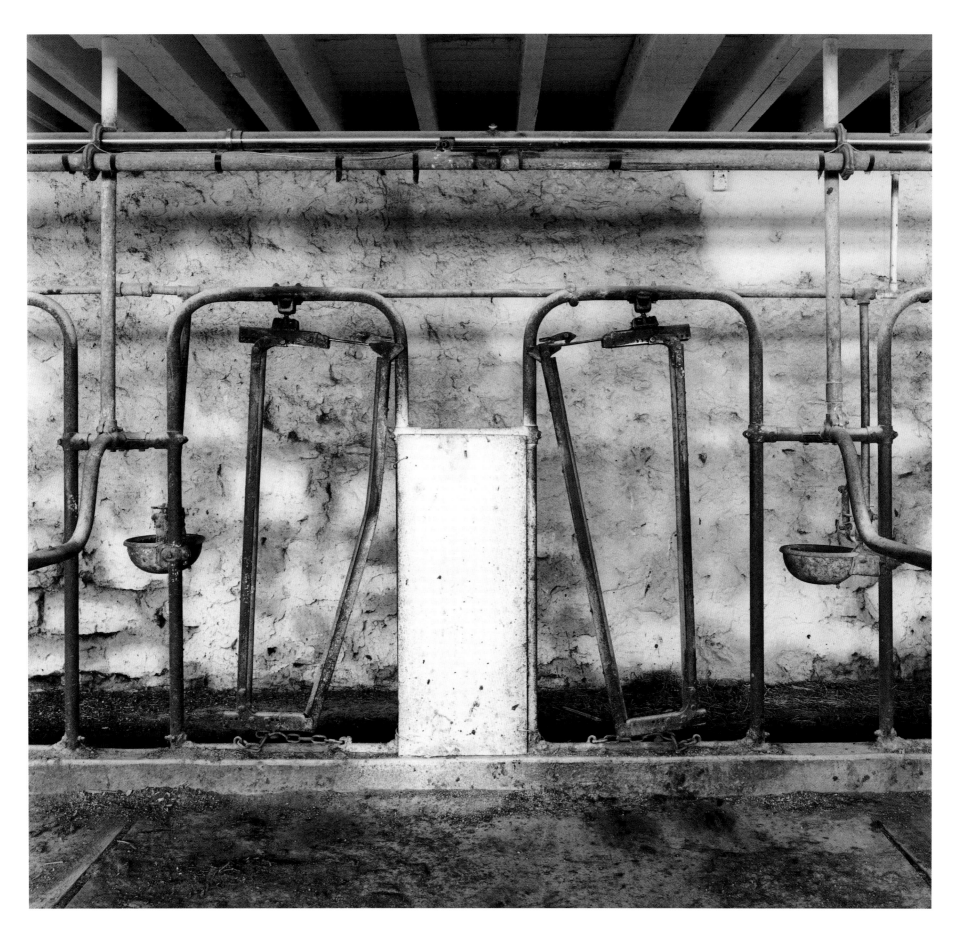

75 · Near Brodhead, Green County, Wisconsin (2000)

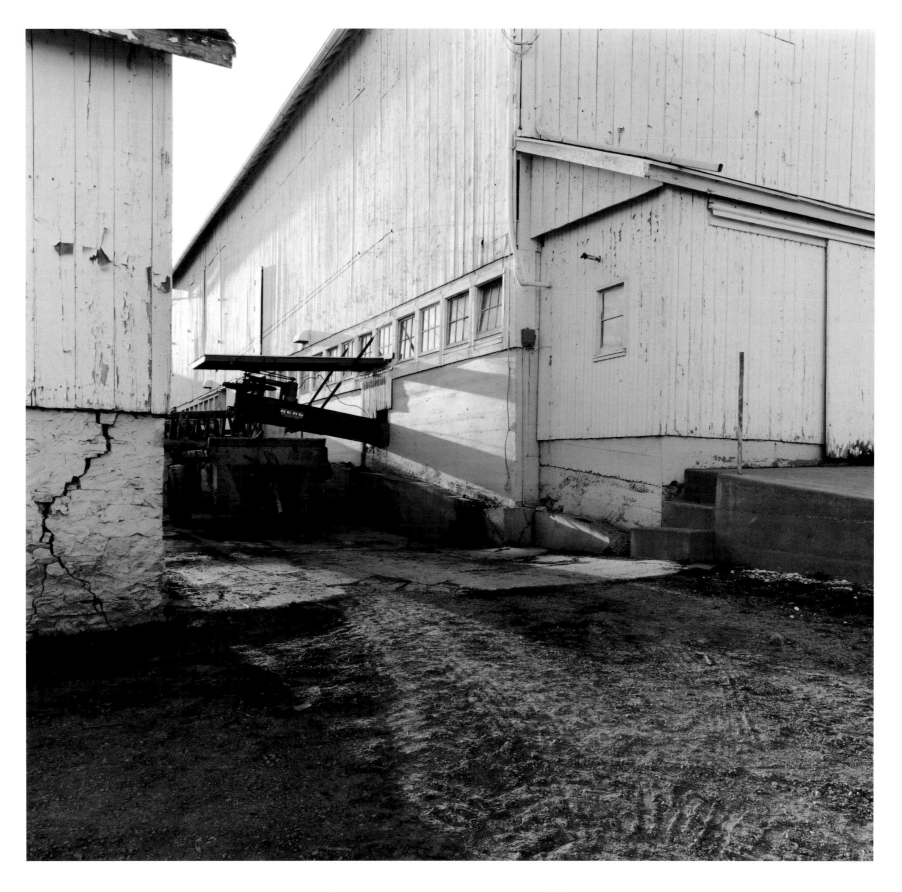

76 · Near Brodhead, Green County, Wisconsin (2000)

77 · Orfordville, Rock County, Wisconsin (2000)

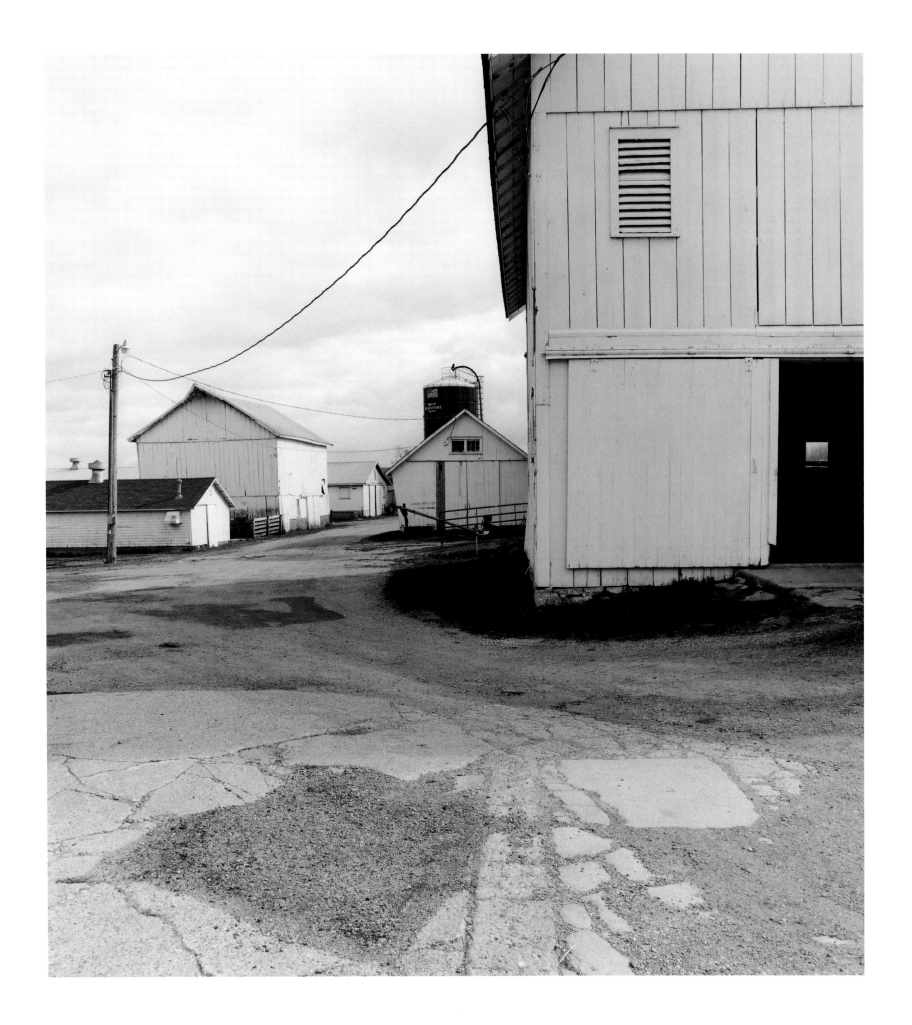

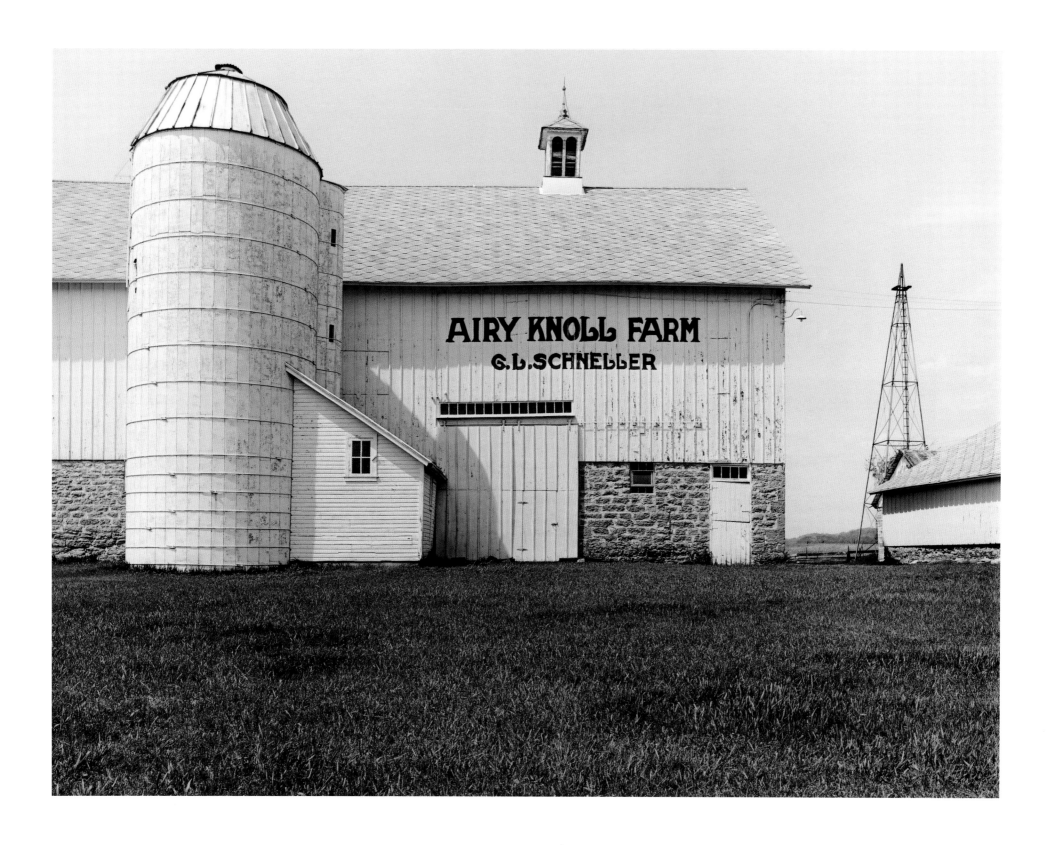

78 · Honey Creek Township, Sauk County, Wisconsin (2002)

79 · Antrim Township, Franklin County, Pennsylvania (2002)

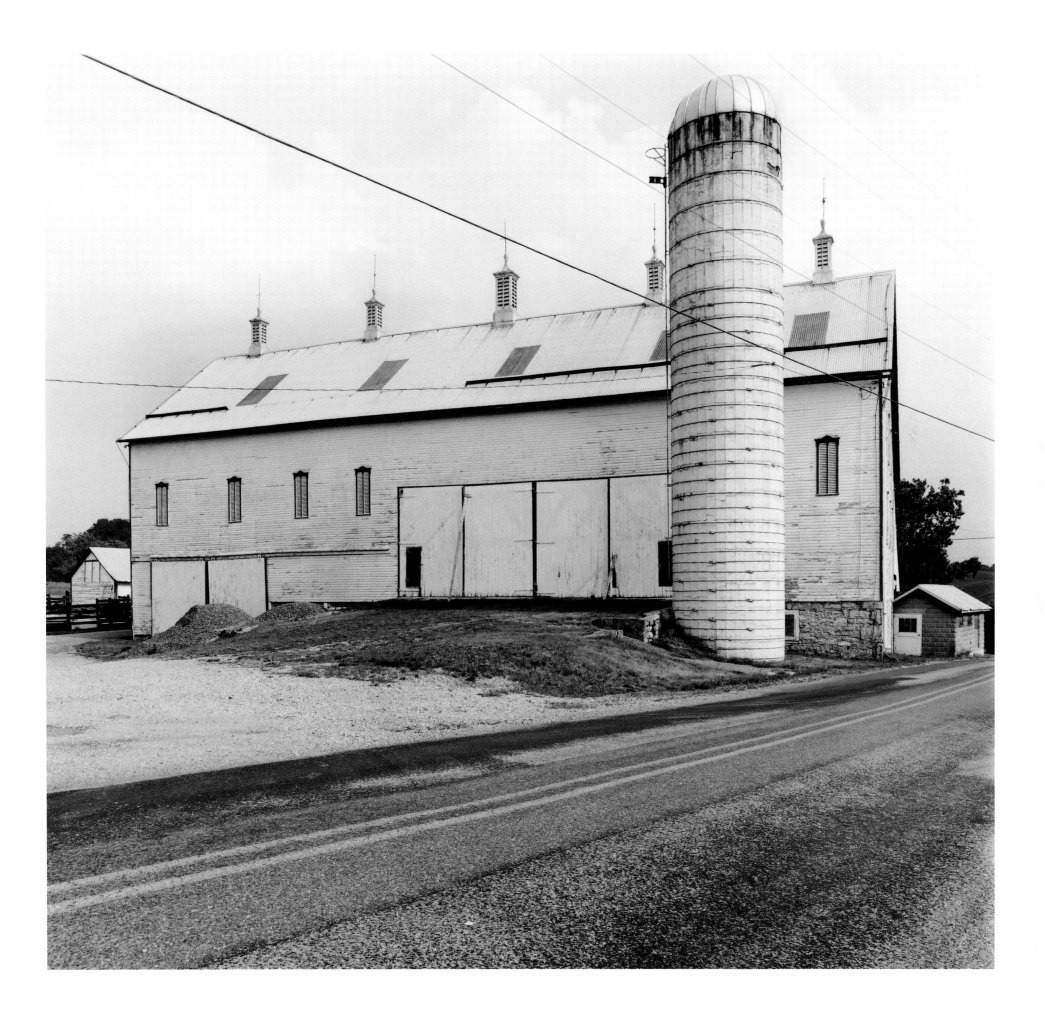

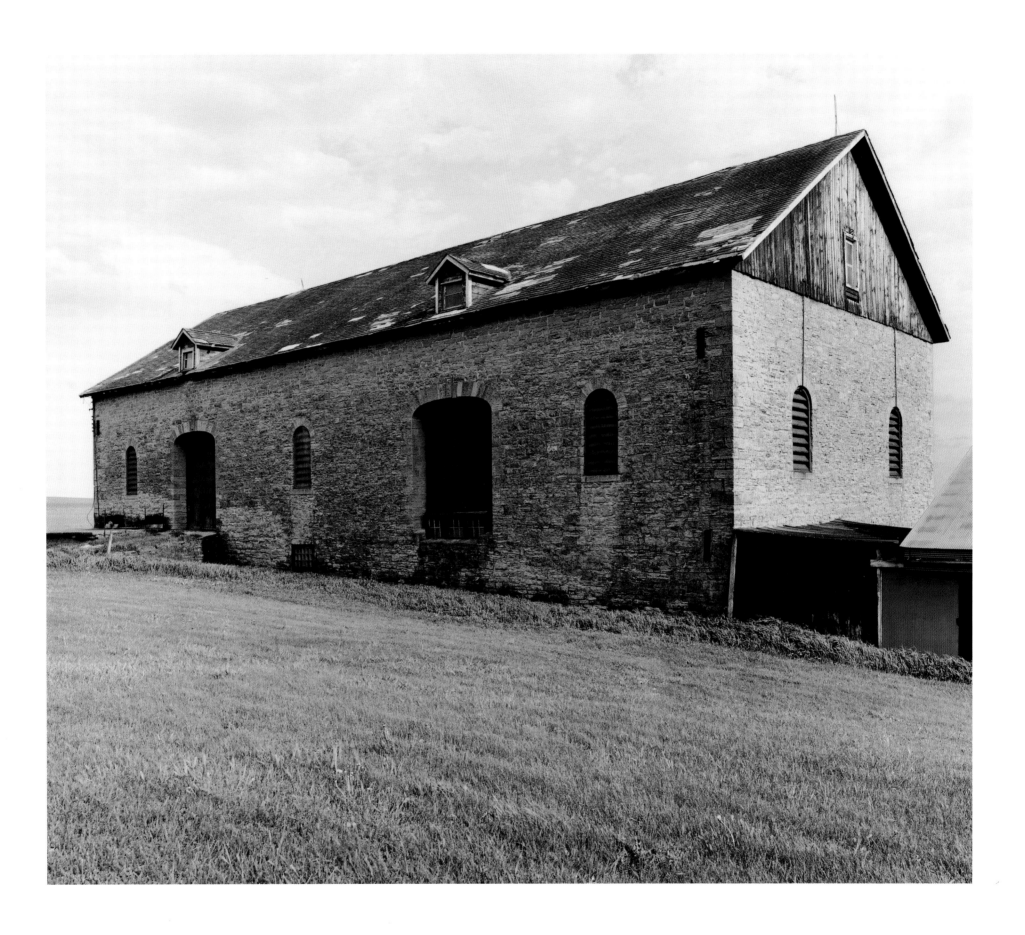

80 · Barneveld, Iowa County, Wisconsin (2002)

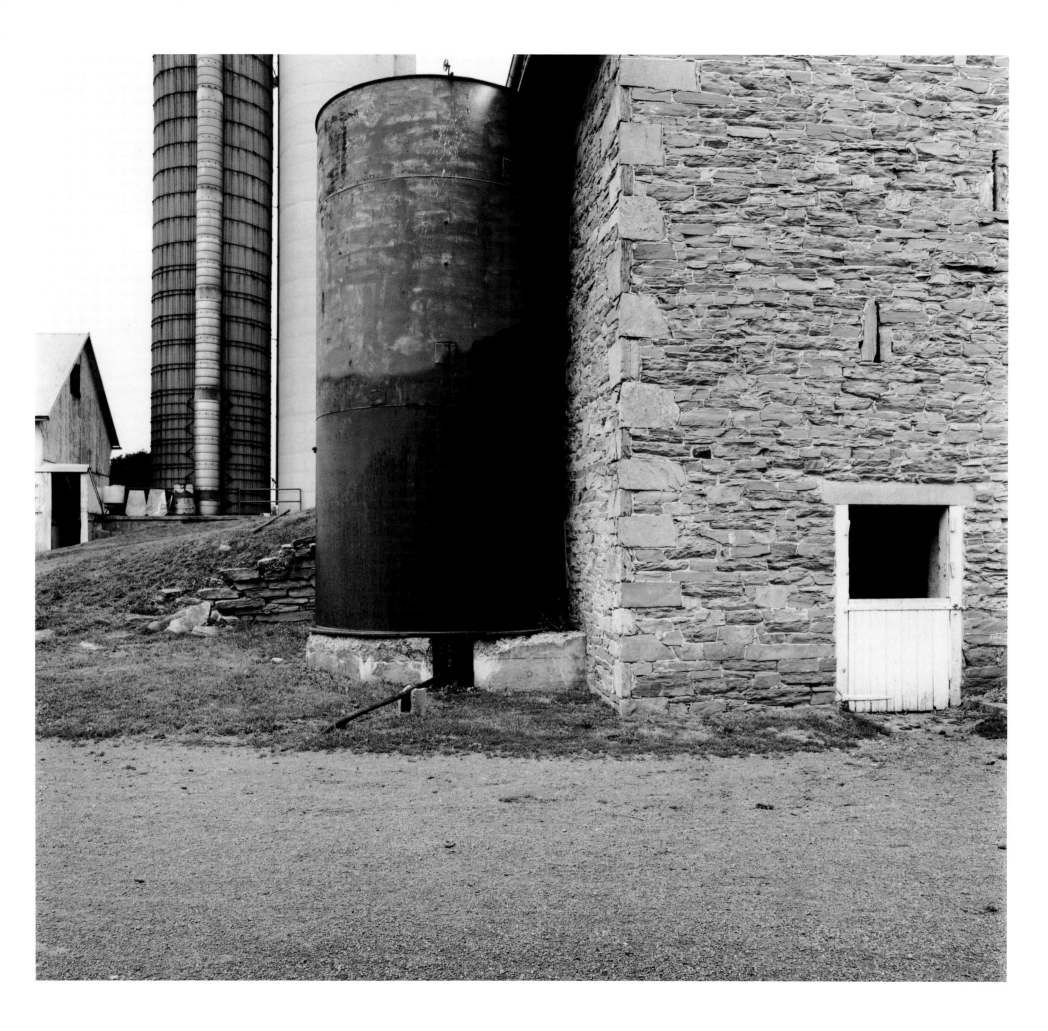

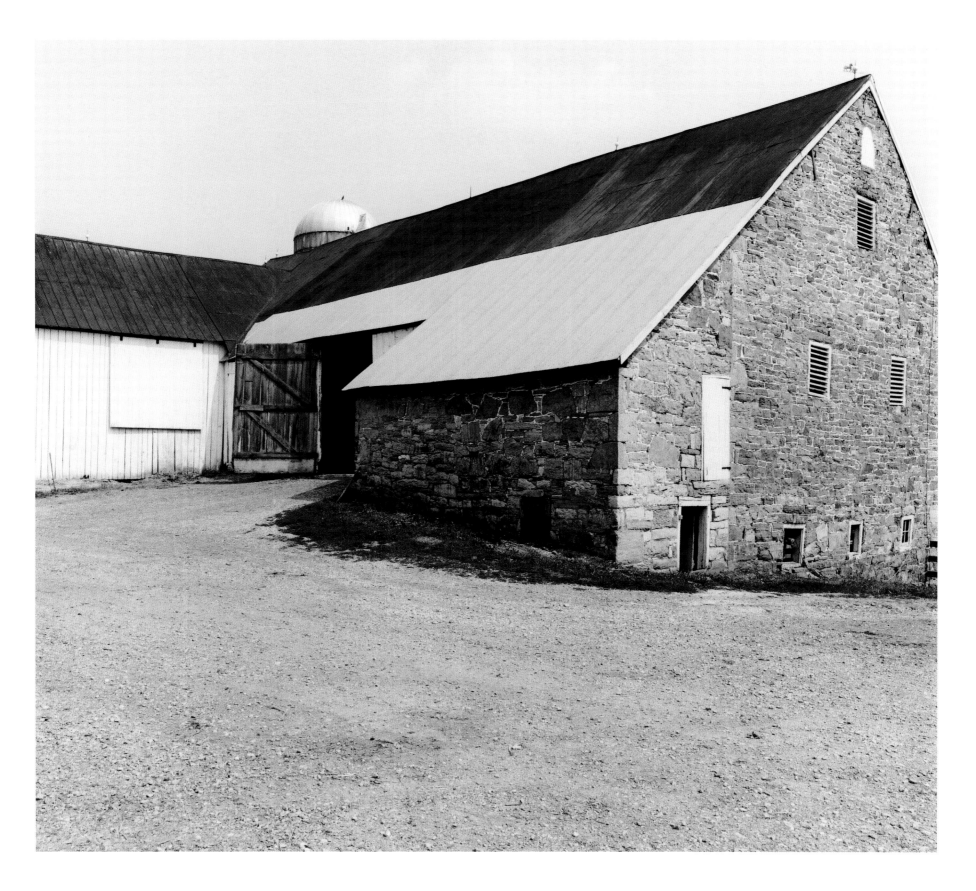

81 · Heidelberg Township, Lebanon County, Pennsylvania (2002)

82 · Quincy Township, Franklin County, Pennsylvania (2002)

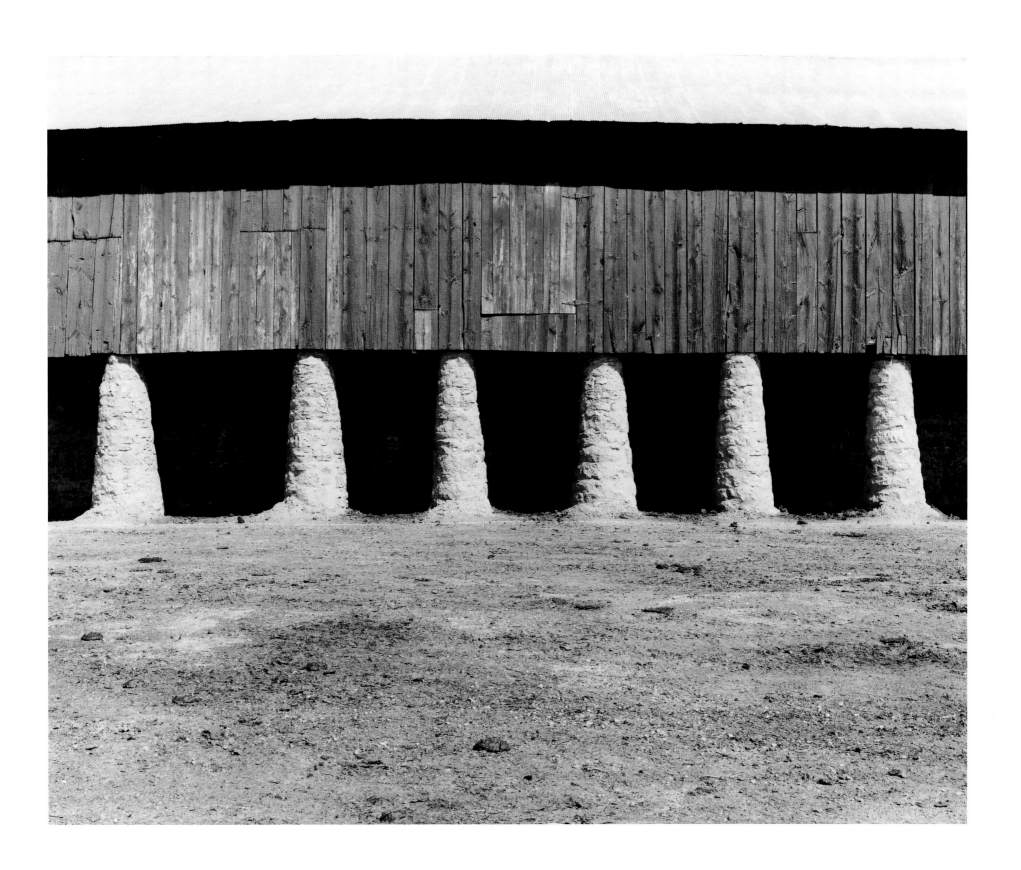

83 · White Oak Springs Township, Lafayette County, Wisconsin (2000)

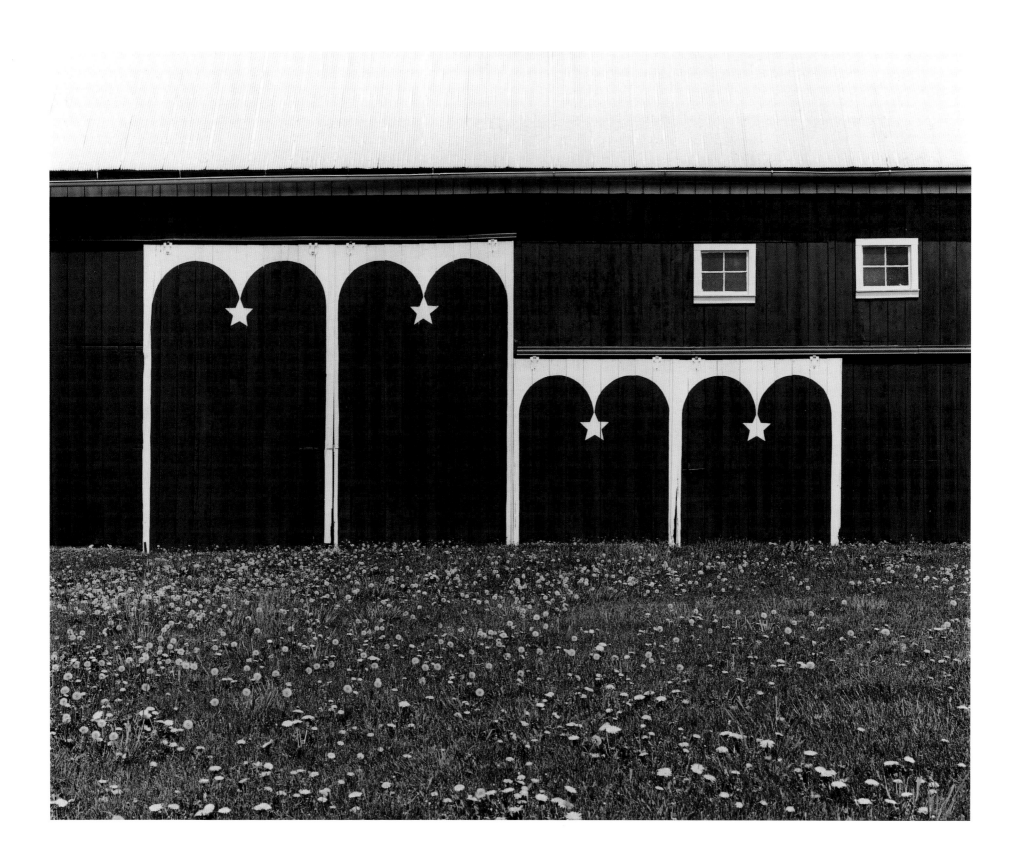

84 · Northwest Township, Williams County, Ohio (2000)

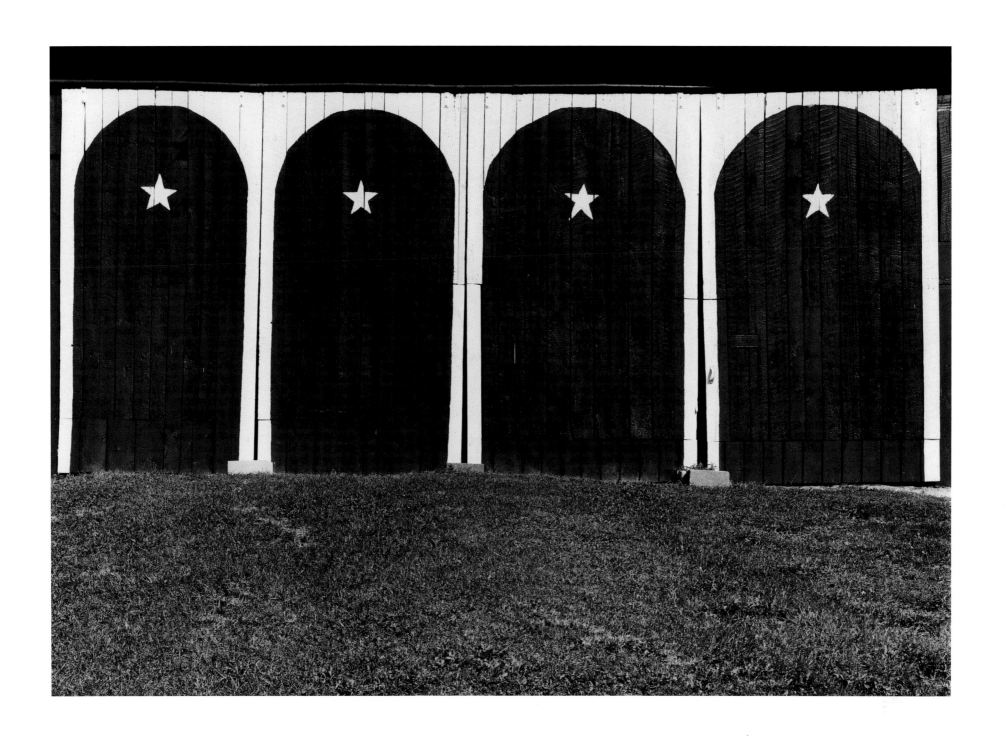

85 · Near Weidman, Isabella County, Michigan (1999)

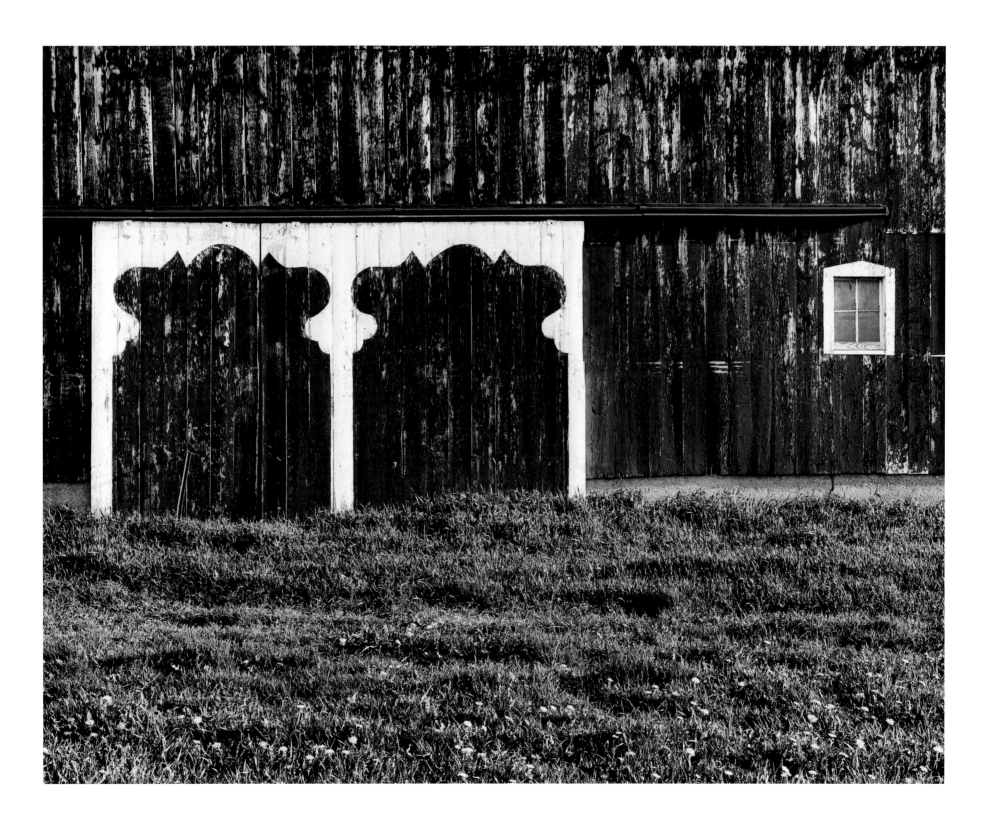

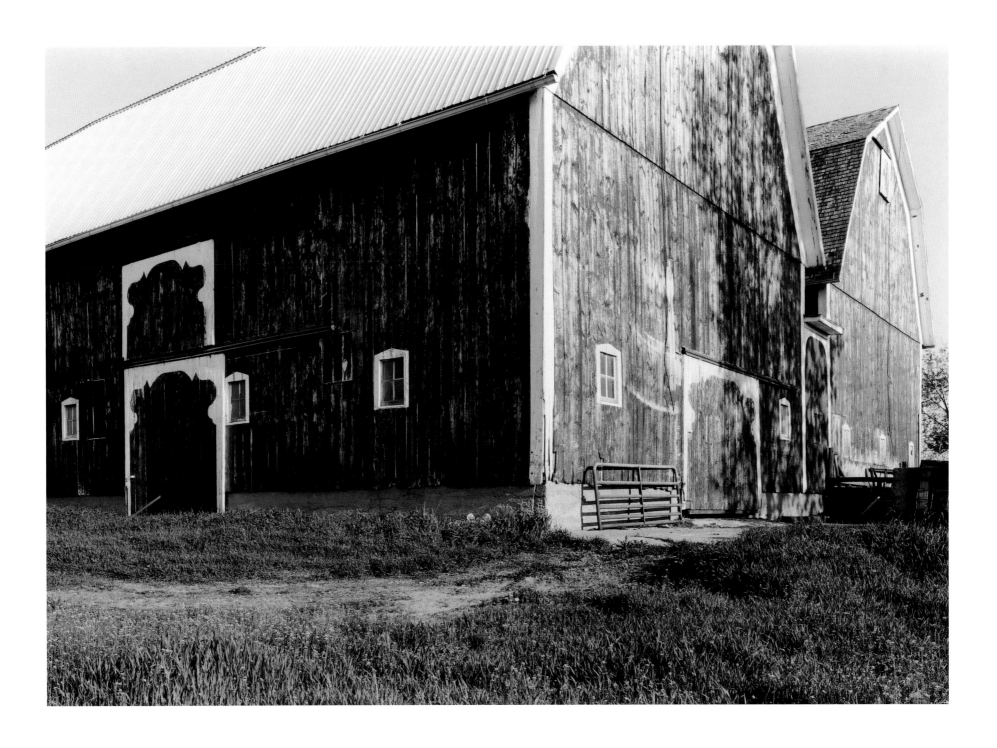

86 & 87 · Near Wauseon, Fulton County, Ohio (2000)

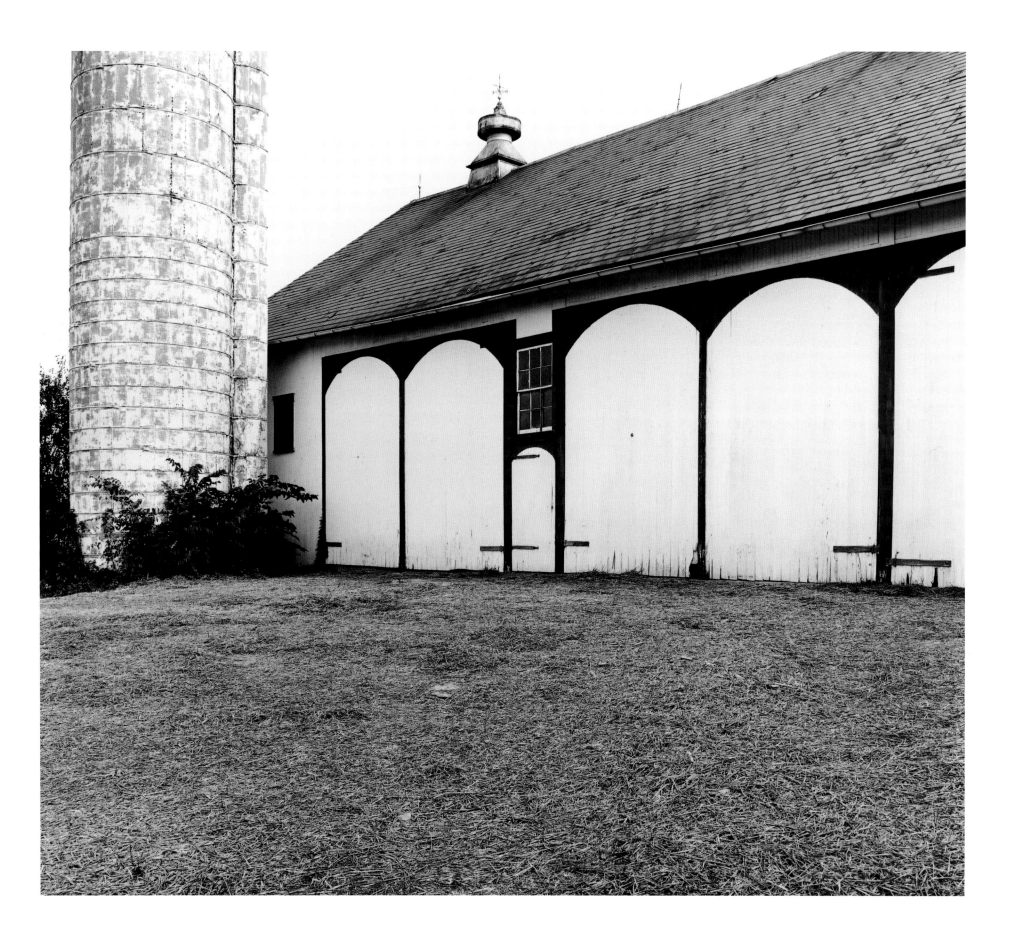

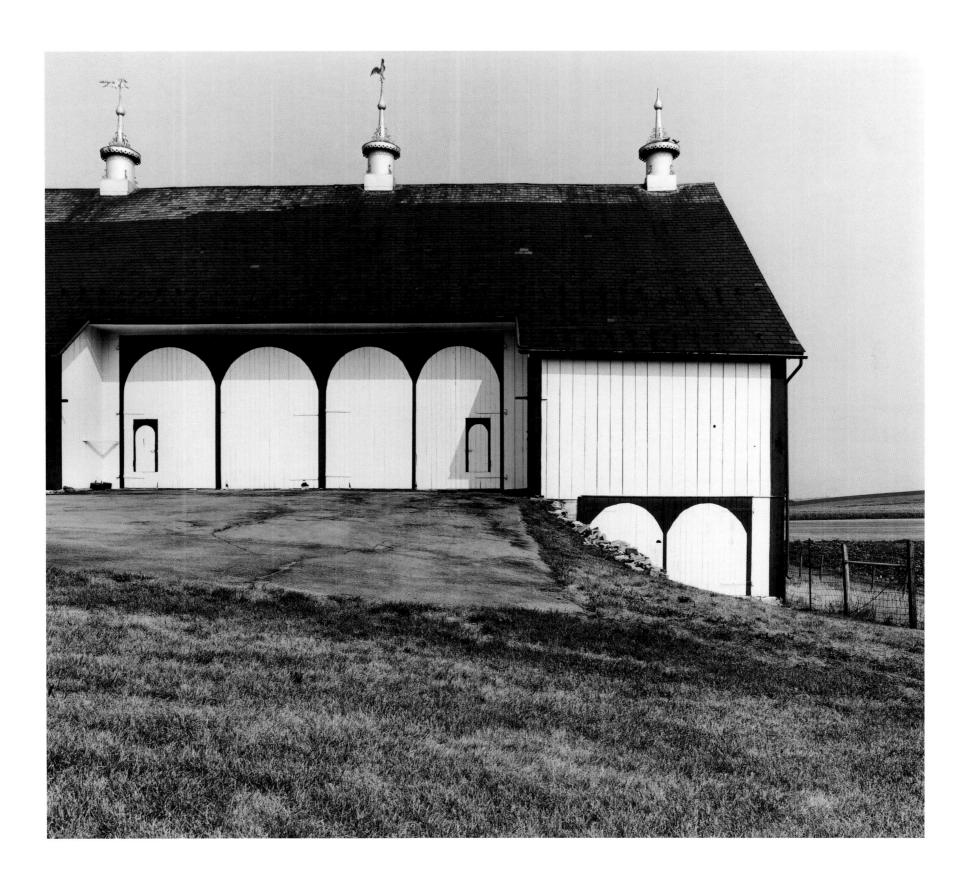

88 · Quincy Township, Franklin County, Pennsylvania (2002)

89 · Shady Grove, Amtrim Township, Pennsylvania (2002)

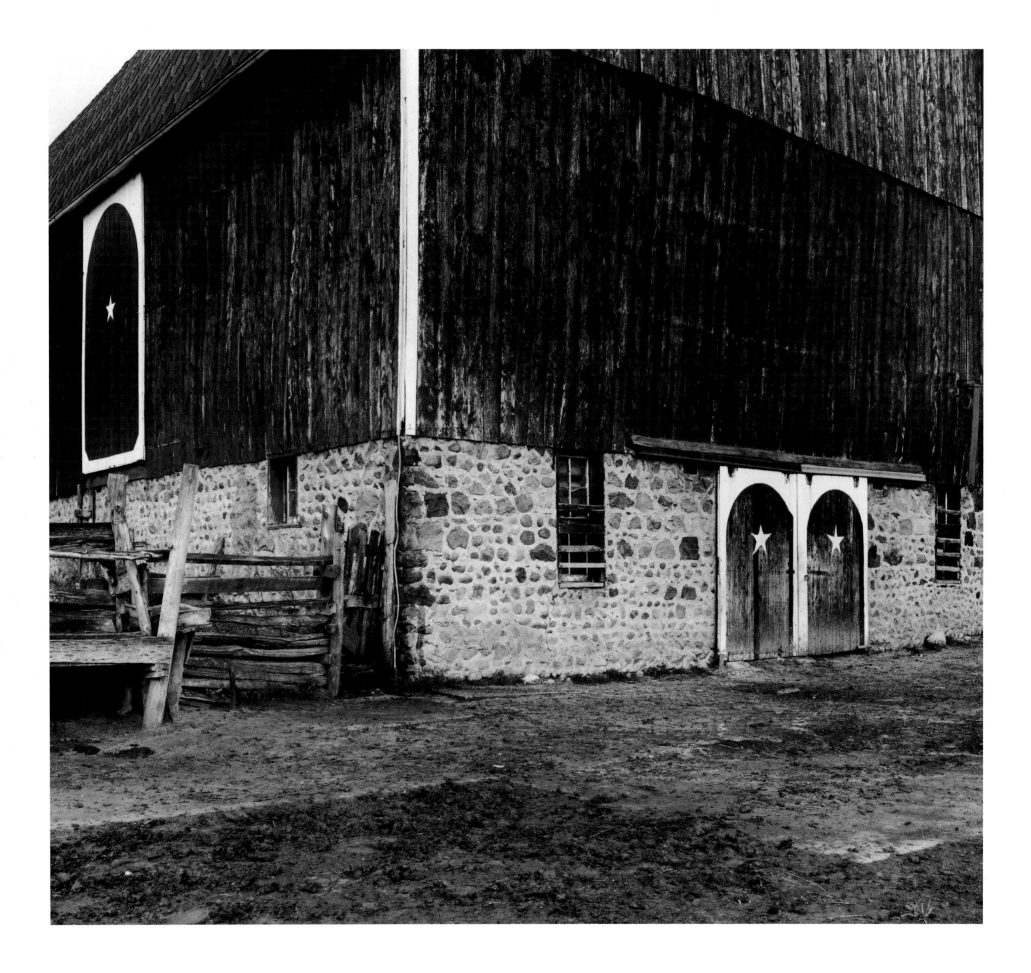

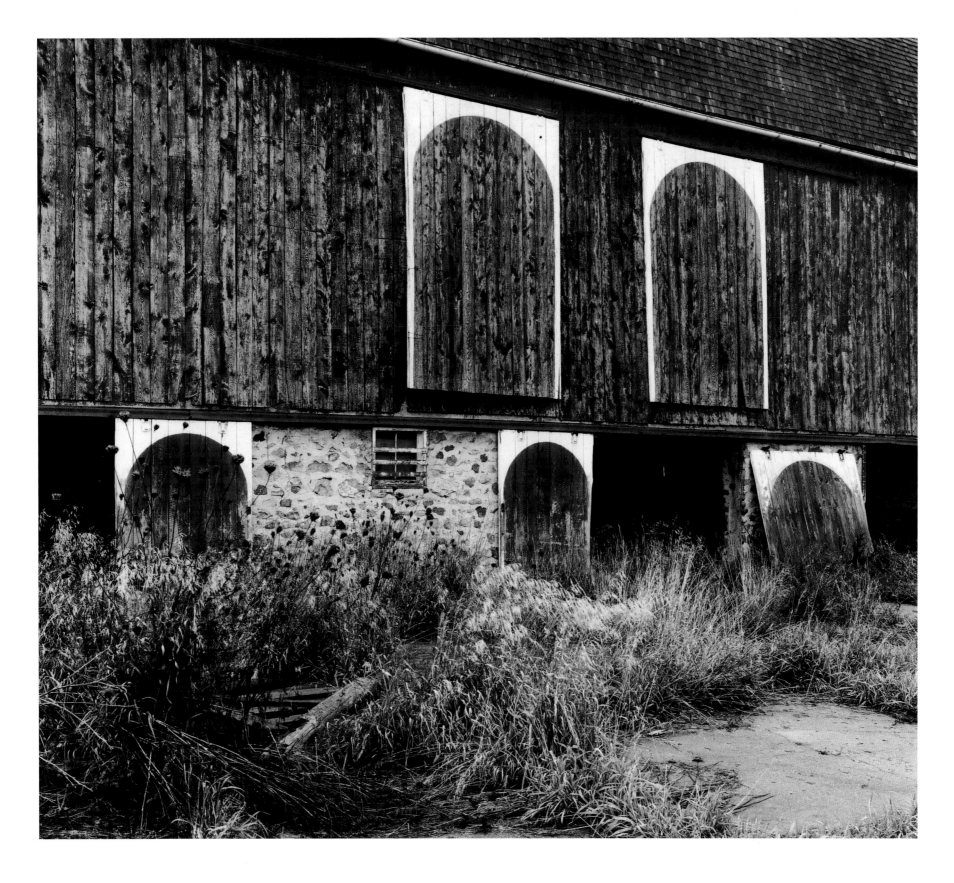

90 · Isabella County, Michigan (1975)

91 · Clare County, Michigan (1975)

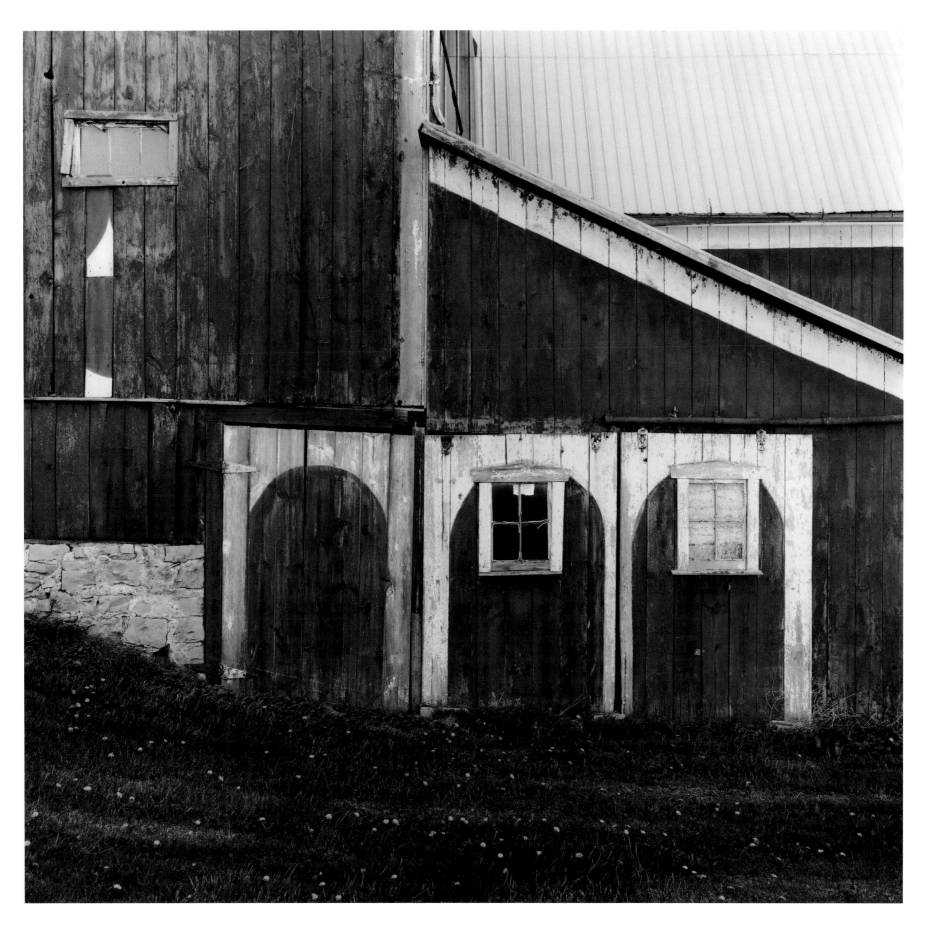

92 · Near Tedrow, Fulton County, Ohio (2000)

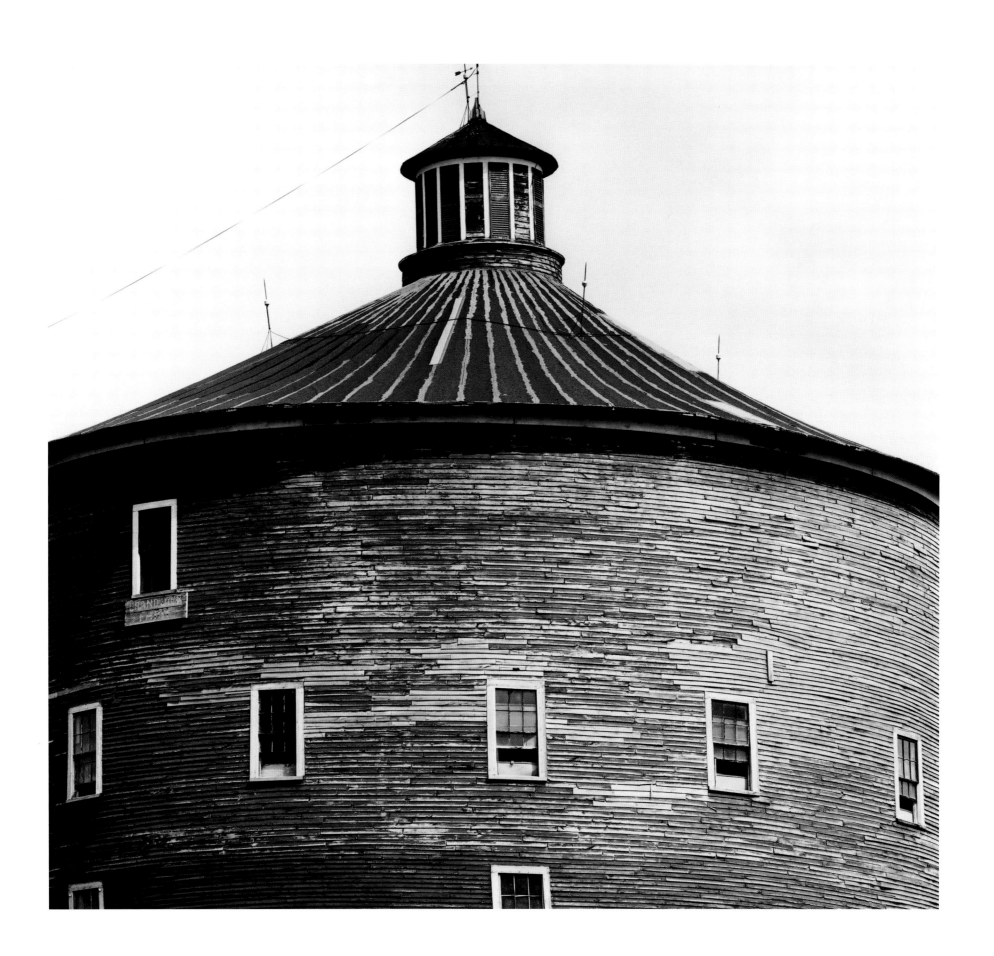

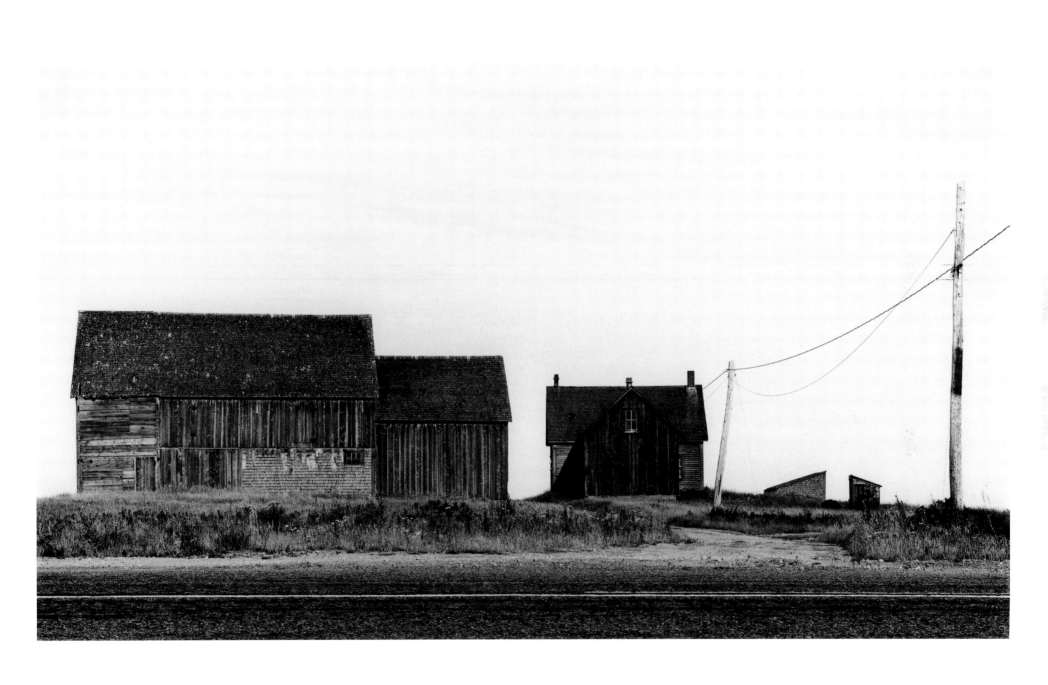

93 · Near East Calais, Washinton County, Vermont (1965)

94 · Cap Lumiere, New Brunswick (1969)

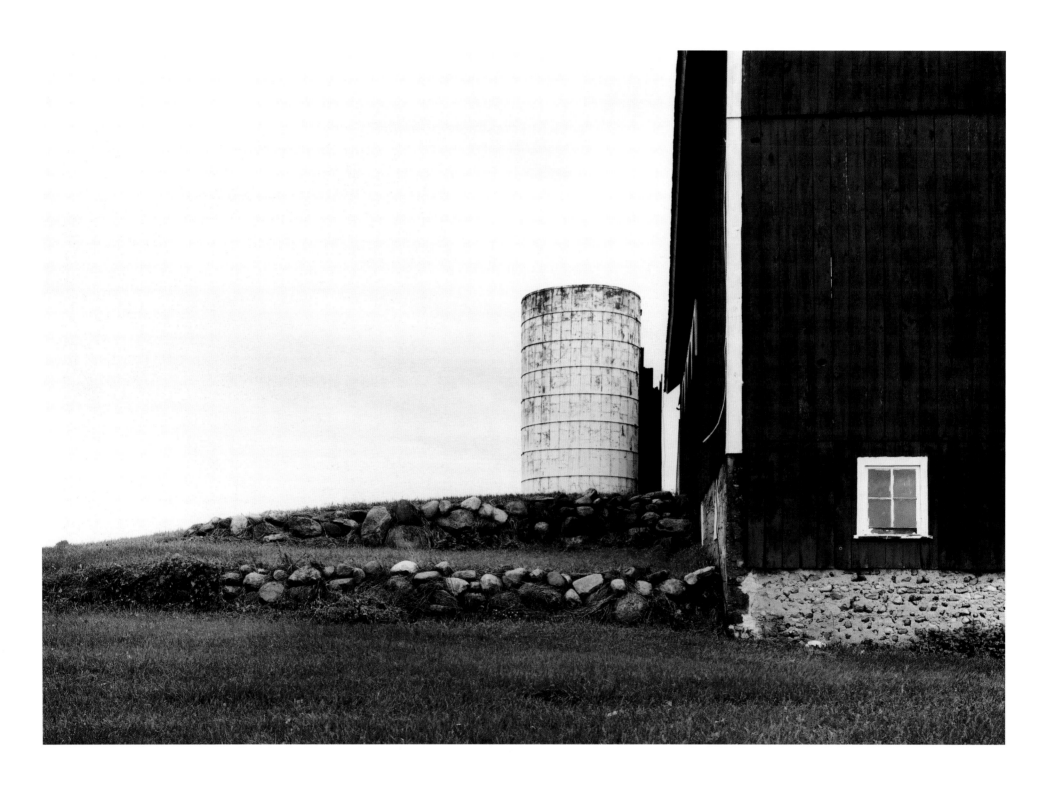

95 · Isabella County, Michigan (1975)

96 · Richland Township, Fulton County, Indiana (2000)

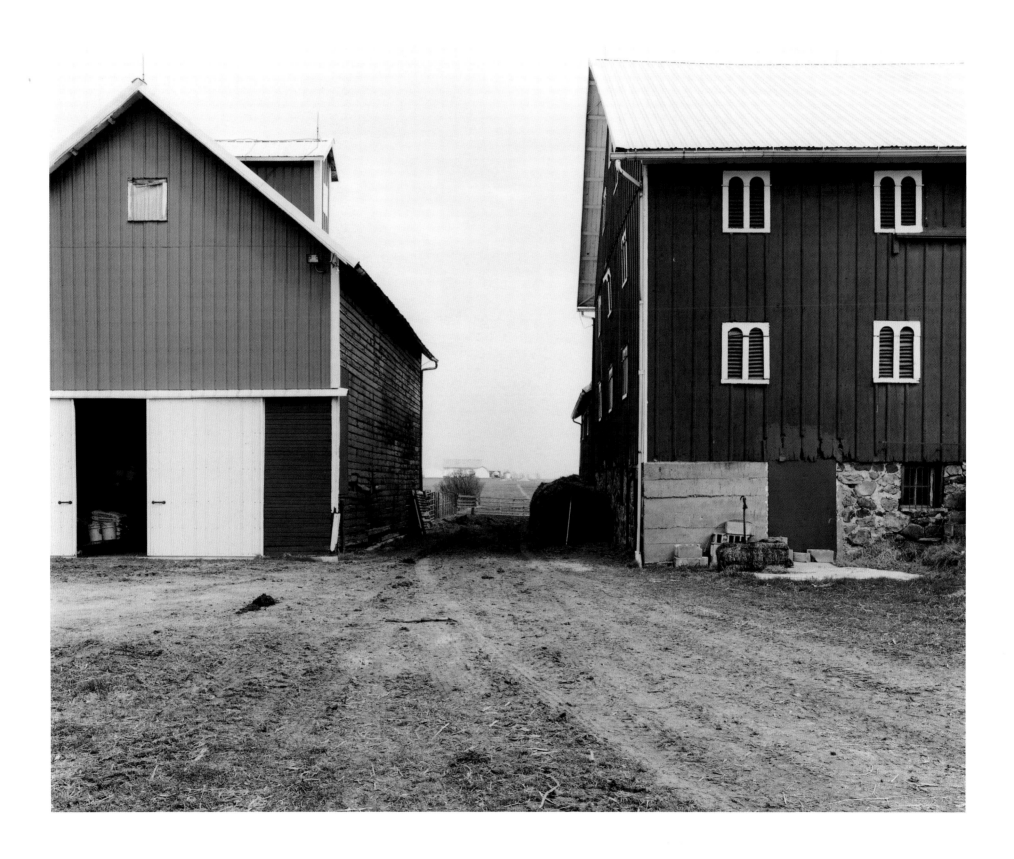

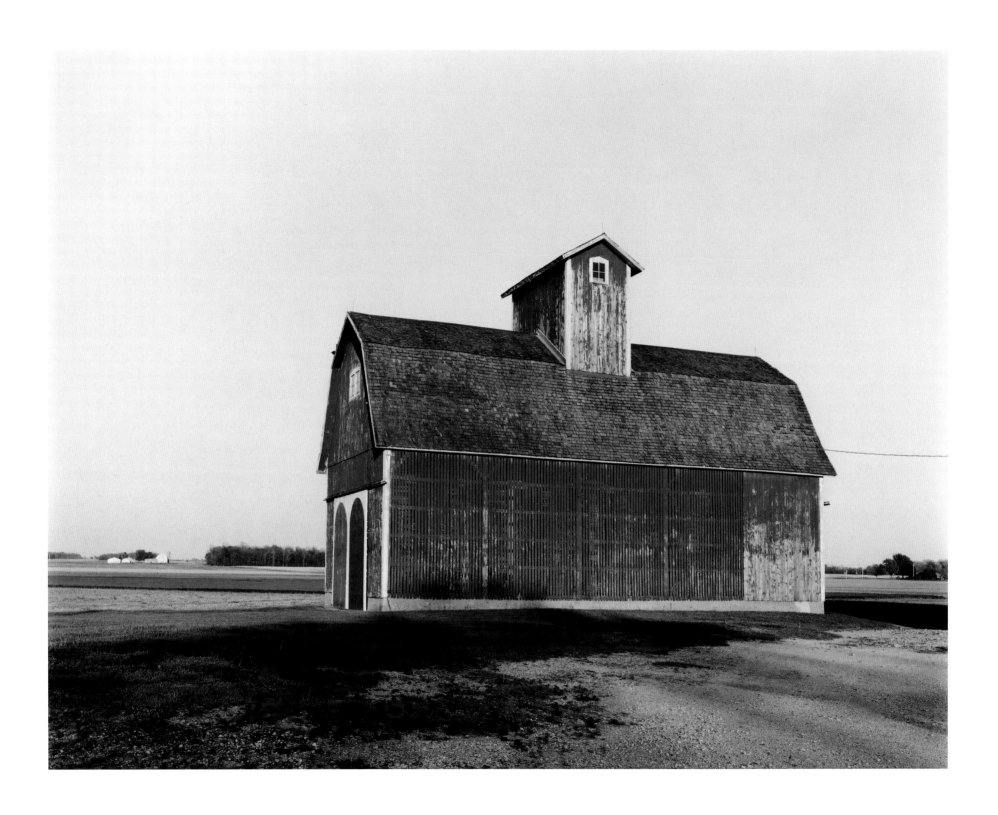

97 · Near Wauseon, Fulton County, Ohio (2000)

98 · Saint Joseph Township, Williams County, Ohio (2000)

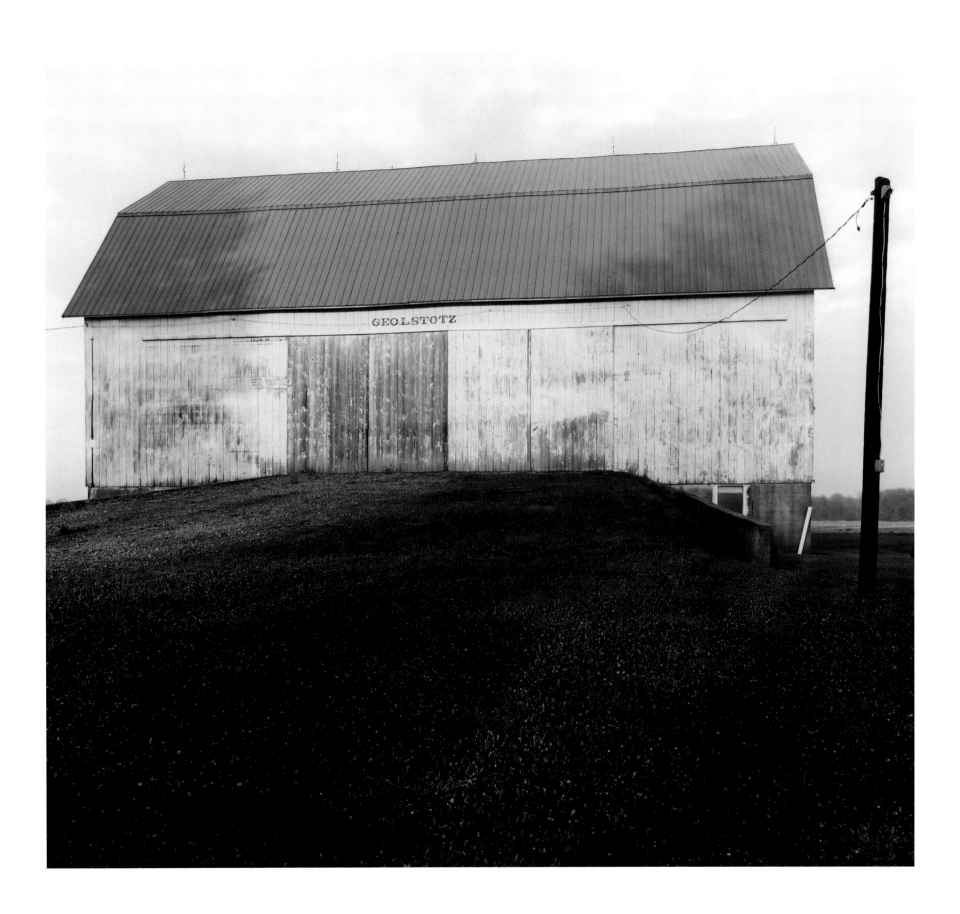

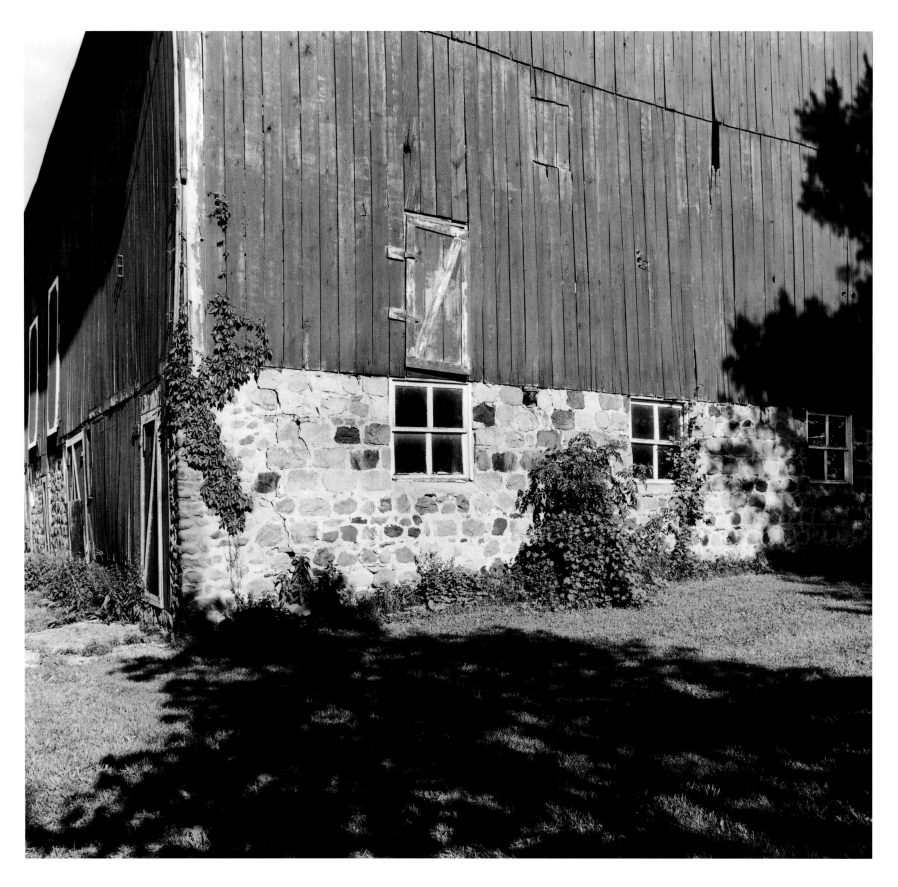

99 · Near Bowe Center, Kent County, Michigan (1999)

100 · Clare County, Michigan (1975)

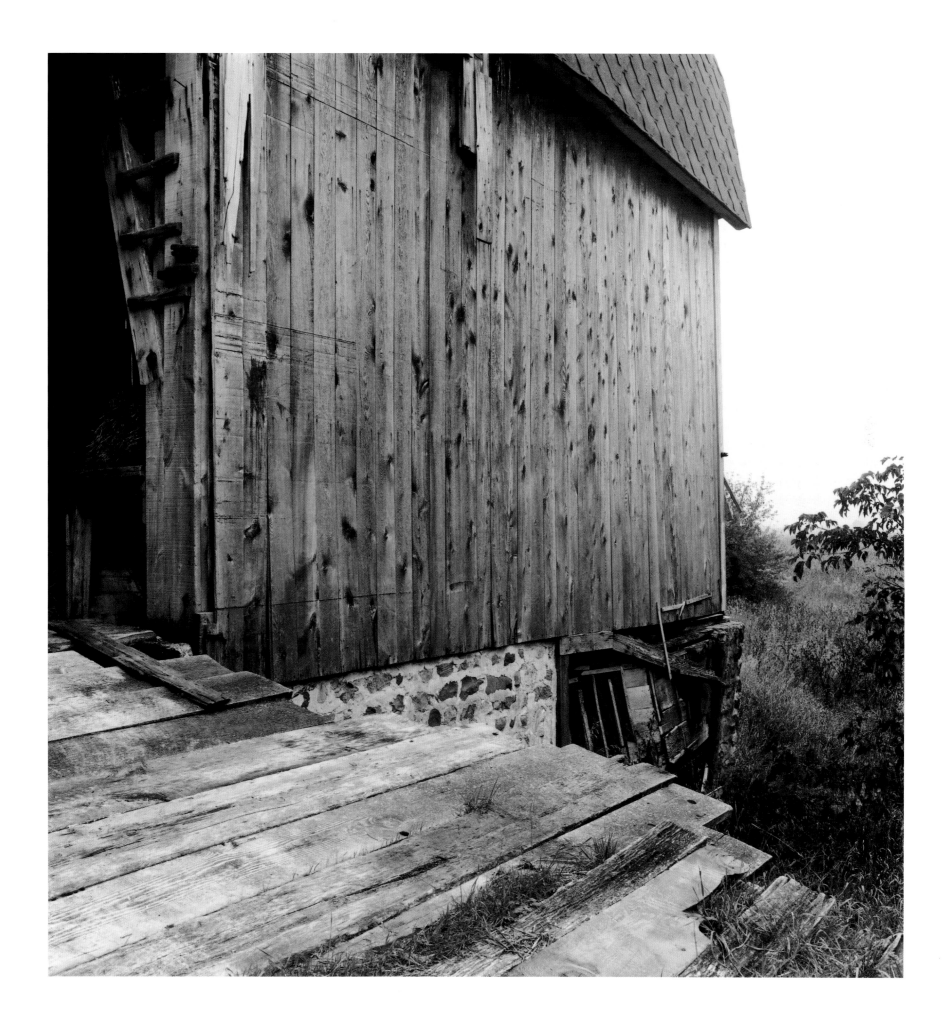

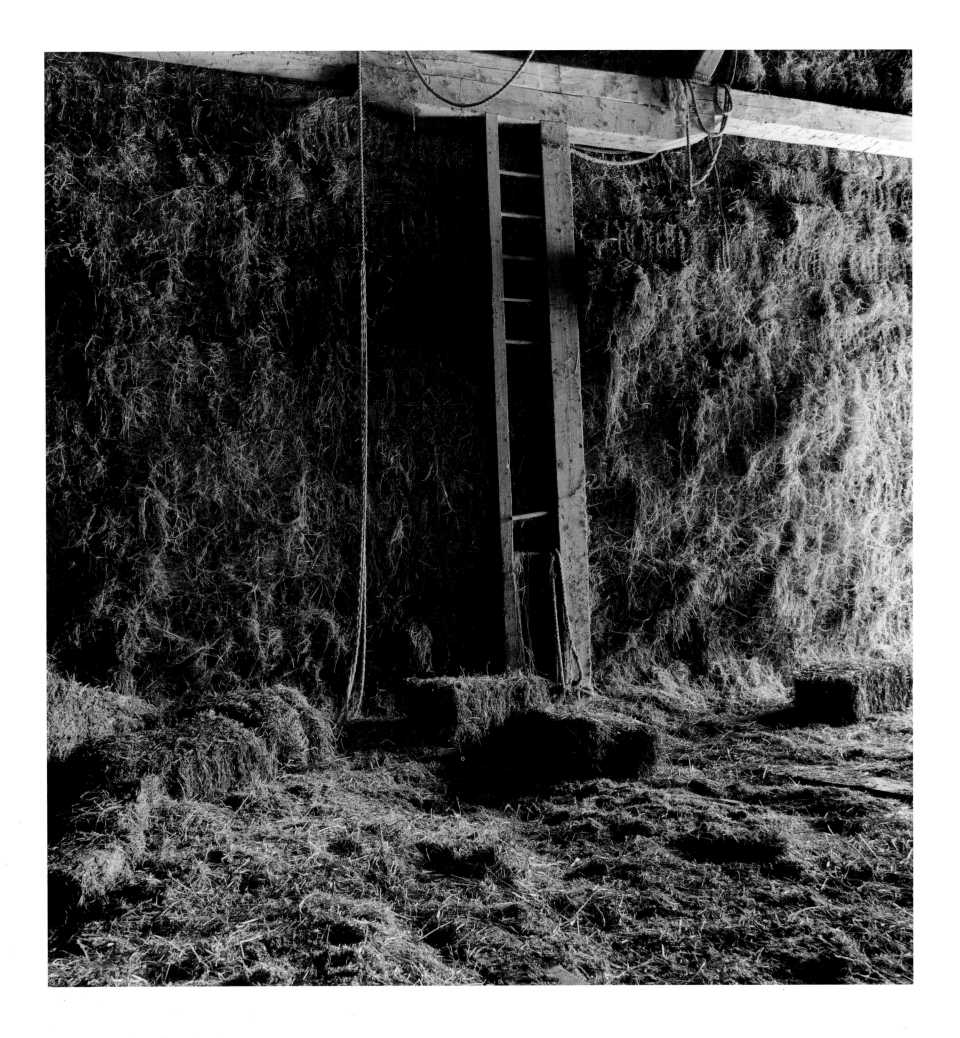

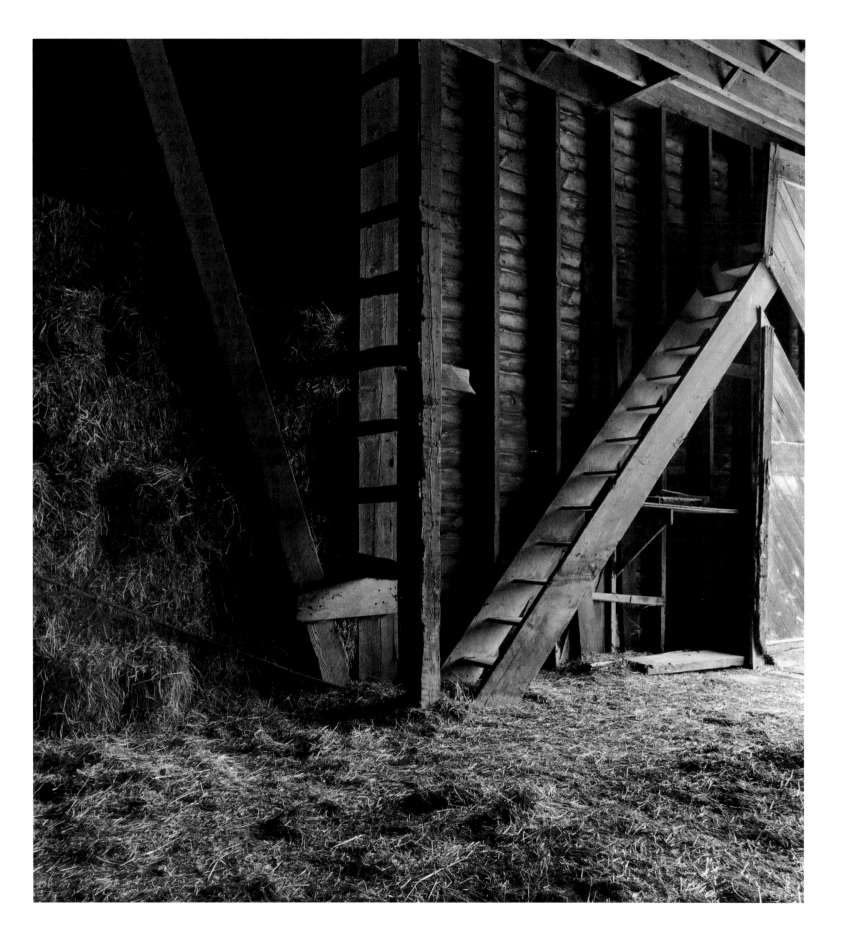

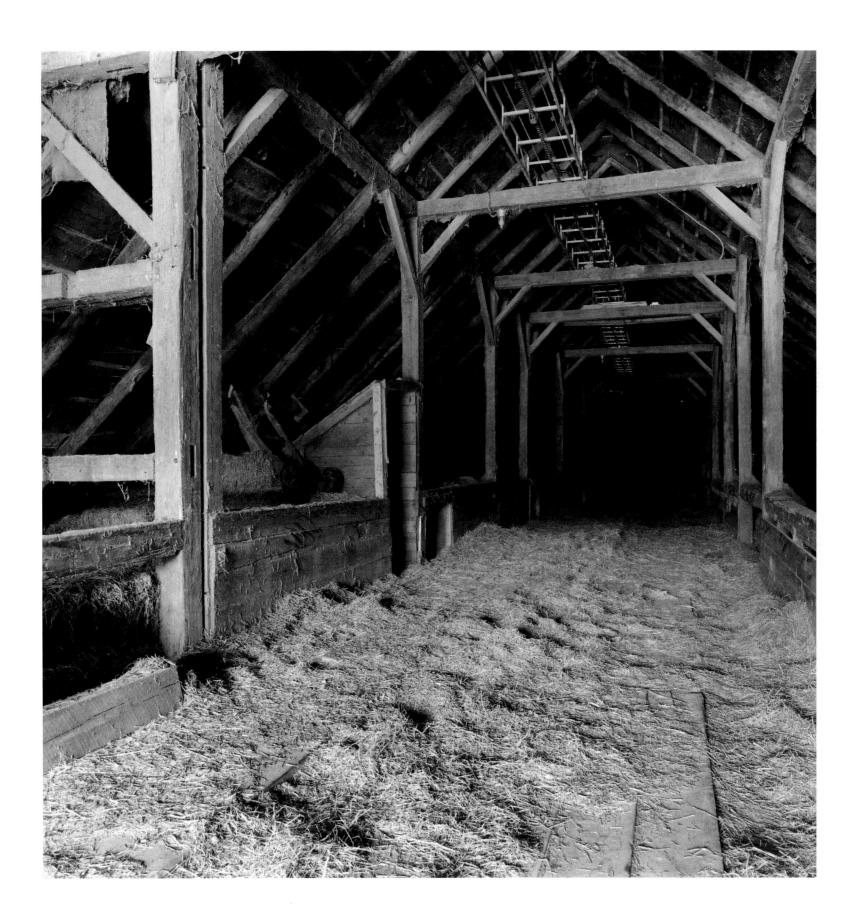

103 · Town of Newbury, Orange County, Vermont (2001)

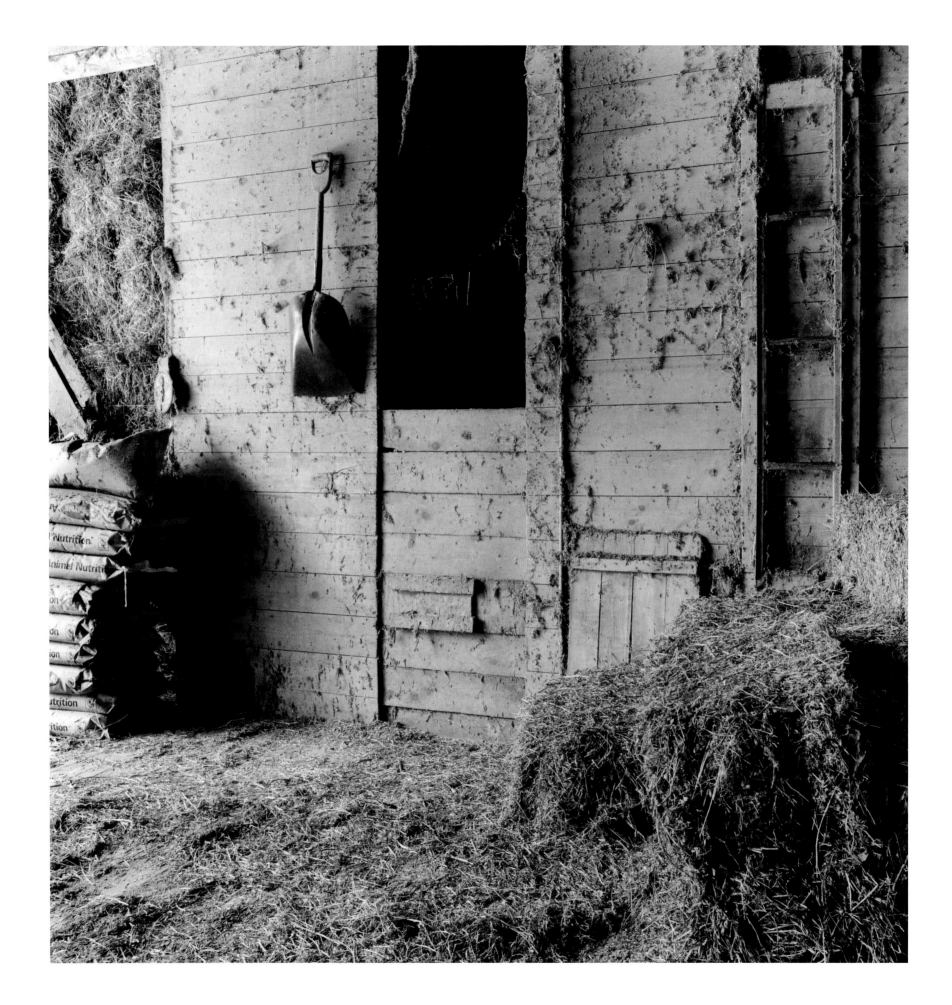

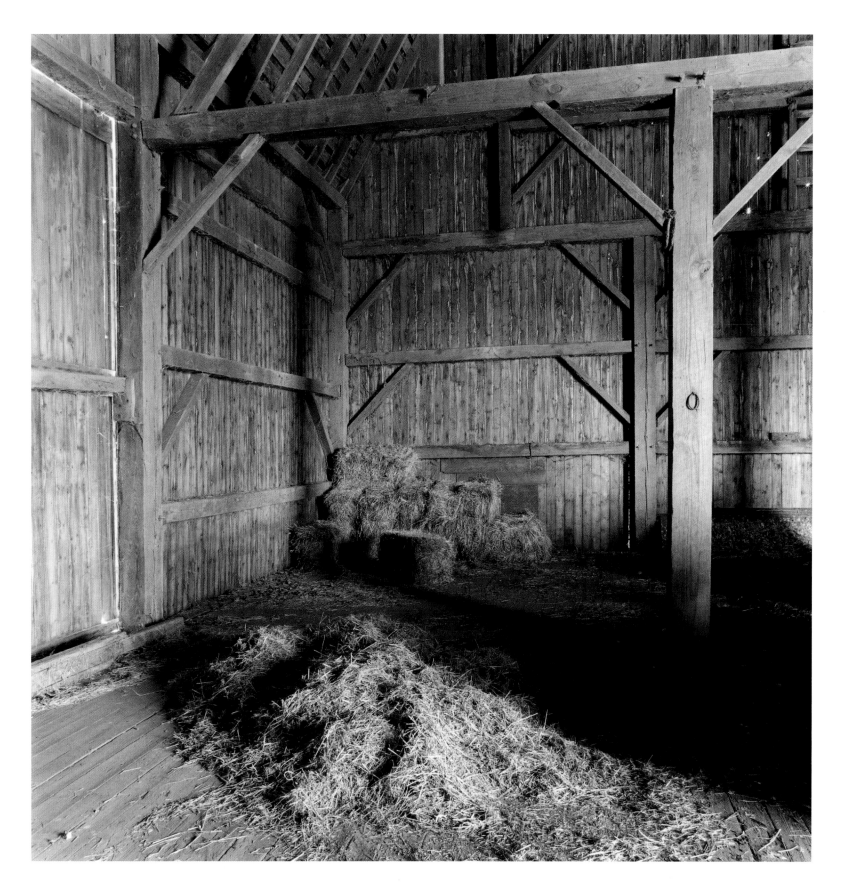

104 · Near Brodhead, Green County, Wisconsin (2000)

105 · East Clarence, Erie County, New York (2001)

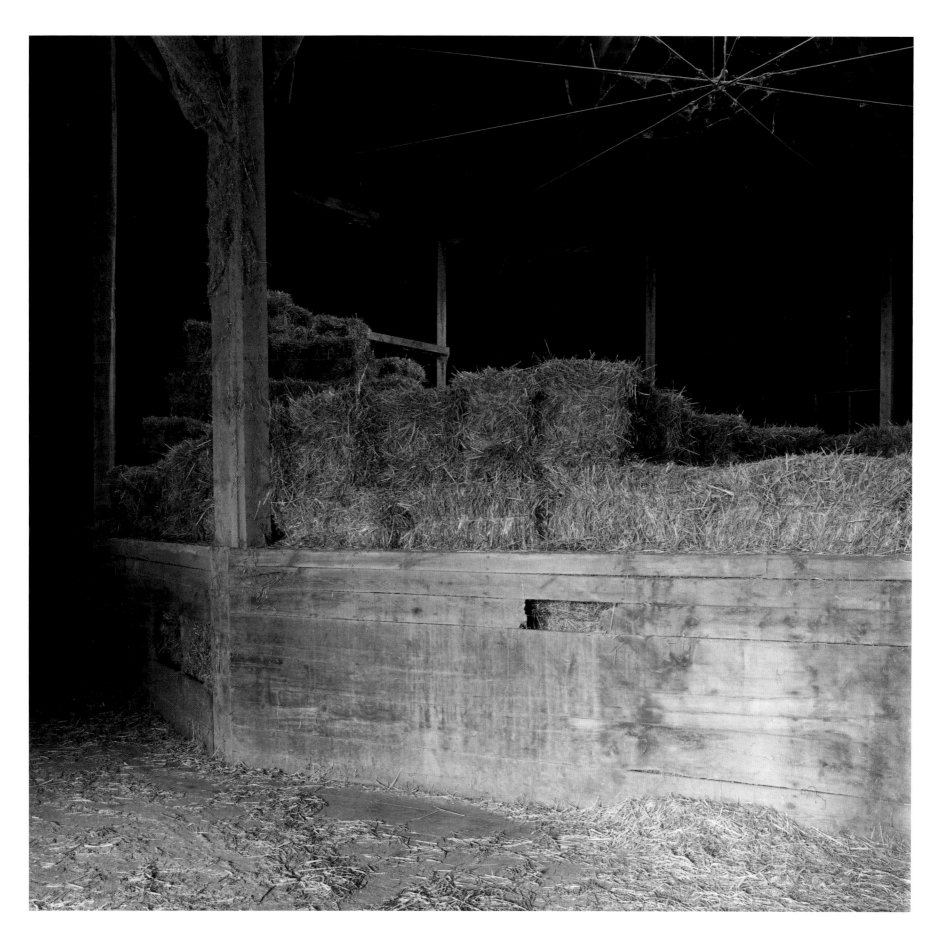

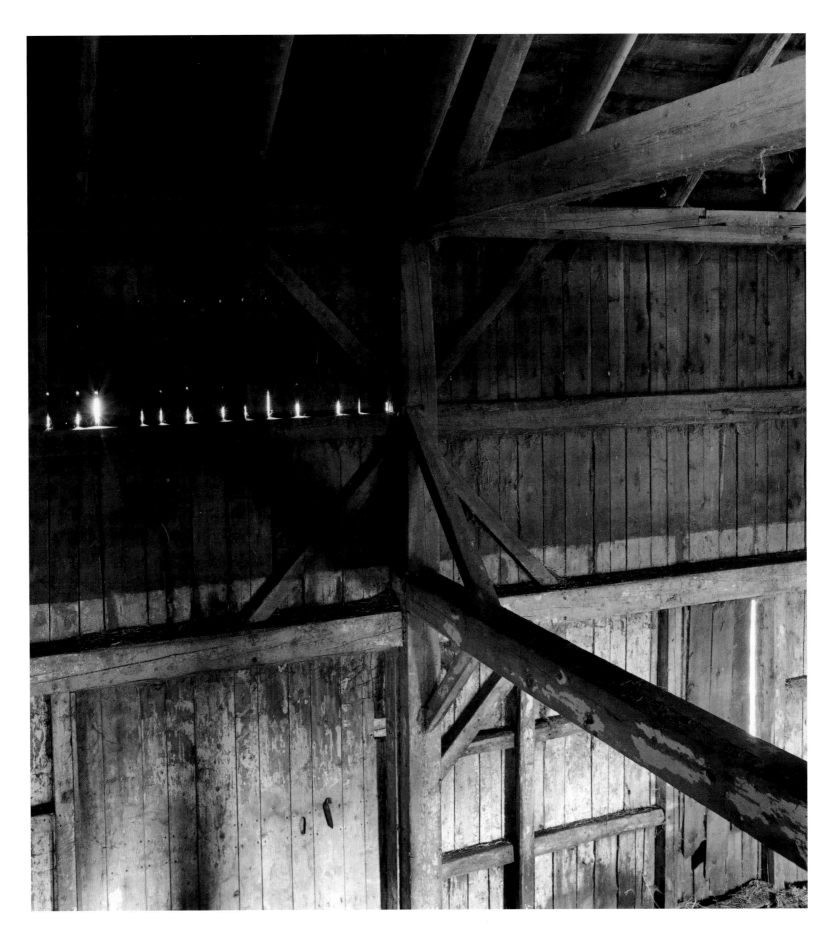

107 · Waitsfield Common, Washington County, Vermont (2001)

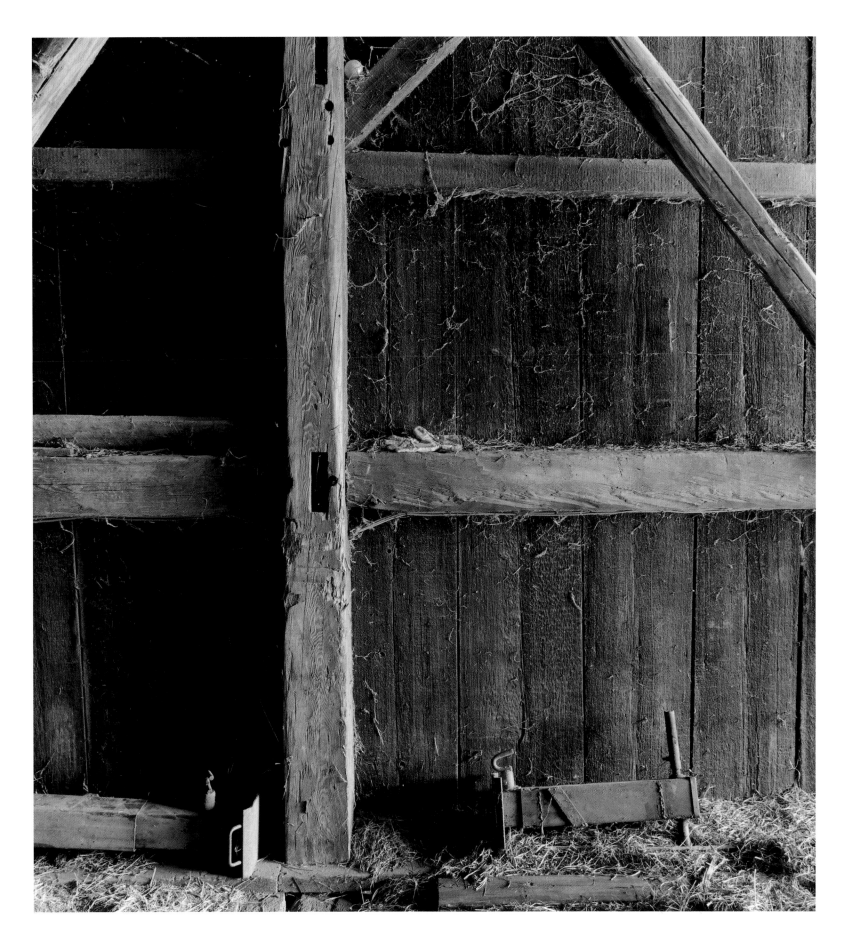

108 · Town of Newbury, Orange County, Vermont (2001)

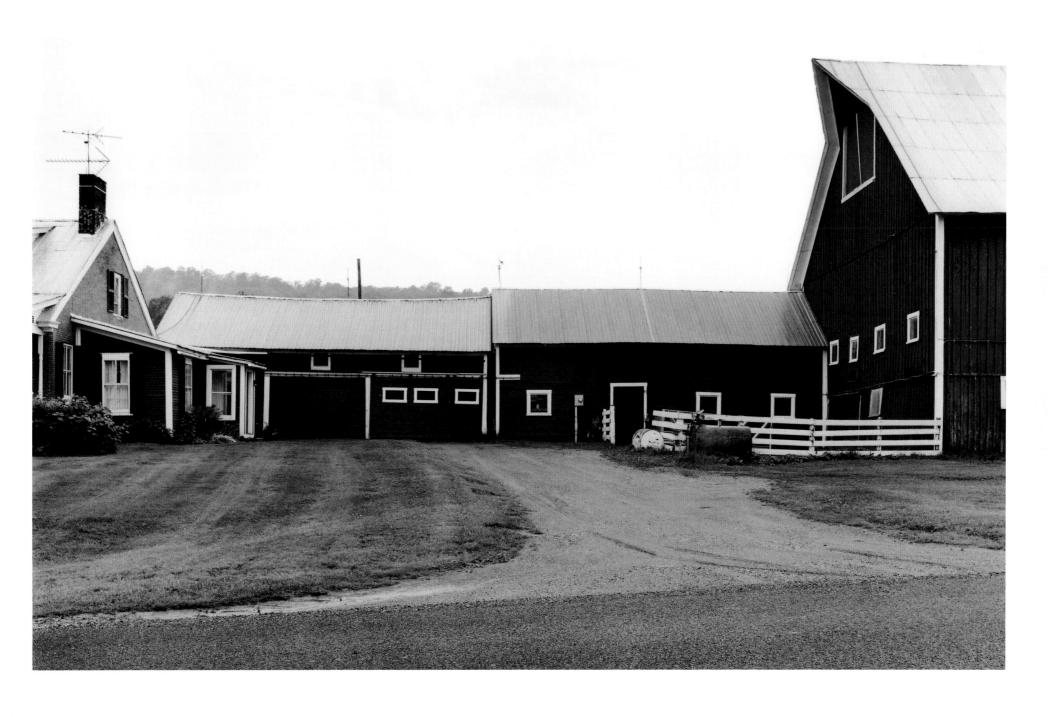

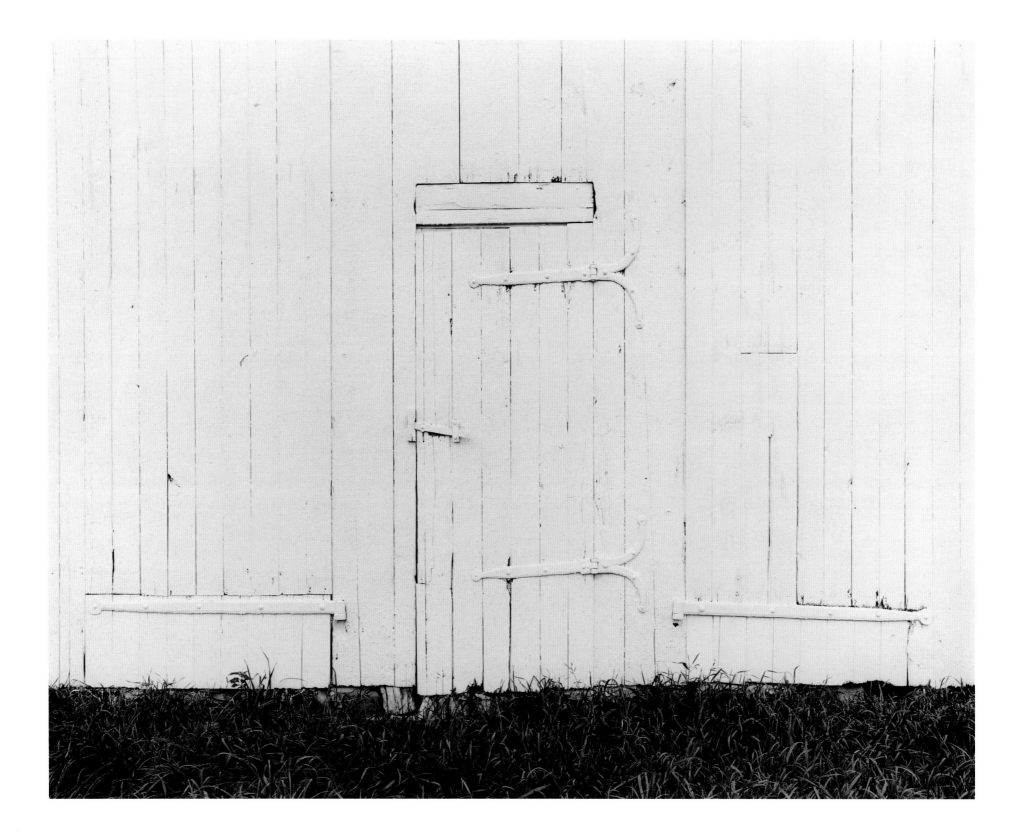

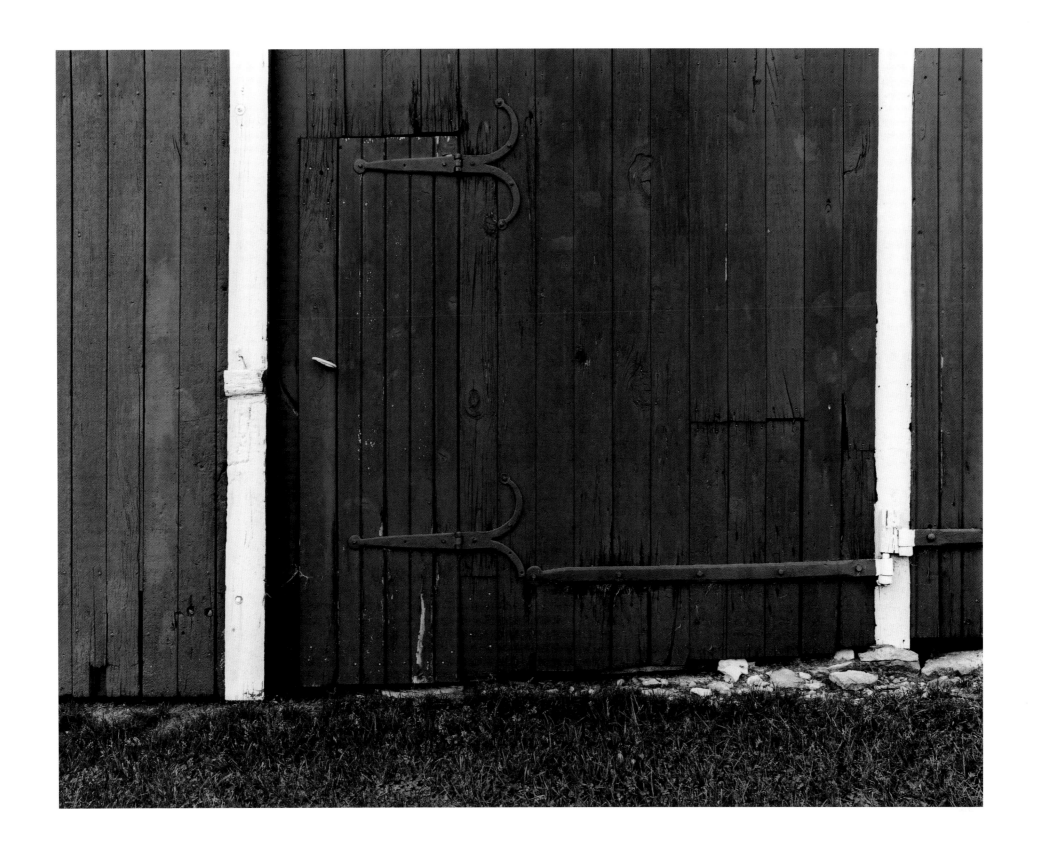

110 & 111 · Near Plainfield, Will County, Illinois (2000)

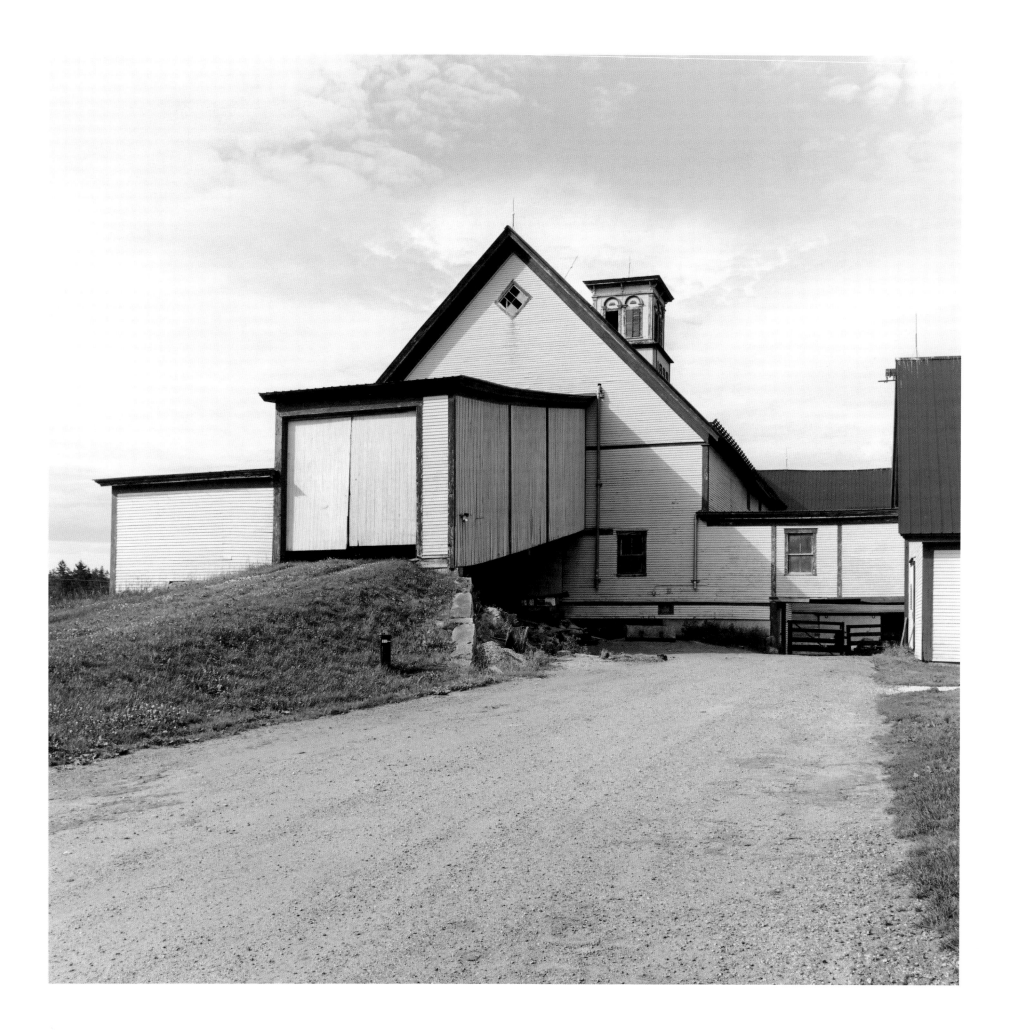

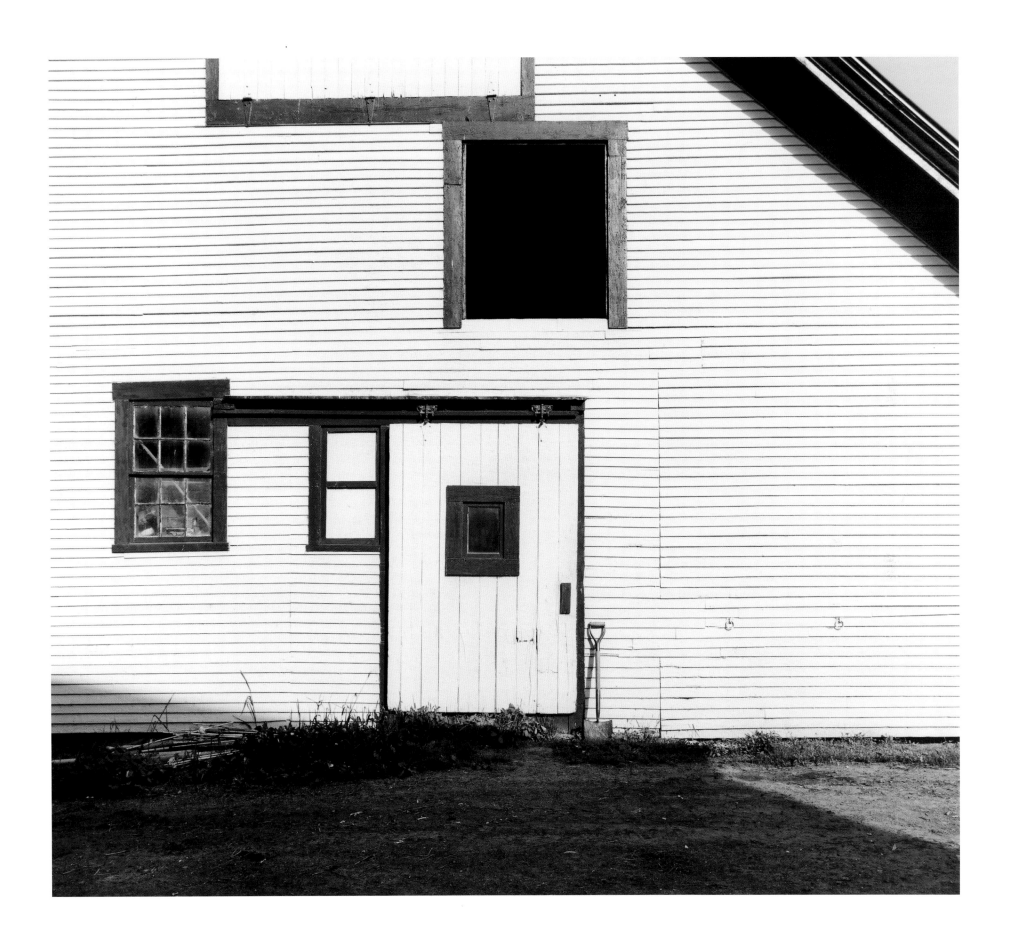

112 & 113 · Near East Montpelier, Washington County, Vermont (2001)

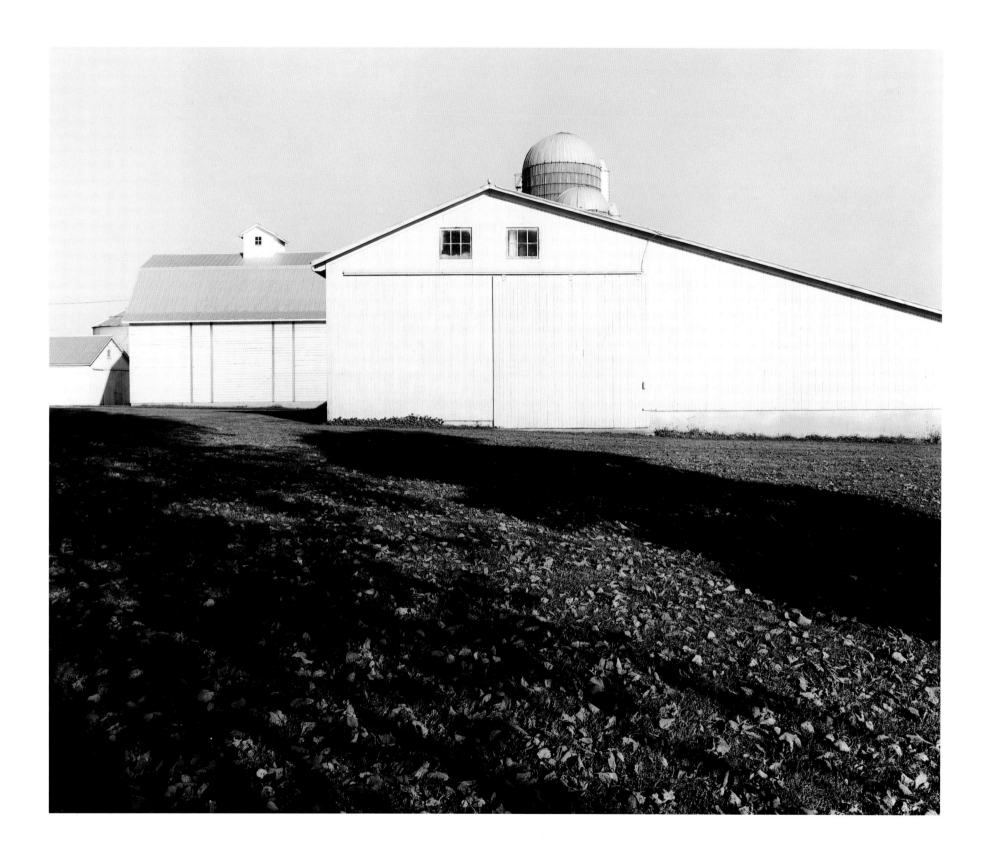

114 & 115 · Oswego Township, Kendall County, Illinois (2000)

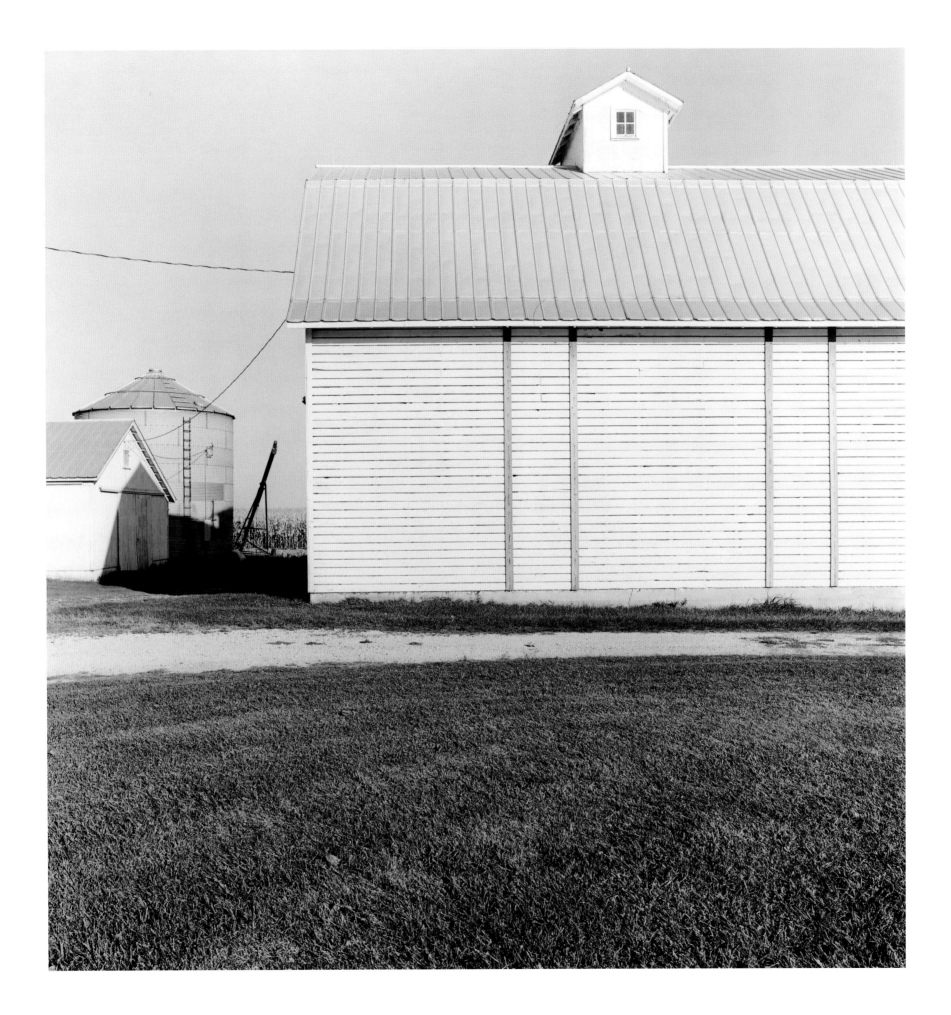

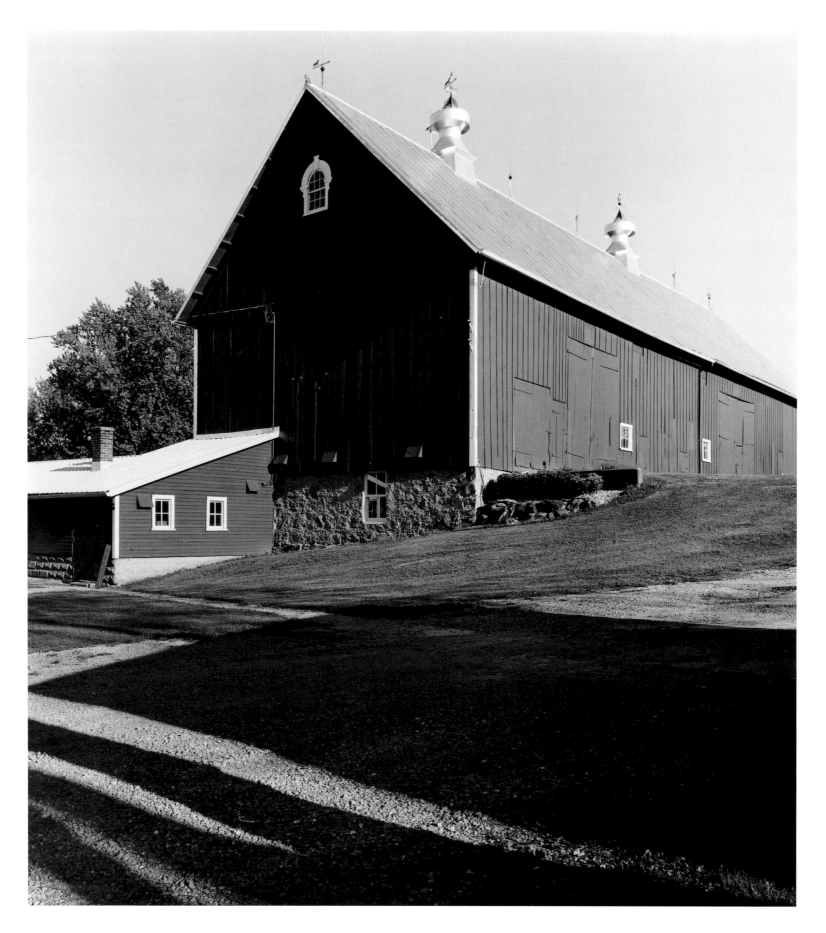

116 · Lodi Township, Columbia County, Wisconsin 2002)

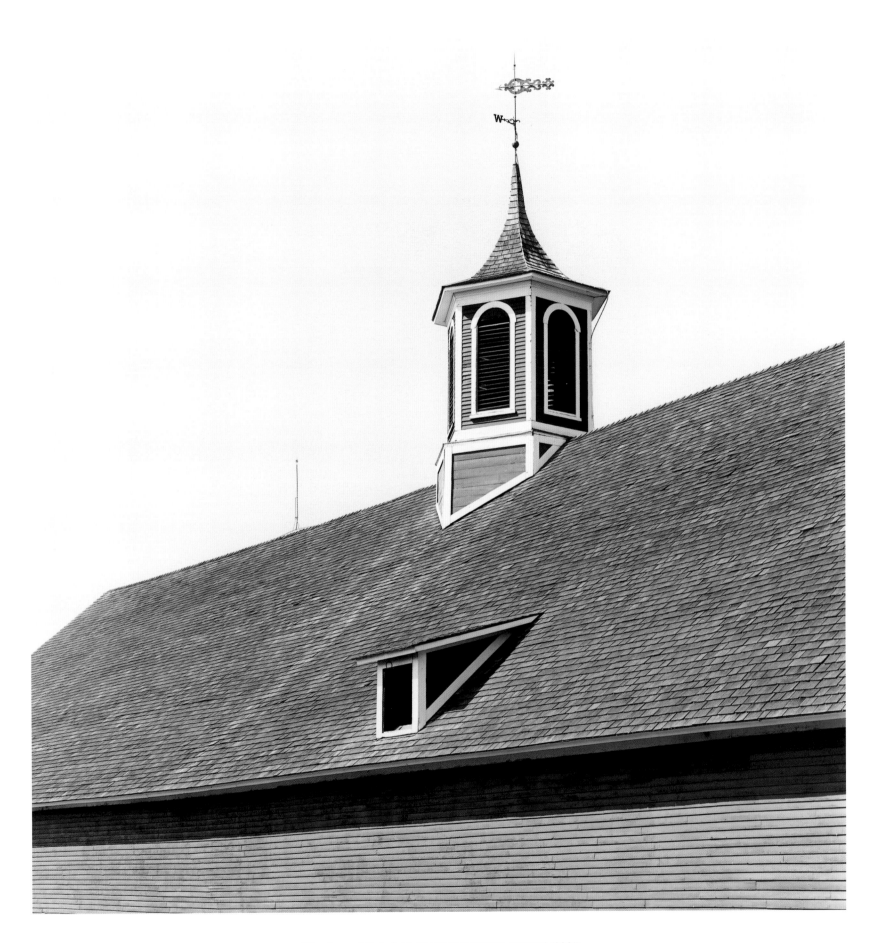

117 · Town of Waitsfield, Washington County, Vermont (2001)

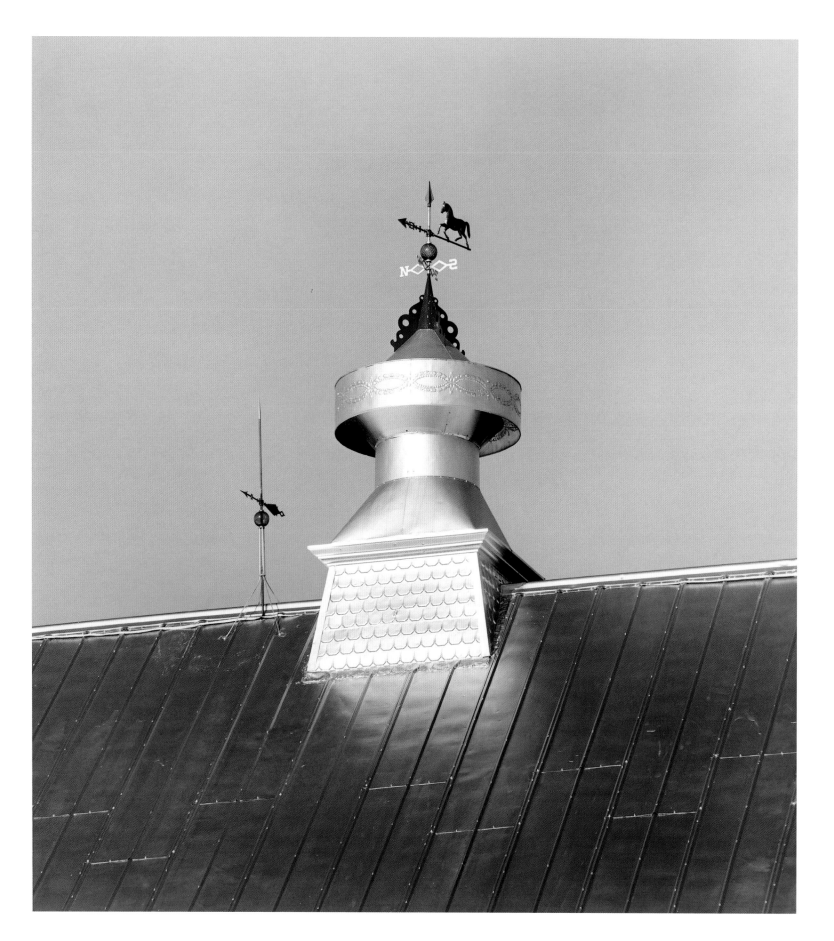

118 · Lodi Township, Columbia County, Wisconsin (2002)

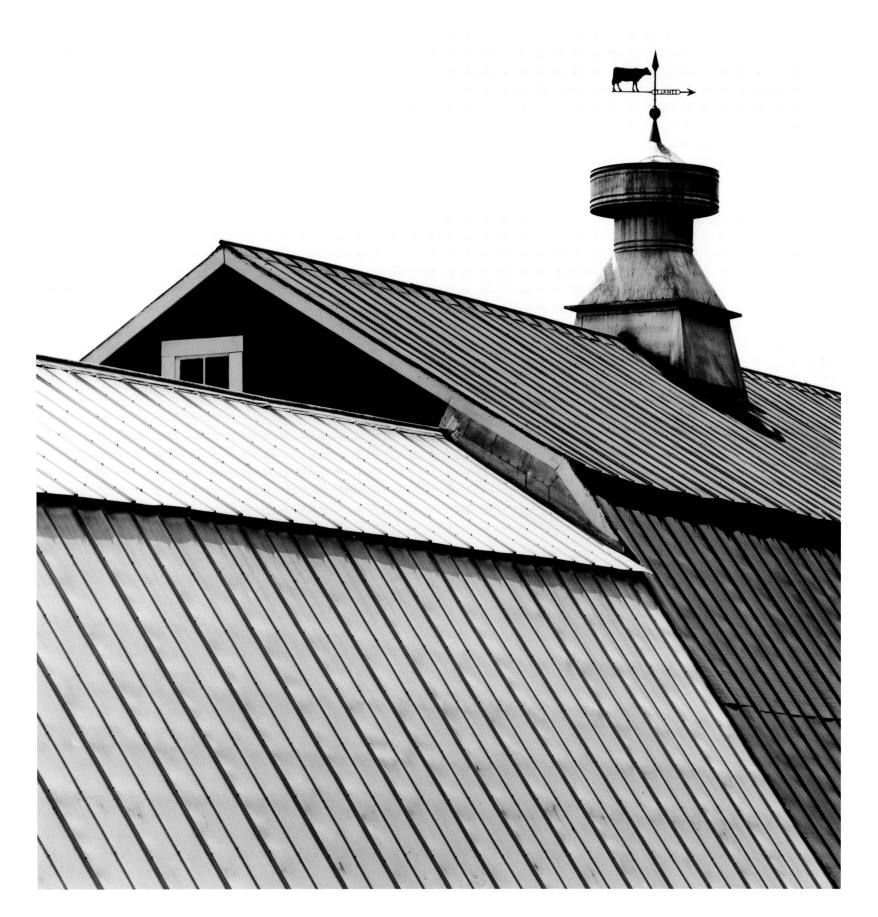

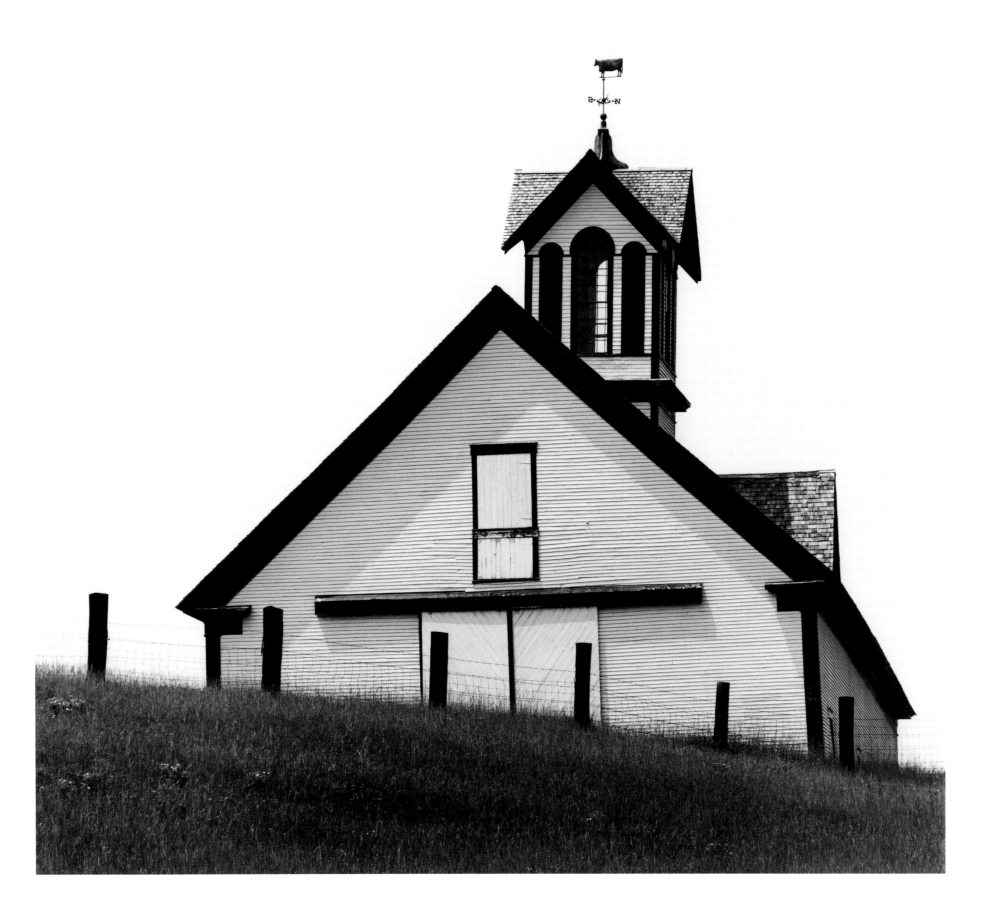

120 · Grafton County, New Hampshire (1964)

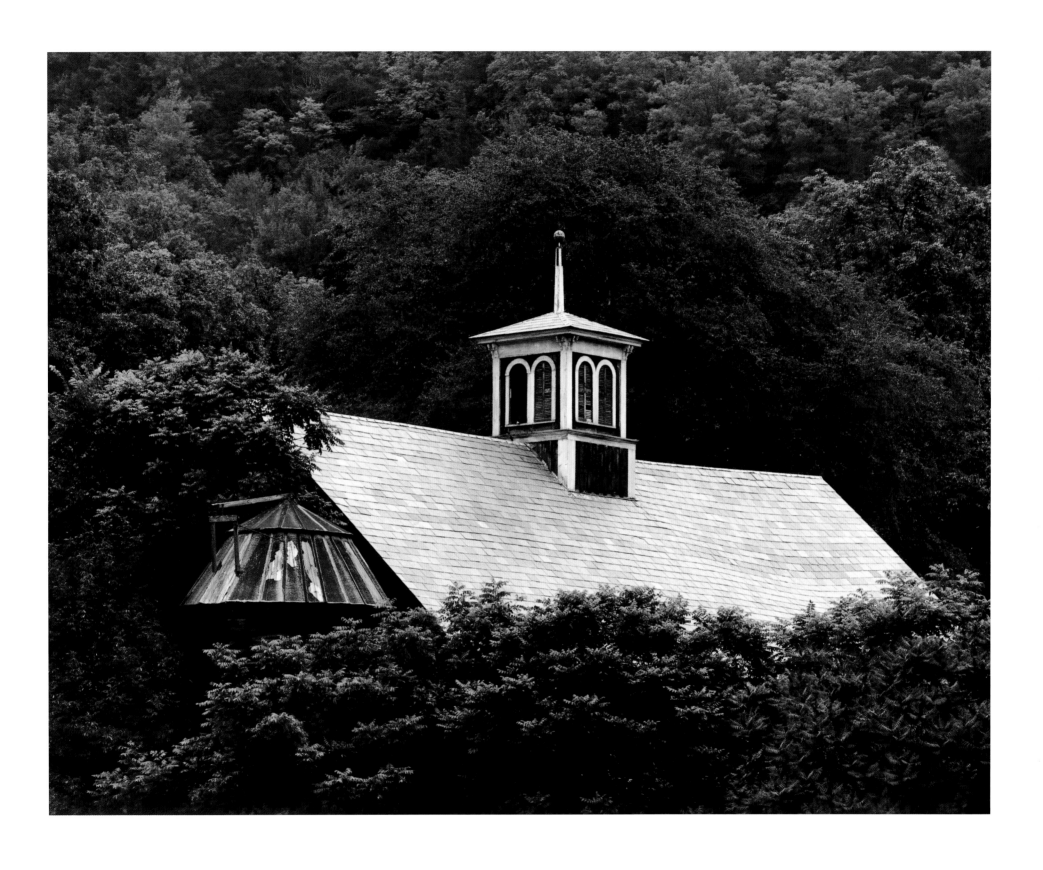

121 · Town of Putney, Windham County, Vermont (1964)

Acknowledgments

I didn't know very much about barns before I started to work on this project except that they were disappearing at an alarming rate. Therefore I had to learn as much about barns as possible before I set out to photograph them. Research will not make the ultimate decision of how to photograph what you find (that is a matter of serendipity, aesthetic judgment, and such intangibles as light), but it will tell you what is important to look for and where to go.

I have always made a point of doing my research from original material wherever possible and of contacting those who are most knowledgeable in their respective fields. Recently I have made extensive use of the Internet and have spent countless hours on the telephone following one lead after another. Over the course of my career I have established a vast network of people whom I have been able to contact for advice. This detective work is an integral part of making every book and is sometimes as interesting as making the photographs.

I have relied heavily on the good graces and assistance of many people who offered to help me and without whose contributions I would have not been able to produce this book: farmers, county

agents, editors of magazines and newspapers, historians, scholars, and friends.

This book is neither a comprehensive study nor a pictorial history of barns. It is more of a poem than an essay — an elegy. Some of the photographs here have been gleaned from those taken over the course of the past forty years, but most were done especially for this book, between 1999 and 2002. It was never my intention to document every type of barn nor their myriad regional differences; rather I have attempted to portray a generic sense of "barn-ness," for want of a better word. No matter where it is or what it is used for, a barn is essentially a simple, noble structure.

It would be impossible to acknowledge, or even remember, everyone who helped me during the course of the years I have been photographing barns. Please forgive me if I have failed to mention your name here. However, there are some people to whom I wish to give a special word of thanks: Robert Ensminger, Gerald Reichard, Tanya Werbizky, Ron Glasgow, Neal Carlson, Curtis Stadfeld, John Porter, Shirley Wilson, Allison Farmer, Aaron Kremer, Lowell Soike, David Ferch, Eric Gilbertson, Thomas Visser, Allen G. Noble, David Simmons, Jerry Apps, Zane

Williams, Gina Prentiss, Timothy Prescott, Maura Johnson, Bruce Clevenger, Chuck Law, Jack Holzhueter, Jane Eisely, Mark Mayer, Paul Winskell, Geoffrey Gyrisco, Daryl Watson, Mike Lambert, Ann Swallow, Nancy Fike, David Sapir, and my bother-in-law, Jake Schoellkopf. Lastly I would like to thank the late Walter R. Hard, who was for many years the editor of *Vermont Life* and a dear friend, the first to encourage me to photograph barns.

I would also like to thank Jill Brooks, who was my darkroom assistant during the early stages of this book. A most heartfelt thank you goes to John Flak, my assistant during the last two years, whose steadfast dedication and hard work were crucial to bringing the book to fruition. Once again, as with so many projects, I owe Steve Serio an enduring debt of gratitude for always being there to help me when I needed him. I thank John Bernstein, who despite our disagreements — and often despite his own sensibilities — deferred to my stubbornness and once again designed a most beautiful book.

I will never be able to find words to express my thanks to my editor and longtime friend, James L. Mairs, with whom I have collaborated for over twenty-five years on one book project after another. His appreciation and understanding of my work has been a constant source of encouragement that has inspired me to continue to photograph. Thank you for your faith in me.

I want to especially thank my daughter, Karen, who was my "grip" on the expedition to Pennsylvania in the summer of 2002. She was always at my side when I needed her, keeping crucial notes about location and film developing data, and lugging all my equipment around because my cardiologist forbids me to do it myself. I hope she realizes how much I relied on her.

And once again it is to my wife, Sandra, that I owe so much. Her devotion and encouragement — her love — have sustained me during the twenty-six years we have been married. She too was by my side, not only in Pennsylvania but throughout the course of the last four years as we forged this book together. Thank you for spending so many precious hours with me sorting through hundreds of photographs, for your editorial wisdom and advice on which I have come to rely. I shall always cherish the countless dinners we had at restaurants where we exchanged ideas and filled the table-cloths — albeit paper — with notes for this book and so many others. We make a great team — not just one that makes books together.

Technical Notes

All the photographs in this book were taken with 2 ¼ x 2 ¼ Hasselblad cameras of various vintages that I have used exclusively since 1966. For years my "right eye" was a 60mm Zeiss lens; however, for this book I relied heavily on a 50mm Zeiss lens. Where the situation called for it I used a 100mm, a 150mm, and a 250mm lens. I have always used a tripod, which as far as I'm concerned might as well be welded to my camera bodies. Ever since I was sixteen I have used the Zone System of exposure and development for my film. All exposures were read with a Zone 6 spot meter. I relied on Kodak Panatomic X film for 90 percent of my exterior work until it was discontinued in 1989. Recently I have used Ilford FP-4 and PAN-F film and still rely on Kodak TRI-X Professional film for all my interior work.

I never want to disturb the light, so to speak, or move anything. Therefore, all my exposures are made with available light, and I see everything in the frame exactly as it will be in the final print before I fire the shutter. The photograph is made on location. I know exactly what I have on film before I go into the darkroom; which images I will ultimately print. The only surprises there are bad ones when I have made some dreadful technical miscalculation.

I have always done all my own printing. I made the photograph, and therefore I am the only one who saw the way it was at the moment of exposure. Others may be better printers than I, but my print is the interpretation of what I saw. The prints for this book were all made on Oriental Seagull graded paper, usually Grade 3. They were developed in Dektol at a temperature of 68 degrees plus or minus $3/10$ of a degree. The contrast was controlled by diluting the proportion of developer and water or by adjusting the time or a combination of both. All prints were toned in 2 ½ to 4 ozs. of Rapid Selenium Toner per gallon of water.